THE
introverted
ARTIST

Defending My Art, My Way, Myself

LISA DOWNEY

Green Tea Press
Needham, Massachusetts

ISBN 978-0-9716775-2-4

Cover design, interior design and layout by Liana Moisescu. Author photo by Michelle Miller.

THE
introverted
ARTIST

For my mother

There really is no such thing as Art. There are only artists.

—Sir Ernst Gombrich

When we refuse to conform, and use all our strength, we can express opinions that others will have never been able to conceive and surprise the constipated minds that take everything for granted.

—Vittorio Canta

Author's Note

*T*HIS BOOK IS A highly personal, passionately written, likely flawed piece of work. The art history I relate is from my own reading, understanding, and sometimes interpretation of a wide range of texts, and can be considered an educated perspective but should not be used to take an art history exam. The statements I make about art school, the art world, and introversion stem from my own experiences and are not intended to imply that these feelings are universal. Your results may vary.

Prologue

THE ART TEACHER WAFTED around the room, circling behind each of us as we worked at our easels, speaking motivationally but gently, occasionally touching a shoulder and giving an encouraging smile. Here we were, all fully functioning adults—and she was talking to us like we were in kindergarten.

"Relaaax. Let it all out. Be loose, be *play*ful. Have *fun* with it!"

She didn't know it and I didn't say it, but she was annoying the hell out of me.

"Let the paint say what your heart really wants to say. You each have a treasure hidden deep inside, and all you have to do is open the door to let it out."

If this was art education, I didn't want any more of it. I had started taking art classes because I wanted to improve my painting technique, but every teacher I encountered instead spent the class saying things like this.

Every class I had taken over the last two years focused on ideas that are apparently now crucial to artmaking,

and none of them was technique. They talked to us about the importance of being original and the benefits of working spontaneously. People said things like "my art interrogates the role of identity at the crossroads of time." The overarching imperative was that you express yourself; the goal seemed to be to dig up some buried trauma, or genius, or ideally both: twin angels that would inspire your painting.

But dwarfing everything else was the insistence that making art is primarily a way of participating in society. Sometimes explicit, sometimes unspoken, the understanding was that we all make art in order to communicate, to "join the dialogue."

I disagreed with all of it. In this art world, painting itself had become secondary to ideas that exasperated me. Everything that was purportedly crucial and integral to artmaking felt, to me, foreign and irritating.

Worse, in a field that theoretically encouraged nonconformity, I felt remarkable pressure to work and think and talk about art in the one accepted way. The teachers, and my peers as well, were all so wrapped up in this gospel that they didn't hear me say I worked differently. The art world I was in didn't make room for someone who might not believe in it all.

The teacher stopped behind me. "Don't be so *care*ful!" she said. "Splash it on—it doesn't matter what it looks like!"

That was the final straw.

I had tried, and now I had had enough.

I quit.

1

WHEN I DECIDED TO become an artist, I thought it was just a matter of working on my art. I thought it would be a completely independent, self-contained and self-governed venture that had nothing to do with anybody else.

I didn't know how unhappy I would be that neither of those things was true.

I didn't know that I had such strong convictions about how art should be made, how it should be taught, and what it should mean to you.

I didn't know that everyone around me would prove to be inescapable influences. My husband challenged me to leave the safety of my studio; my children triggered the time-honored guilt of the mother who also tries to be more. Thoughts of my beloved late mother motivated me; my childhood with my difficult father left me with a crippling dread of not being taken seriously. And society in general—our culture's expectations and assumptions

about artists—forced me to confront my introversion, and tested the strength of my own beliefs and selfhood.

I didn't know that I was embarking on an odyssey that would dig up feelings I thought I had permanently banished—

(grief)

(resentment)

and deficiencies I didn't even know I had—

(identity)

(self-worth).

I had no idea that becoming an artist would be such a complex, emotional, soul-baring and self-analyzing process.

In becoming an artist, I did a lot of work on my art, but along the way, I learned much, much more.

This is how it began.

ONE NIGHT—AS A SINGLE girl in my twenties, working in publishing in Boston—I was alone in my studio apartment, and bored. I picked up a book of poems a friend had lent me: *The Lives and Times of Archy & Mehitabel,* by Don Marquis.

I don't usually like poetry, but this was different. It was not only funny and clever, but said insightful things about artists, through the eyes of a cockroach named

Archy who types stories by jumping on a typewriter, one key at a time. He writes about his friend Mehitabel the cat, a dancer with a checkered past who confesses her troubles to Archy. My favorite poem is long and rambling, but begins:

> *archy she said to me*
> *yesterday*
> *the life of a female*
> *artist is continually*
> *hampered what in hell*
> *have i done to deserve*
> *all these kittens*

I read it over and over. I loved it. I wanted to do something with it, to put it somewhere I could keep looking at it. Casting about for a way to do this in a manner grand enough to be worthy of it, I decided to stencil it on the wall of my apartment.

I planned it carefully: I counted the number of lines, measured my wall, and calculated how tall the letters could be. To make it fit, I had to cut a lot, cringing as if I had written it myself.

Over the next few weeks, I worked every night after I got home, stenciling the poem letter by letter, from the ceiling to the floor. If I had been more poetically

minded, I might have said that I felt a little like Archy the cockroach, getting it out one letter at a time.

It took forever, but that didn't matter; I was doing it because I enjoyed the work. Almost nobody else would ever see it, but I didn't even think about that: I did it because I wanted to do it.

MY LIFE HAD ALWAYS been about books and art. I grew up surrounded by people who were either writers or artists. My mother did every artistic thing imaginable—painting, sewing, illustration, design—sometimes for a living, sometimes just because she loved it. My father was an art historian and a writer, my uncle an architect. It seemed every ancestor had been one or the other.

If you grow up in a house full of books, you will probably be a reader. In our house, writing and art were not only valid things to do, they were natural things to do, the foundation of everything. Without even thinking about it, I did the same.

I painted and sewed; I sat and drew for hours. But while I loved it all, words felt more essential to me than art. I read voraciously, and wrote stories all the time. People say that reading provides an escape from real life; the writers out there know that writing does too. When something happened, I worked through it not by writing

4

in a diary, like many people, but by writing a story about it. Only by writing about something could I really know what I thought about it. I figured myself out by writing.

Of course, I was going to be a writer when I grew up.

I got a bachelor's degree in English literature and then a master's degree in linguistics—and I was fascinated by both subjects. But when it came time to make a living, I had to do something practical; luckily there was publishing, the love child of reading and writing. With no hesitation I dived in, and stayed for twelve years.

I loved it; I worked with books during the day and when I came home I either wrote or made art. I was working in publishing with (as I thought of it to myself) a minor in art. I did both, but only one of them for money. I was at peace, and my creativity thrived.

Then things started happening in shockingly quick succession.

I got married, and we moved.

I had a baby; we moved again.

I quit my job.

My mother was diagnosed with lung cancer, and died.

It was a rollercoaster of joy and anguish; many of the clinically most stressful life events in a short period of time. My brain shut down. I didn't have either the time or the peace of mind to do anything creative. I didn't write or make art for years.

TWENTY YEARS AFTER STENCILING Archy & Mehitabel on my wall, I was a stay-at-home mother of two kittens of my own—children, actually. I have to admit that the comparison to kittens was not only from Archy & Mehitabel; I frequently felt like an actual mother cat. I was aware that the quality of my love for them was the fierce protective instinct of an animal mother. Even more, I felt like a mother cat who lets her kittens roll over and under and around her until she finally, suddenly, has had enough and jumps into a dresser drawer and pretends she's not there until she has regained her sense of self. I definitely wanted to stay home with them, and almost never second-guessed my decision to not go back to work... but.

Staying home to raise children is a very particular kind of self-erasure. The scariest moment is when you realize that you have nothing to talk about except your children, because they are your sole purpose. When your husband comes home at the end of the day and tries to talk to you as if you were a real person, tries to be kind by asking how you are, you literally cringe with embarrassment: there is nothing to say about yourself that doesn't have to do with the children, because there *is* no you outside of them.

There was also the issue of money. After leaving college, I had never been financially supported by anyone, and was extremely proud of making my own way. Now my

husband's work paid for everything, and while I knew how lucky I was, it wasn't good for my ego.

Most of all, I had never had simultaneously so much empty time and so little time to myself. My day was so full that I didn't realize what I *wasn't* doing: I wasn't writing or making art. There was no time, no energy, no available brain space to do anything creative. This emptiness, this *lack* made me feel itchy and restless; doubly so because I couldn't figure out what was missing.

The combination of these things left me feeling bad about myself. I had no more identity of my own. It was as if—at the same time as being so terrifyingly necessary to two tiny people—I didn't exist.

However, now the little darlings were in school full time, and I was thinking about what to do with myself. I needed to find fulfilling work—work that would make me feel better about myself, make some money of my own again, make me feel like a real person again. Work that would give me an identity again.

I was lucky enough that I no longer had to make a living from my work; this time I could choose self-fulfillment over practicality. Much as I had loved and been good at writing and publishing, I wanted to do something different. In a slightly embarrassed mission statement to myself, I decided that this work must be hands-on, creative, and meaningful.

Hands-on was important to me after a career working at a computer, with words as my medium.

By *creative* I meant that I would be free to use my imagination and construct things (literally or figuratively) in any way I wanted.

Meaningful was the most nebulous of the three, yet also the most important. I was at the point in my life (age forty) where I wanted whatever I did to be undeniably *not* a waste of time, not killing or filling time. I've never been a good enough citizen to have the goal of doing something that will change the world; it had to be meaningful *to me*.

What should I do? I was essentially a writer, but I thought this itch might mean I needed to try a different medium. I decided I was going to become an artist.

But how to do that? What art had I done before that I could build on and have any hope of doing professionally?

You have to understand that my dreams of doing something always involved me doing it at a professional level. Every time I made a decision to pursue something, I imagined myself taking it to its highest heights. I took piano lessons, and visualized myself as a concert pianist. I studied linguistics, and imagined myself being the world authority on the relationship among the Scandinavian

languages. Even when I once decided to follow a cookbook and make chocolate-dipped meringue mushrooms, I fantasized about what it would be like to take *that* all the way and become a pastry chef. I wanted my job to be something I loved doing in which I was a recognized expert.

But it had never happened. And so, however varied and interesting the things I did looked from the outside, I always felt like a failure.

I never cared about making a lot of money—I think I knew from the beginning that I would never get rich working in a creative field—but I cared a lot about being taken seriously. I had a powerful aversion to the idea that people would think of me as average, insignificant, inconsequential; or worse, that I was so irrelevant that they would not think of me at all. A professional, whatever you think of them otherwise, will always be respected.

I never questioned this need that I felt for expertise and respect; if I was aware of it at all, I thought of it as a positive thing, a worthy goal. It was only much later, when I grasped that it was a worry that was getting in my way, that I examined it. In it I saw the shadow of my father, not only in my ideas about work but in how I thought of myself. How had that happened? Although we didn't have a great relationship, my father had never said

anything disparaging, derogatory, or even discouraging to me. How had he done it?

I had to think back to my childhood, pull off the fireproof blanket I had thrown over these memories, and try to understand.

In the meantime, how could I take my previous dabblings in art and become a professional?

I had taken exactly one class in each of oil painting, paper marbling, sculpture, and drawing the live model; those didn't get me anywhere. On my own, I had made artsy things regularly since I was a child, but a lot of it was ephemeral and maybe not that impressive after all: geometric abstracts in colored marker, pencil reproductions of images from *Vogue*, posters for friends' birthdays to practice lettering. I couldn't make a business out of any of those things.

I thought through all my old art projects, and the one I remembered as the most satisfying was stenciling that poem on the wall. I liked that it was methodical, painstaking, time-consuming; it had the perfect balance for me of creativity within boundaries. I liked making an image out of words, and I liked that they were someone else's words. I liked that it made a grand statement, being so in your face on the wall. It even felt kind of excitingly rebellious to know I'd get in trouble when I moved out for defacing the wall.

Stenciling became my new obsession. I drowned myself in gorgeous books about it (seemingly, for some reason, all by middle-aged Englishwomen). I pored over the photos by a woman who stenciled her whole house—the walls, the furniture, even the curtains of some dark English cottage—using glorious designs of fruit and vines she had drawn herself on enormous rolls of butcher paper. I wanted that to be me. I thought nostalgically of my future career.

So, with this goal in mind, but feeling slightly ridiculous, I googled "stenciling" to see if there was any way to take what I had loved doing and do it professionally. I made two discoveries that I wasn't expecting.

First I learned that, sadly, stenciling as art had been taken over by vinyl decals. You could now custom order a phrase like "Our hearth is our home" or something about God in any of 24 fonts and 48 colors. There was no room anymore for the beautiful old-fashioned art of stenciling by hand, let alone any jobs doing it. So much for that idea.

The other discovery I made was faux painting. I had never heard of it, but I liked it instantly. I learned that it is usually done as decorative painting on walls, but actually can be done on anything. Its life story was fascinating: it started centuries ago as frescoes in Greek palaces, had several lives before reaching its American Dream moment as the "in" decoration of every tacky living room in the

mid-1900s, and was now experiencing a revival with all kinds of amazing new materials and techniques. I liked that the same art could take the form of anything from an easy wallpaper pattern to a flawless imitation of fine natural materials like wood, marble, or even precious stones. It could be done in two or three dimensions, in paint or plaster; it could be a wall texture, a trompe l'oeil mural, a fake marble column or a gilded ceiling.

I immediately fell in love. *This* was what I was made to do.

THE FIRST BOOK I picked up was called, appropriately, *Faux Finishing for the First Time*. I bought all the mini rollers and sponges, acrylic paints and glaze, and started teaching myself the techniques in the book. It was beautiful art and I wanted to know how to do it; at first I didn't go much further in my plans than that. While that was really the core of why I wanted to learn, I also fantasized about eventually doing this as a paid job; I imagined myself with a faux painting business. *That* would really be proof that I was an Artist.

So I read books like the conveniently titled *How to Start a Faux Painting Business*. I learned, among other things, that you need to have a portfolio of samples to show clients; I started doing my work on properly

base-coated sheets of polystyrene, so that my finished experiments could also serve as samples if and when I started a business—sometime in the hazy future.

Having recently read *Julie & Julia,* I decided to start a blog and document my own progress as I taught myself all the finishes. I called the blog "Becoming a Painter," and I set out to do exactly that.

BOOKS WERE MY TEACHERS. I started at the beginning, with the simplest faux techniques like spattering, sponging and combing. I had great fun with crackle: you paint one color over another, and when you apply the "crackle medium," the top coat cracks like an old enamel teacup and reveals lines of the first coat underneath. I learned to imitate bronze, leather, and distressed wood. Most techniques worked; some went horribly wrong. The best of all was a spectacular faux lapis lazuli. This technique involves abstract blending of blue and black and green; sponging off to create white streaks; adding more and more layers of colors and finally spattering on gold and applying many layers of gloss varnish. It's "Starry Night" heaven.

Then, eagerly, I moved on to techniques that use plaster instead of paint: 3D! It was easier than I thought: you manipulate wet plaster on a board into the texture

you want, let it dry, paint it, and you have fake metal, wood, or stone.

I was doing all this in a house with two children and three cats, working in the guest room, which I liked to call my studio. I only got pawprints in one piece before I learned my lesson and closed the door at night; but the children were harder. They were curious, and I thought the techniques were so cool that I enjoyed demonstrating for them and sometimes gave them a little bit to experiment with themselves. Even when I announced that now, this is mommy's work, they loved watching me paint. In theory I wanted them to—my mother had always let me watch while she worked—but they would go from "helping" to chatting about their Calico Critters to wrestling like puppies, until I lost my patience and yelled at them to get out. After enough instances of this (and the wracking guilt that follows yelling at your children when they were just being children), I told them they could no longer be in my studio while I was working. I just couldn't concentrate when I was not alone; I couldn't imagine how my mother could, and did.

With this (somewhat) greater degree of peace, I completed all the finishes in one book and moved on to more complicated techniques in other books: faux parquet, glazed tiles, embossed leather. I got books on classic faux and drooled over the imitations of marble and

wood grain, but did not attempt much. These techniques require tremendous skill, years of training, and result in true works of art. The artistry and painstaking detail that goes into creating the veins in marble is mind-boggling; the colors are almost more beautiful than nature; the depth in the paintings makes them glow like the most magnificent polished stone.

Creating samples suited me perfectly in every way. I liked that some of it was mindless (basecoating twenty boards at a time) and some of it very conscious (choosing which technique to do next, and with which variations). I liked the small scale, though I itched to know if I could do it on a large scale as well. I liked the process: learning the technique from a book, doing a few tests and choosing my colors, followed by the performance aspect of it: many faux techniques are one-shot works of art.

I had a few showstopping failures, but many more successes that I was proud of, that I thought were so beautiful I wanted to frame them. Much of it was easy for me; my attention to detail and methodical work (which had also helped me succeed in publishing) served me well. It was enjoyable and fulfilling even when it was hard or time-consuming. It even suited life with small children more than most art: most faux techniques allow you do one step at a time, let it dry, and come back to finish once everyone is safely in bed.

I *loved* the work. It was exactly what I had been looking for: hands-on, creative, artistic but also practical. I liked that my work—once on the job—would involve ladders, overalls, and gallons of paint rather than prissy little tubes. It was the perfect combination, for me, of exactitude and open creativity. It had exactly what I remembered loving from the Archy & Mehitabel project: creativity within boundaries.

And best of all, I knew I was good.

I HAVE ALWAYS LEARNED best working on my own, and teaching myself faux painting from books suited me perfectly. I had a romantic (or possibly just introverted) wish to learn on my own and then emerge, like a butterfly from a chrysalis, a full-fledged artist.

Looking for support of this idea, I grasped at examples of self-taught artists, people who started by experimenting on their own and magically ended up professional; who seemingly became artists without participating in society. It was with that in mind that I fell head over heels in love with the story of Patti Smith and Robert Mapplethorpe, as told in Smith's romantic book *Just Kids*.

They were absolutely penniless when they started making art. They couldn't afford a formal art education (although Mapplethorpe did take some classes at

the Pratt Institute, where nobody understood what the heck he was making) and so spent their nights at home making art, often from scrounged materials. They were so poor that they sometimes had to choose between a sandwich and art supplies—as Smith says poetically, they were "unable to distinguish the greater hunger." She tells how they couldn't afford for both of them to go into a museum, so one of them waited outside while the other went in, and described it afterwards; and how Mapplethorpe said, "One day we'll go in together and the work will be ours." (Doesn't that give you chills?)

But as on the fringes as Smith and Mapplethorpe may have been, their story is nonetheless one of involvement in society. In their case "society" was the Chelsea Hotel and the supportive network of friends and strangers who helped them. With the benefit of hindsight, it's a mind-blowing story to read, when you see the randomness with which crucial connections are made, how powerful people enter the story and perform a small act of kindness that (we know) changed everything.

It started with friends giving them soup when they didn't have enough to eat, or letting them crash in an apartment when they didn't have anywhere to live. They made friends along the way who turned out to be enormously influential. One lent Mapplethorpe her Polaroid camera for his first experiments; Allen Ginsberg gave Patti

Smith a dime she needed to get a sandwich at the Automat. (Not exactly life-changing, but still cool. That was New York at the time: you might run into Allen Ginsberg at lunch.) A lot of people helped in the best way artists can, simply exposing them to their medium: at the Chelsea, Patti Smith got to examine composer George Kleinsinger's original scores, and observe how musician Matthew Reich shaped poems into songs, which was exactly what she went on to do. Oh, and Bobby Neuwirth introduced her to Janis Joplin, which might have helped too.

Reading about the chain of connections in Mapplethorpe's path is extraordinary. He idolized Andy Warhol and, by hanging out at the right bar, gradually got to know some of the people in Warhol's Factory. One of them introduced him to David Croland, an artist who got Mapplethorpe his first commission. Croland in turn made two pivotal introductions. (A pitiful story, because Croland was in love with Mapplethorpe and, by trying to help him, inadvertently hooked him up with two men who would also fall in love with Mapplethorpe and steal him away.) One was to Sam Wagstaff, who became not only Mapplethorpe's patron but his partner for the rest of his life.

The other was to John McKendry, the curator of photography at the Metropolitan Museum of Art. Despite his (also) unrequited love, McKendry gave Mapplethorpe

several crucial things. He took him into the vault of original photographs at the Met, where Mapplethorpe could "touch them and get a sense of the paper and the hand of the artist." He bought Mapplethorpe his own camera, and got him a grant from Polaroid that supplied him with as much film as he needed. But the most valuable thing McKendry gave Mapplethorpe was intangible—and social: entry into the celebrity world. And with that, he was made.

So Robert Mapplethorpe ended up bursting my bubble. I had hoped his story would be the ultimate reinforcement of my position, that teaching yourself and making art on your own is just as valid a way to learn as any other. Although he and Patti Smith were self-taught and did succeed, things took off for them only through relationships with other people.

Participating in society seems to be key to artistic success. But even short of "success" (whatever that really means), just *being an artist* seems to involve society. If you do it completely on your own, you are just a tree falling in the forest with no one around.

I knew this, but I ignored it. I didn't want to hear it. I worked best on my own; I wanted to continue making art that had nothing to do with other people.

I was still happily ensconced in my own private chrysalis.

DID SOCIETY *HAVE* TO be involved in my—anyone's—artistic life? It always has been. It has put on different faces and demanded different things at different times, but it has always been there. Society is not only involved in but *in control of* how we become artists, because it organizes the system of art education.

What's interesting is how that control that is exerted has changed over time.

Today most of us take education for granted, something that you can just go sign up for. But what we forget is that education requires *access to instruction.* Historically, this access was limited by class, gender, and—in art—the status of the visual arts as a subject for study.

The way art is taught is determined by a society's attitude towards art and artists; which is to say, the status that art and artists hold in that society. This status forms the structure of art education, and vice versa. (It's important to distinguish between the status of *art,* which affects the system of art education, and the social status of the individual *artist.* They are of course intertwined. But more on that later.)

Social attitudes about artmaking have been different both over time and between cultures. Here, now, there is great diversity in the arts—in both the people and the educational opportunities—but this was not always the case. Some societies regarded knowledge of the arts as

the privilege of a social elite; others thought that the visual arts was work fit only for slaves and the children of artisans. And *within* the visual arts, there were further rules of appropriate alignment. For a very long time the study of the fine arts was reserved for men; women did decorative arts. The history of art education has long been dominated by distinctions between the decorative arts, crafts, and the fine arts. There are still remnants of differing levels of respect for each kind of art, but it no longer has quite the social ramifications it used to, dictating who can do which.

The Systems of Arts

From the Middle Ages straight through to today, people have set down the "systems of arts"—essentially, a decision at each time about what we call "the arts." What qualifies as an "art" is still under debate—we like to use the term loosely—but we have narrowed it further than it used to be: at various points in time, the list of arts has included opera, gardening and military strategy. Part of the issue is that, for a long time, the definitions of art and science were in flux: before the 18th century, for example, painting

and sculpture were mixed in with optics and mechanics.

In the 18th century, there were declared to be exactly five fine arts: painting, sculpture, architecture, music and poetry. (This was the earliest version of the arrangement that sounds familiar to us today.) In the late 20th century a pile of new things were added to the list, like performance art and printmaking; photography, fashion, and film; ceramics, industrial design, and neon art. These fall in the broader category of studio arts; they are now enriched by more idea-based, "academic" disciplines such as art history, visual studies, and criticism; even computer science and linguistics can get involved, as well as (as in this book) sociology.

James Elkins, a professor at the School of the Art Institute of Chicago, makes the brilliant observation that much of what we take for granted in our society, we've *invented*. Systems of art are a great example of this: they are arbitrary; unscientific, if you will. The way art schools classify the various disciplines, both then and now, has a lot to do with social opinion: how much status each discipline has, based on its perceived importance in society.

The motivations behind our categorizations are fascinating. In the early days we were refining our definition of art; what we are doing now is becoming more inclusive and exceedingly specific. Elkins (amusingly but still seriously) asks us to think about how far this political correctness could go: how many possible divisions there are within each medium. He posits that, for example, we could divide the (already small) neon art department into a Department of Free-Standing Neon, a Department of Flat Neon, and a Department of Installation-Art Neon; or add to the painting department a Department of All-Over Painting and a Department of Hard-Edged Abstraction.

These days there is so much interdisciplinary art that most people don't think about the divisions; but again, if you remind yourself that a military strategist used to be able to call himself an artist, you might rest a little less easily in your assumption that the system as you know it is set in stone.

ART EDUCATION HAS CHANGED radically over time, but each system grew out of the previous one. (Sometimes a new system made only minor changes to its predecessor; frequently, however, it was an angry reaction to the foregoing and thus was its opposite.) Arthur Efland, a professor of art education, explained, "The way that the visual arts are taught today was conditioned by the beliefs and values regarding art held by those who advocated its teaching in the past."

The *beliefs and values regarding art* are not what you'd think, offhand, would be the driving forces of education; yet, as I learned, they are its very foundation.

IT MAY SOUND OBVIOUS, but it's important to realize: the profession of artist is not as old as artistic activity. There was art being made literally millennia before anyone tried on the label of "artist." How did people learn to be artists then?

In the Stone Age, did the people who went into the caves and painted those extraordinary creatures actively *learn* how to do it? We don't know. For the earliest and longest period of people making art—from 30,000 until 2500 BCE—we simply don't know how people learned to make art. Our theories about the purpose of cave paintings keep being revised; unfortunately, understanding the

people is (as always) many steps behind interpreting the art. Nobody has even hazarded a guess about anything about the artists themselves.

Ernst Gombrich's fabulous, wide-ranging and now classic book *The Story of Art* leads us through the artmaking of other civilizations from the Stone Age to the Renaissance. For example, in Egypt, from 3500-30 BCE (again an unimaginably long period of time), the pyramids were built by thousands of slaves who were, in more ways than one, like worker ants. The extent of their artistic work was mechanical construction. Egyptian fine art, on the other hand, required careful instruction. A would-be artist had to learn the strict laws of style, and the art of hieroglyphics; "but once he had mastered all these rules he had finished his apprenticeship. No one wanted anything different, no one asked him to be original." (This is partly the reason that, for three thousand years, Egyptian art changed very little.) It probably goes without saying, but the contributions of even these fine artists remained anonymous.

Following the trail of Western history, we come to Greece, in the long period from the 7th century BCE to the 1st century BCE. Here, the vases and statues of idols (which were their main arts) were made by people trained in group workshops; their work was still largely anonymous.

We have largely forgotten, but there was a huge chunk of history in which the concept of the individual did not exist. In this social system and mindset, group society was everything. As Gombrich says, there was little room for individual expression, let alone the *self*-expression in which we luxuriate today. For all of history before the Renaissance, artists worked in anonymous occupational groups, creating art that represented an ideal. With very few exceptions, there was no originality or self-expression or personal fame.

This changed radically in the early Renaissance of the 1300s, and the embodiment of the change was Giotto di Bondone.

Giotto painted religious frescoes with a realism that was revolutionary. Gombrich says that in Giotto's painting "we seem to witness the real event as if it were enacted on a stage." His composition, full of movement, foreshortening, and shadows, made it seem as if the viewer was inside the painting. "Nothing like this had been done for a thousand years."

But what was even more unusual than Giotto's artistic style and achievement was people's reaction to it. The people of Florence were proud of their native son; people became interested in his life; his fame spread, and his name was cemented as a master artist. Such fame not only likely made Giotto happy but, by shifting attention

from the group to the individual, changed art education entirely.

Gombrich writes that Giotto should be remembered almost more for the changes to the system that he involuntarily brought about than for his paintings themselves. Before Giotto, people "thought of [artists] as we think of a good cabinet-maker or tailor. Even the artists themselves were not much interested in acquiring fame... Did not even sign their work. Giotto begins an entirely new chapter in the history of art. From his day onward the history of art ... is the history of the great artists."

This development—recognition of, indeed awe of, an individual artist as a master—changed society's view of artists, and enabled a radical shift in the educational system. The new concept of an individual master in his studio catalyzed the way that artists learned for the next seven hundred years, starting in the Renaissance and straight through to today: apprenticeship.

This is where I pricked up my ears, because the topic of apprenticeship had become, let's just say, my personal bête noire.

A Brief Tangent on Time

Time, in art history, is a slippery thing. Gombrich describes it as an "optical illusion": it seems as if in earlier centuries, art movements progressed in a more orderly succession of styles than they do now; it looks to us like movements followed each other "as soldiers on parade." Of course they didn't, but it seems so because most art movements only take shape in hindsight—a useful but deceptive trick history plays on us.

The passage of time, and our distorted perception of it, influences and complicates our categorization of art movements.

The way we define time in different periods varies wildly. What we call an art period lasts radically different amounts of time depending on the rate of cultural change (that we know about). Hence the earliest "periods" lasted thousands of years, while later—especially after the Industrial Revolution, which made time speed up—a period lasted more like twenty years.

Naturally we can only work with what we know, but it seems unfair that just because it happened longer ago, we lump thousands of years of human life and work into a box and call

it one thing. In the beginning, the Stone Age for example, the periods of time we're talking about are so long that it's quite ridiculous to make one category of it. Cave art was "the longest artistic tradition humankind has ever known," and we know next to nothing about it. Imagine the changes that happened over thousands of years, that we are callously collapsing! We don't know enough to make it more specific, but at the same time it seems embarrassingly ignorant to not know much about something so huge.

On top of that, there are geographical problems. How do you describe as one period things that happened in several different parts of the world, with entirely different cultures?

Once we reach Neoclassicism and Romanticism (roughly the 1760s until the 1850s), we call the categories movements rather than periods: artists were doing different things in the same period. And as we get into more recent history, there is more and more overlap: artists doing *many* different kinds of art at one time. Now it is clear that movements do not follow each other neatly in time, but are different *possibilities* present simultaneously.

This is reflected in our labeling system: we

use a single category, "the Stone Age," for a time comprising more than 30,000 years; but within the period 1900-1945 ("Modern Art") we have distinguished forty-one different categories.

But let's remember the other hazard of categorizing everything: that we forget that our art history timeline is not *human* history. It can be helpful to classify artworks into these categories, for our own reference; but actual historical developments happened messily, blurrily, *around* the categories later imposed on this one very particular aspect of history.

ALTHOUGH I SPENT EVERY free minute I had in my studio, my usually supportive husband mysteriously said nothing. He never praised, criticized, or asked questions. When I asked him what the problem was, he finally said, "You need to stop doing this for yourself, and get someone to hire you to do it for them." When I protested that I was still learning, he said, "You'll learn on the job. That's the way most people do it."

I was terrified. I knew that was the general plan, but I wasn't ready.

I knew I didn't know enough yet to go out on my own, so I started to look around for an apprenticeship. Wasn't that the classical way to learn to become a painter? Isn't it how things worked in the Renaissance?

My timing could not have been worse. This was 2011, the economy was terrible, and faux painting was dying. People couldn't afford to have this kind of painting done in their homes, and so faux painters—these incredible artists who could paint you a trompe l'oeil door so good you'd walk into it—were refinishing furniture instead. What I had been imagining—going on a job with an established company, working side by side with someone on a scaffolding and being shown how to do a five-layer damask in a thirty-foot-tall foyer—wasn't going to happen.

Searching online for an apprenticeship, or any kind of teaching, I was excited to find several faux painting schools, and immediately picked up the phone. Each time, I got a despondent owner saying in a dead voice that there aren't any classes scheduled for the foreseeable future, but thank you for your interest, and good luck.

This was harder than I thought it was going to be.

One day, in a *carpe diem* mood, I sent my portfolio to a local faux painting company and asked for a job; the answer was that they would take only experienced, full-time help, and I was neither of those things.

This made me despair. I wasn't supposed to teach myself, and I couldn't find anybody to teach me. What alternatives were left? How was I going to learn?

This problem was the real origin of the book you're holding: it made me think long and hard (when perhaps I should have been painting!) about how people become artists. I thought about how the system of art education has changed over time: my situation was so different from the apprenticeship system that I vaguely knew was how things used to work. I wished I was living in an earlier era, in order to learn this art the way I wanted to and thought I could and should. I was annoyed that my life as an artist—my creative life—seemed to be out of my hands, and was instead being determined by the society I lived in.

I WAS RIGHT THAT apprenticeship was how artists were educated in the Renaissance, but what I didn't know was that apprenticeship didn't—*couldn't*—exist before the Renaissance. Apprenticeship, and all other ways of learning, can exist only in certain circumstances, like a biological phenomenon, when the conditions are right; in this case, when the foregoing history and the current social beliefs were just right.

There is a beautifully clear progression of events leading to the invention of the apprentice.

First was the prerequisite that I mentioned before, for the individual to be recognized from within the group. From the acknowledgement of the individual stemmed an awareness of the work of one person; that awareness allowed the possibility of one person becoming famous for his work. The fame of one artist meant that more people wanted work by that artist, or if that was not possible, work by someone equally good or better. This generated competition, which led to increasing demand— which created the need, simply, for help. The need for help meant that people had to be trained to help. This created the need for a training system, which led to a new system for learning to paint. Thus, along with the new phenomenon of a recognized master in his own studio came a new educational system: apprenticeship.

In the 1400s, Michelangelo, Raphael, and Leonardo da Vinci (who all started as apprentices themselves) had more commissions than they could handle on their own; to meet the demand, they had rafts of apprentices. The system functioned like an elegant machine: meeting the demands of fame enabled the wheels of learning to keep turning.

This is what we've all heard the romantic stories about. A boy of about eleven or twelve left his home and went to live, often in another city, with a master painter. He ran errands and generally made himself useful, in return

for room and board. When he got to do some painting-related work it was preparing boards or canvases, or grinding pigments, which was often deadly due to their toxicity. Eventually he was allowed to help with an unimportant part of a painting—something nobody would see if he messed it up. If he could imitate the master's style to perfection, he would be given more important tasks to do.

It's apples and oranges from today. Back then, a student had to make his work indistinguishable from his master's; to try to make his individuality as invisible as possible. Nowadays a student must show originality, unique vision, powerful self-expression.

It is in this way that today's art assistant is related to yesterday's apprentice. They serve the same purpose—doing the grunt work while the master (or, today, the celebrity artist) is off performing the non-painting components of the job—but the distinction is a sizable one. A first job in art is no longer an introduction to the profession. Today, artists hire full-fledged artists to be their assistants. Just as modern art schools allow—nay, expect—students to arrive as full-fledged artists, assistants are not there to learn, and are certainly not there to learn to imitate the master. They may not get any more credit than they used to in the old days (that hasn't changed—why would it?),

but it's like a first job after college: it gets you an item on your resume. *It isn't how you learn.*

The change in terminology is significant. We no longer call them apprentices, because that term implies two things we don't want to imply anymore. One, a master/student relationship. This no longer holds; they are now employer/employee. Two, that the student will copy the master's style. It is still true that an assistant must be able to imitate their employer's style—they must be able to step in and do work that he doesn't want to do—but they are doing it as a great forger would, for a job, while, crucially, holding that work entirely separate from their own personal style and purpose as an artist. They are individual, often thriving, artists in their own right.

Some of the work modern assistants do makes you wonder what they are getting from the deal. The British artist Damien Hirst, for example, had his assistants paint thousands of perfect spots, going to great trouble to recreate in paint the colors he used in his design on the computer. While they can't expect credit—they don't get to sign the bottom right-hand corner—there is a definite benefit. They get a connection to a famous person: a huge advantage in the all-important work of networking.

And the fact that apprenticeship has morphed into an avenue for networking attests to the point of this book:

that the social aspect of art is what is now considered essential in your art education.

HISTORICALLY, IF YOU WANTED to become a painter, there was a single, well-mapped-out path you had to follow. Society offered *one* route into the profession, and if you wanted to be recognized as an artist, you had no choice but to take it. Now, a myriad of factors (ambivalence about formal art education, the economy, and political correctness, to name the big ones) have led to there being more choices than ever in ways to become an artist. And this leads to trouble: uncertainty, ambivalence, stigma.

It is no longer true that to be an artist you must go through the formal channels; you don't have to have a degree. But the fact that it is available, sometimes preferred, but not required, plays mind games with you. Should you go for the only legitimization offered in a field that does not require legitimization?

The traditional ways to learn to become an artist of course still exist. If you do decide to get an MFA, you can now choose between a "regular" art school and a new, retro kind of institution: the modern atelier, where you learn classical techniques following the model of the French academy.

If you want art instruction but don't care about the degree, you can take the more informal route of adult education. This phenomenon originally began in the United States in the early 1900s with the goal of Americanizing immigrants; the focus shifted in the 1930s to leisure activities, including art and crafts. It is a useful, compromise way to learn: you are taught how to paint but with less emphasis on technique than on enjoying the experience.

But what is *really* new are all the ways that you can now become an artist without any training at all. You can still be self-taught, with the same possibilities of success or failure as before; now you can even be completely *un*taught.

More people than ever are trying to figure out this puzzle. Second careers are big business, as a result of the economy, people living longer, and our culture coming to accept that people will have more than one career in their lives. There are millions of people reinventing themselves every day. And one of the most popular things people decide they want to do is make art.

A large percentage of these are women. Huge numbers of women face the challenge of deciding what to do after staying home to raise their children. After such a long period of renouncing yourself—your sleep, your thoughts, not to speak of your ambitions—you slowly begin to

have enough time and mindspace to see the possibility of there being a *you* again. You are older and wiser, with the wider perspective that children give you. But what should you do? Usually you can't get your old job back, even if you wanted it.

You can recreate yourself. You can ask yourself what you *really* want to do. You're being given a second chance: what should you do with it?

I knew what I had to do with it: I had to start my own faux painting business.

2

I T WAS A BIT of a shock to the system. Starting a business was not an entirely *new* goal—having a business had been the hazy dream—but I had been luxuriating in the dilettante pleasures of just learning the art, when suddenly the deadline was pushed up and I had to get practical, quickly.

But I didn't think I was ready. When my husband challenged me to do this as a job, I was terrified because I felt like I wasn't enough of an artist to do it for other people yet. Was I? I loved what I did but almost no one had even seen my work. As I debated what to do, I would wake up at night thinking, *am* I an artist? I thought my work was good, but I needed a professional opinion before I dared to announce that I could do this.

One of my neighbors was an interior designer who had been in business a long time and won some awards; I asked her to come over and look at my work. When I showed her my sample boards, she lost her normal chilly reserve and got excited. She told me which were

her favorites and suggested I get a professional photographer to create marketing materials. She said she would recommend me to her clients. She hired me herself to do two rooms in her house.

That was good enough for me.

So, I started a business. I found it strange how painless it was: it was in fact terrifyingly easy. I was used to some outside validation being necessary to get a job—a degree, or at least work experience—but now I could print up some business cards and declare myself an artist.

It was fun, designing business cards and a website. A professional photographer friend of mine professionally photographed my samples. I created the three-ring binder all the professionals have with samples of the different categories of work they do—stenciling, stripes, sparkly children's rooms, et cetera.

My company had to have a name. I thought about how I loved paint: how it was smooth, heavy, sensual, like molten gold. To me it was like the essence of color, of beauty, made physical. When I poured it from the can, the word "delicious" came into my head every time. So when I needed a name for my business, it was easy: Delicious Colors.

Like all the offbeat but personal things that come to me intuitively, I was fiercely devoted to this name. My husband and I still laugh about the moment when his parents asked me what my company name was going to

be. I told them, and—straight out of a cartoon—there was silence. Crickets may have actually chirped. Then they changed the subject.

That hurt, but I didn't *really* care. Other things still to come would hurt more.

I NOW WENT ABOUT the business of announcing my business. I handed out business cards, tacked them up on bulletin boards in the library, coffee shops, everywhere. I told people that I had just started a business. *I'm a painter,* I said.

Sooner than I thought, I got my first job.

It was easy in every way. The job was to paint a nine-year-old girl's room—they were getting rid of the little-girl wallpaper and wanted something that she would like into her teenage years. The client seemed strong-willed, and I assumed it would be a case of the child being told what she wanted. But when I arrived at the (enormous) house for the design consultation, I was surprised: the mother had her daughter run the meeting. My surprise quickly turned to admiration: she was possibly the most decisive any client (or nine-year-old) has ever been. She chose colors from my fan deck, looked through stencil samples, and made a few sketches for me. She asked for "something inspirational" above her desk; she quietly fended off her

mother who clearly wanted the sparkly dragonflies from one of my sample boards. We decided on long-stemmed allium flowers stenciled all around the room in various pinks, and a 36-inch anemone over the desk.

It was a cakewalk: the mother had "her guy" take down the wallpaper and do the base coat, then I came in to do the stenciling. I had the huge house to myself and spent a lovely day stenciling flowers, the hardest part of which was deciding which harmonious shade of pink should come next.

It took only a few hours. I restrained myself from investigating the wet bar or hitting some balls on the private tennis court, packed up my stuff and went home.

It was a great start to what I hoped would be a long and fulfilling career.

BY STARTING A BUSINESS, I felt I was making a declaration, to myself and to the world, that I was an artist. I had (arguably) passed through the training stage and was now announcing my new identity in the world.

This felt, to say the least, odd. Why was it up to me to do this? On what qualifications and chutzpah was I basing my assertion? I wasn't even really thinking of what people would think of me; I was wondering about it more existentially. How would I know when I "was" an "artist"?

Nobody understood what I meant by this question. "Why do you care about the label?" my friends asked, frustration creeping into their voices. "If you make art, you are an artist!"

No. First of all, I disagree, but more importantly, that undiscriminating, literal usage of the word was not what I was talking about. I was pondering the question of identity. What makes you an artist? At what point do you merit the label? Who says?

WHY WAS I SO concerned with identity?

It was because I wanted, finally, to be able to say, proudly and with no doubt in my mind: *I am a [fill in the blank],* and I wanted it to be undeniably true.

I had spent my life learning many things, but never got even within spitting distance of being a professional at any of them. I could play the piano, the flute and the violin, but knew that I didn't love music enough to make it my life. I learned several languages, had a naturally good accent, and even lived abroad, but I almost never spoke with any confidence. I did a summer course in architecture, but never took it any further. I wrote all the time, but was never published. I loved reading, and was an English major in college, but everybody in my book club is better at literary analysis than I am. I got a

master's degree in linguistics, but didn't do particularly well and I am quite certain that they gave me the degree as the easiest way to get me to leave.

I was a dilettante, and I hated that.

People put a positive spin on this—"oh, you can do so many things!"—but that wasn't satisfying to me. I wanted something that defined me. I wanted a claim, a territory. I wanted a label that I had earned. I wanted the confidence that I was at a level worthy not just of encouragement but of respect. Worthy of what I thought the label should imply.

MY SECOND JOB CAME about when I took my sample boards to my photographer friend for the photo shoot. She fell in love with several of the techniques and decided she wanted to use them in redoing her half bathroom.

"I want it to look like an impressionistic garden," she said. "Trees, grass, birds, blue sky and clouds."

This is one of the best parts of a faux painting commission: the dreaming and designing stage. The client gives you a rough concept and it is up to you to go off and let it percolate in your brain, think about textures and colors, occasionally look up stencils and other materials to see what is doable; and finally, translate the idea into something that can be done in paint. Sometimes you have

to talk the client down from an unrealistic vision, but more often, happily, they have no idea of the possibilities and you have the pleasant task of enlightening them on the amazing things you can do.

It was quite a challenge to turn my precise stencils into an impressionist mural. A large part of the reason I liked and was good at decorative painting is that it was usually precise, measured, carefully planned; she wanted me to come in and be Monet. I wanted to plan the stenciling exactly; she wanted to just start and make decisions as it progressed. Luckily we were friends; she joked that she would have to loosen me up with a glass of wine before I started work each day; that she would say to her friends, "I have to get my painter drunk so she can do a good job."

Alcohol turned out not to be required. On top of a beautiful bright cream base coat, I stenciled white aspen trees of various widths, some in eggshell, some semi-gloss, some pearlescent white. I sponged on glazes of green and cream to soften all the edges, and it became, truly, an impressionist garden.

The finishing touch was a few birds perching on the tree branches. When my friend requested that I paint a bird above the toilet complete with its own droppings, I balked... but, as they say, the customer is always right.

IT WAS CONFUSING. HOWEVER confident I was of my painting abilities, I never got away from feeling like an impostor. Once I was on the job and painting, I felt better because I knew the client could see that I was doing my job well; but during all the preliminaries—going to a client's home for the consultation, even saying the words *I'm a painter*—I was cringing inside.

Many people are familiar with impostor syndrome. It is when a person—frequently a high-achieving woman—feels like a fraud despite evidence of competence and achievement. Much as it feels like a personality trait, it is officially more of an *experience* that can happen at any point in your career. It is also a common experience of youth, which makes sense: figuring out who you are and what you are good at is a natural phase of life.

Psychologist John Gedo says that young people, as they establish their identity, often go through a period of imposture. He says, generously, that establishing one's identity could itself be called creative work. "Perhaps self-creation is ... a necessary creative act that must precede other creative efforts." He even describes this kind of imposture as performance art—a wonderful way to think of it, because that is, after all, what it feels like.

But the feeling of imposture is far from being limited to amateurs. True creative geniuses sometimes go through periods of uncertainty about their talent. Sometimes

it's because of the radical nature of their ideas; we are all familiar with stories of negative reception of highly original work. (This is the reason that posthumous fame is such a thing.) But there can be a similar period of uncertainty just before a creative breakthrough: Freud and Einstein, while working on their *tours de force*, reportedly felt like they must have not known what they were talking about because they were "temporarily deprived of positive feedback." Sometimes this was the case because, let's just say, their skills did not lie in human relationships and they had alienated everybody—Freud was famous for ostracizing those who were not utterly loyal to him and his ideas—but for Einstein it came from the actual period of isolation required to produce the work.

There is, of course, an important difference between feeling like an impostor and *being* an impostor. The painter Arshile Gorky, born in Armenia as Vostanik Adoian, came to New York claiming to be a cousin of the Russian novelist Maxim Gorky and to have studied with Kandinsky—neither of which was true. The art world accepted the lie without question for twenty years—despite the fact that "the impossibility of this claim was evident to the émigré Russian community, because 'Gorky' was not the novelist's family name either, but a nom de plume."

Imposture is now encouraged as part of learning. As Baron Baptiste said this morning in my power yoga video, "Fake it til you make it!"

I was faking it as hard as I could, but I don't know if I fooled anybody.

So how do you know when you are an artist? What makes you an artist, anyway?

The answer to both questions, as always, is society. Sometimes openly, sometimes with great subtlety, society lets us know where we stand.

While I was so tormented by feeling like an impostor, I wished desperately that it could just somehow be a *fact* that I was an artist; that way neither the world nor I would feel any doubt. Why couldn't it be that simple?

Historically, it pretty much was. For better *and* for worse, society used to control the process more openly and objectively than it does now. Things were much more black and white. You went through the required training, touched down at the defined points of achievement, and then you *were* an artist. (The group orientation helped: a society had an interest in filling all the roles appropriately.)

There used to be landmarks along the road to becoming a painter which we no longer have. Craft guilds

(which ruled the artist's world from the 1100s until the 1800s, collapsing, as so many social systems did, after the French Revolution) had a system for ensuring that people who called themselves painters were indeed skilled. After completing the required number of years as an apprentice (which varied, but was usually about seven), you were labeled a journeyman. As such you were an employee: earning money for your work, unlike an apprentice, but not allowed to be self-employed. Journeymen were paid by the day (hence the word, from the French *journée*, for day). A journeyman painter was considered competent and fully qualified, but nobody expected a genius. (The dictionary definition of journeyman is "a worker who is reliable but not outstanding.") Journeymen often traveled to work for other masters—in a stint called the journeyman years—which gave them experience of different workshops, and also served as an unofficial way of spreading ideas and techniques.

Journeyman could be either a temporary or a permanent state, depending on your ambitions. Many painters worked like this forever—in the same way as us: most of us always work for someone else—but if you wanted to run your own business and were sufficiently talented, you could apply to the guild to become a master. This required submitting a piece of work (your *masterpiece*) to the guild for evaluation, and if you passed, you would

be admitted to the guild as a master. After that, you could open your own studio and hire apprentices to do *your* dirty work for a change.

So being an artist was considered more of a fact than a claim. There was no question of legitimacy. Art was an objective skill to be learned, so once you had learned it, there was nothing to doubt.

Artists may not have had to worry about legitimacy, but they had much less choice of profession than we do today.

Through much of history, one did not choose one's profession. (Ironically, those who might have been in a position to choose did not have to have a profession at all.) This was partly because your job was (and still is) equivalent to your social position, which is not something that has ever been a personal choice. You pursued work that was considered appropriate for someone of your social status; after you did the training that was required, society then bestowed upon you the title (and accompanying status) of that role. This may have felt like restrictive, discriminatory pigeonholing, but it also provided external validation of your position and abilities. Now that this arrangement has gone away, we kind of want it back.

Now we have the freedom (at least nominally) to pursue any work we choose, but we have lost something equally important: the certainty of our legitimacy. Not

only do we sometimes worry that others will see us as frauds, but we worry about it for ourselves: *am* I worthy of this? If there is no social legitimization, we might never feel sure that we are good enough to do what we say we can do; that we qualify to be what we declare we are.

If it is relatively new in history that a person can choose what they are going to be, it is even newer that you can take the independent step of declaring it so. We decide what we are, and announce to other people what we have decided that is going to be. It felt unpleasantly artificial for me to make this kind of independent declaration about myself, with no formal training, no degree, no external legitimization whatsoever.

I didn't know if I was an artist. I didn't mean it in a fuzzy, personal-definition way; I wanted to know if I was enough of an artist to go out and be one in the world. Nobody had told me that teaching myself *wasn't* enough, but I was used to the old order of learning a skill and then being hired to do it by an organization, where the hiring itself is validation that you know what you're doing. I had looked for legitimization in apprenticeship and couldn't get one; but I still felt I *needed* it. With no apprenticeship and no art degree, I had no external validation that I was an artist before I had to make the leap and declare myself one.

The art world still holds out the prize of legitimacy, but only through participation in the system. Those who go through traditional channels will still be awarded the label of "artist" by society, by dint of either a degree or exhibited work.

But what if you don't participate in the system? So many of us, by choice or otherwise, are now making art outside of the formal "art world." If you make art outside the system that bestows the official label, it is up to you to apply it to yourself.

You can call yourself an artist at any point along the path from beginner to professional, because the amount of training you need before the label applies to you is now undefined. I didn't know if teaching myself, plus the passion I had for it, was enough or not.

Make no mistake, in leaving us to define and declare ourselves without its benediction, society is still influencing our lives just as much as before. It has just exchanged overt rules for intangible social pressures.

WHILE I WAS CHANNELING Monet in my friend's bathroom, we started talking about another job in her house. She had a decorator redoing her living room and she wanted me to paint something interesting under the chair rail all around the room. But there was a snag: the wall

color would have to match the rug, and she couldn't decide whether to order the rug from Uzbekistan or buy one here. So my part of the project was on hold for a few months.

This period of limbo when things are under discussion, before the contract is signed, is worth talking about. I discovered that this is how every faux painting commission works: someone calls you because they are vaguely interested in having something done; they ask for ideas and samples to help in their contemplation process. From the painter's point of view, however, this means treating it like a job before it is a job: you have to go through the design process, present color choices, make sample boards. Particularly as a beginner, I had to do everything I could to nurture a fledgling job, including lots of work on spec. Luckily I loved this part of the work too, so I didn't mind too much.

Finally the rug arrived (from Uzbekistan) and we chose a delicate peach color to coordinate with it and the curtains and furniture; we decided to do it in a bold Moroccan stencil pattern.

This was the first time I was doing an overall stencil—creating an overall pattern, like wallpaper, using a single panel of stencil—and I ran into problems that I had not anticipated. I discovered that the chair rail was not at exactly the same height all around the room; that

I couldn't fold the stencil at the corners of the walls; that the stencil had so much open space that the adhesive didn't hold well to the wall, and I had to hold it up with bits of painter's tape and touch up the blank spots afterwards.

Thinking back, I'm embarrassed about the problems I had to figure out, issues that an experienced painter would have known how to avoid. The silver lining is that it was an excellent design, color, mechanical, even mathematical challenge. It came out unequivocally beautiful, and harmonized with everything else in the room... especially the rug.

NOW THAT WE HAVE exchanged the comfort of externally assured legitimacy for (ostensible and often problematic) freedom, how can we *feel* that we are artists? In that, we are on our own.

When I was groping for a feeling of legitimacy, it wasn't only because I feared other people would doubt me. I was looking for legitimization so I wouldn't doubt *myself*. I wanted it in order to feel comfortable in the label I had put on myself. I was looking for something beyond self-definition; I was seeking self-belief.

The awesomely cool art ethnographer Sarah Thornton says that being an artist now "requires intense self-belief"

and that in fact the whole of contemporary art is a "system of belief." (Does this remind anyone else of the Emperor's New Clothes?) An individual artist—even a celebrity—has to work, both publicly and privately, to keep the myth alive. It is not only us mortal artists who have to actively believe in ourselves; the current art world has made it so that professional artists must also be in no doubt.

Thornton calls an artist's studio a "private stage for the daily rehearsal of self-belief." This sounds very much like my difficulty in believing myself to be an artist without external validation; it made me feel better to think that Jeff Koons might be just as insecure.

But wait—how is it possible that highly successful, professional artists have to actively engage in "intense self-belief"? Isn't their success sufficient proof that they are good at what they do, that they are irrefutably an artist? Apparently not. Even material success—which you'd think would be evidence of legitimacy—is not enough: our definition of *artist* is so weak that we sometimes question its applicability to us even in the face of the strongest support that society can give an artist. Financial security from artmaking is no longer even a realistic goal for most of us; but even those at the pinnacle of the field might lack validation and the feeling of legitimacy.

There is apparently no external validation sufficient to ever make you fully comfortable in your label.

I wanted validation that I was good enough to call myself an artist. What I learned is that there isn't any to be had. Nobody is going to help you with your private self-belief.

Publicly asserting your self-belief, however, is easier: you write an artist's statement. This is a projection of your self-belief out into the world. To write a public statement touting not only the quality of your work but its significance to other people requires powerful self-belief (or at least the appearance of it).

I could never write anything like this of myself and my work; not only did I not know whether to laugh or cringe, but to me it felt like small talk of the most painful sort. I find small talk awkward because of its lack of sincere meaning; I felt the same about art jargon, and even more so about its use regarding my *own* art. To babble superficially about my own creation felt like I was betraying it, like I was taunting my own child.

However, now that everyone can and does have their own website, the most unassuming aspiring artist has published an Artist's Statement. The goal is to make themselves both sound and feel professional. Even when I met artists I found to be utterly unpretentious, I would go home and look at their website, and there was their

Statement. They all wrote the same way; they all played the game in a way I couldn't.

I felt so naive. I felt like I needed to become someone other than I was. The apparent requirement to file an artist's statement felt like pressure not only to do this but to *think* like this.

Using an artist's statement demonstrates belief in your own work, but even more importantly, your commitment to your role as artist, to the requirements of being an artist today. I couldn't do it. Did that mean I couldn't be an artist?

AT LEAST SINCE WE left the anonymous occupational group behind, it has been true that when someone takes on the label of "artist," they involuntarily take on the role that society has assigned them. Art, maybe more than any other field, is one that people (both inside and outside of it) carry around assumptions and beliefs about: in other words, a mythology. When you declare yourself an artist, you are taking on the longstanding myth of "The Artist."

Today being an artist means playing into the myth more than ever. And the public practice of self-belief plays a crucial role: its expression is your persona.

Today's celebrity artists—just like celebrity chefs and, come to think of it, any kind of celebrity—merge

their identity into their work, and vice versa. Everything they do, in and out of the studio, contributes to their persona. Being an artist today, especially a celebrity artist, is reflected in everything you do, not just what you put on a canvas (or a page, or a stage, or a shark).

One current artist who has a Persona-with-a-capital-P is Jeff Koons, who makes mirror-finish stainless steel sculptures of pop culture figures and balloon animals that have gone for world-record prices at auction. Sarah Thornton interviewed him extensively for her book *33 Artists in 3 Acts,* and comments on his smoothness, saying he came across as "an actor playing the role of the artist."

In 1989 Koons made the ad for his own show at the Whitney Museum, and it was a slick, perfect example of identity being seamlessly blended into the work. It was a billboard advertising a fictional porn film, showing himself lying on top of his (actual) ex-porn star ex-wife. While artists have painted reclining nudes for centuries, this may have been the first to portray the artist himself on top of one.

Contributing to the merger of identity and work, maintaining a persona has become a crucial part of the work. A large part of your "commitment" to being an artist is engaging in self-promotion. Both celebrities and the rest of us must promote ourselves more vigorously

than ever. In everything from painting to dating, we must now *put ourselves out there* or we might as well not exist.

Being an artist used to be a business in many ways—courting patrons, suffering as an apprentice for your future—but this modern requirement to promote yourself, to have a Persona, asks us to incorporate business into what is otherwise an interior, mental endeavor. It is in this way that being an artist has morphed into an outward-oriented, confidence-requiring, participate-or-disappear line of work.

Jeff Koons makes no bones about how important self-promotion is, dividing his time equally between "creation" and "platform."

Ai Weiwei—who is on Twitter and Instagram all day—distinguishes between product and practice, saying that while "an exhibition is a classic way to show some product," "giving interviews is part of my practice." (A *New York Times* critic said of Ai Weiwei that he "doesn't make great art as much as great use of the role of the artist.")

Damien Hirst is the epitome of what Sarah Thornton calls a business artist: "[His] financial acumen is an integral part of his artistic persona. He has made money a main theme of his art and auctions part of his oeuvre." (And in case you need more evidence of the artist's ego:

Hirst wears a lot of rings, three of which, according to Thornton, are in the shape of the letter H.)

Unsurprisingly, self-promotion is now a large part of what you learn in art school; you are taught—or rather, shown the importance of—the right attitude. Sociologist Judith Adler talks about the confidence, even pushiness, required to become an artist; the prerequisite of "an aggressive belief in one's own importance." For someone of the right temperament, this need for self-promotion is not a problem: psychologist John Gedo encountered many students with a knack for it who "were delighted to be the center of their own existence."

Belief in your own importance needs to be distinguished from related ideas. It is subtly different from self-confidence: you can have one without the other. Robert Mapplethorpe and Patti Smith had confidence in their *work* but were not necessarily able to go out and wow clients, win friends and influence people.

It is also different from belief in one's own *talent;* Mapplethorpe had that in spades. When he showed Patti Smith the now-famous photo of the Black male model in the Olympic pose in a circle, he said, "It's genius, isn't it?"

Finally, there is a difference between a belief in one's importance as an *artist* (that you make good stuff, meaningful stuff, that you "have something to contribute")

and one's importance as a *person*. This mental leap to the latter is, again, a consolidation of your art and your self.

But the most important thing for us to understand here is the paradox that has been created: we still cultivate the romantic ideal myth of the artist, but the art world simultaneously wants that artist to meet the new prerequisites of pushiness and ego. The two just cannot coexist. It is impossible to fulfill both requirements; no wonder we feel conflicted and unhappy.

It may be new that self-importance is being *taught*, but there has long been a fixture in art famous for aggressive belief in the importance of themselves and their work: the art monster.

An art monster is a person who believes they were put on this earth to make their art, one who pursues their art at any cost—and the price is usually the happiness of the people who love them. To others, they are the epitome of selfishness; to themselves, there is nothing selfish about it: they are simply doing what must be done to make the work.

I know a little something about these people.

My father was an art historian who regularly traveled around the world to do his research, and when he was not traveling, he was closed up in his study writing and

Must Not Be Disturbed. Our family life accorded to his schedule, his moods, his presence. When he was home, things were tense: there were dinners on a strict schedule, and late-night yelling. When he was away in Rome or Istanbul or somewhere, my mother, brother and I would conspicuously relax, and it was only when I began to understand that these trips also involved other women that my enjoyment of his absence was tainted.

Where my mother had invisibly bolstered and boosted me, my father, equally intangibly, did the opposite. Art history seemed to be the only thing he was truly dedicated to. It wasn't only the amount of time he spent writing in his study, or his abstractedness when he was with us, or even the emotional distance that we never crossed; everything he did conveyed the unambiguous message that his work was much more important to him than us.

His schedule at home did not fit having children. He got up for breakfast long after my brother and I had gone off to school; after dinner, he would return to his study and work until the small hours of the morning. It was my bedtime, in the middle of those long stretches of work, that held a particular strain for me.

He was of the antiquated English persuasion that children must go wish Father good night. I had to go to the closed study door, knock, and wait until he answered. I would then enter quietly and stand there waiting until

he raised his eyes from his yellow legal pad to receive a good night kiss.

I *hated* it.

It may sound small, but this memory is the distilled essence of how my whole childhood felt in the face of his work. The fact that I had to go to him rather than the other way around; that he had to finish a thought before he would notice me; the very fact that I was interrupting: I was *way* down on a list of priorities presided over by Art History.

Author Claire Dederer studied her male writer friends to figure out how selfish you have to be in order to be able to do your work undividedly, unreservedly. The answer is: plenty selfish. As she describes it, "Lock-the-door-against-your-kid-while-you're-working selfish. Work-every-day-including-Thanksgiving-and-Christmas selfish. Sleep-with-other-women-at-conferences selfish. Whatever-it-takes selfish."

And that's the key right there: to be a true art monster, you have to be able to do "whatever it takes" … without guilt. (This condition is the reason there are fewer female art monsters than male; but that's a subject for another book.)

Art monsters do not feel guilty; they do not care how many people they hurt (if they are even aware of doing so). They are true narcissists: they have the ability to

prioritize their work over everything else, including the needs of their nearest and dearest.

This unquestioning belief in the importance of their work allows the art monster to consider their behavior as out of their hands: I must create the work, at any and all costs.

It is probably clear that my father and I did not have a good relationship. Luckily my mother was always there, with enough love and attention to more than make up for the hurt; but it still hurt.

When I decided to become an artist, I had one rule for myself: I must not be like my father.

EACH FAUX PAINTING JOB followed the same pattern. There were weeks of the client deciding what to do and whether to do it, culminating in the nail-biting task of writing up the estimate: finding that magic number that was fair to me but not scary to the client, appropriate to my beginner's status but still reflecting my skill and the hours I was going to put in. There were a few days buying the paint and the tools; a few hours gathering the ladder and the kneepads and the brushes and the buckets. Then the day would come. I confirmed childcare arrangements, loaded up the car, drove to the client's house, and, with a bit of stage fright, rang the bell. The client would let me

in and show me to the space as if I'd never been there before—as if I hadn't memorized every inch of it and seen it in my dreams for a week. There were pleasantries, maybe the offer of a cup of coffee, and then the client would say, "Well, I guess I'll leave you to it."

That was the moment. My body would relax, my brain would focus. This is the part I was good at; this is what I loved about this work: the work itself. I really valued doing it as a business—it provided me the gratification of having my work seen and admired, the validation of the check—but the social aspects of it were exhausting. I wished I was back in my studio, painting just for myself; better yet, I wished I could paint for people without the people.

If declaring myself had been hard, marketing myself was harder. I had to act in a way that felt unnatural to me. It is just not in my personality to say *Look! I do this really well, hire me!* I found myself in a vicious circle: I didn't put myself out there, so I didn't get jobs; I wasn't getting jobs, so I doubted myself even more.

I could see how self-defeating I was being, which made me feel even worse about myself. I hated that my temperament was preventing me from getting the business that would have made me feel better about myself; it felt like my introverted traits would make it impossible to do

what I loved. Was my introversion really going to kill my business, not allow me to do the art I wanted to do?

I have always known that I was an introvert, and felt its pressures, but when I decided to be an artist I assumed that I was choosing a career that suited my temperament. Isn't painting a solitary activity, one that is only enhanced by introvert strengths like concentration and planning and attention to detail?

Introvert strengths do enhance creativity, but they thwart you in every other aspect of being an artist. This is a truth about being an artist that shocked me when I first encountered it, and it still surprises me: that being an artist now rewards a very specific kind of personality.

In her fantastic book *Quiet*, Susan Cain explains our society's strong preference for extroverts. We have an Extrovert Ideal that favors, rewards, and benefits people of the right temperament. She traces the growth of this phenomenon—how at the turn of the 20th century we shifted from a Culture of Character to a Culture of Personality—and says "we measure ourselves against ever higher standards of fearless self-presentation."

This is clearly true in the art world. The artist must now agitate for herself, fighting to be acknowledged, respected, even relevant. It takes a lot: Sarah Thornton says that being an artist is now "dependent on a broad range of extracurricular intelligences." An artist has

to be a strong protagonist, maintaining authority and immense self-confidence. Verbal skills—which happen to go hand-in-hand with the extrovert personality (coincidence?)—have become the primary way to succeed in art.

WHY SHOULD BEING AN artist have to be an outward-oriented enterprise at all?

It's partly thanks to the extrovert ideal that people assume you make art with other people in mind.

It's partly a linguistic issue: by yourself, you can be whatever you want to be, but by using a label—using language about it—you are claiming a place for yourself in society. Applying the label to yourself is a social act, outward-oriented in a way that making art is not.

But most of all, how you present yourself outwardly is now taken as a measure of your abilities and commitment to being an artist. Susan Cain introduces us to a fascinating parallel to this issue in the world of religion. It also makes clear why it's a problem.

Adam McHugh has written a book called *Introverts in the Church: Finding our Place in an Extroverted Culture*, describing how evangelical culture ties faith to extroversion. On one level you can understand that church is basically community, and so social skills might be useful to a minister. But it gets darker when you see that their

faith "must be displayed publicly." McHugh says that, in the evangelical world, faith is equated with outward enthusiasm and passion. The problem is not only that this is more difficult for introverts—which it is—but that this requirement makes you "start questioning your own experience of God. Is it really as strong as that of other people who look the part of the devout believer?"

This was exactly my experience in making art. When you are less conspicuously an Artist than others, you sometimes question your own art. Is it as good? Am I as much of an artist as someone with the marketing skills and the patter?

In the general effort to be as extroverted as possible, there are strengths of introversion that often are forgotten. Many introverted traits—enjoying time alone, the ability to focus for extended periods of time—have been proven to be conducive, even necessary, to creativity. The cultural preference for extroversion creates a monoculture that works *against* this creativity, by discouraging introverts from having confidence in these strengths and by allowing the rest of the world to discount them. With the completeness, the unforgivingness of the extrovert ideal, we shoot ourselves in the foot.

As Cain says, "Figure out what you are meant to contribute to the world." Monoculture pressure to be

extroverted works against this goal, against the richness that our world has in potential.

But beyond that, what's the harm in the extrovert ideal? If our society supports one group more than another, does it do introverts any actual harm?

Yes.

The problem is that we don't just prefer one over the other, but we make value judgments about traits. Shyness and other introverted traits are reflected back to the introvert as pathology. The message is sent that not only are you doing it wrong but that there's something *wrong with you*. Introversion is, in Cain's spot-on phrasing, "now a second class personality trait, somewhere between a disappointment and a pathology."

The issue becomes *who you are* rather than what you do. The problem with this is not only that you won't succeed in the art world—although that's bad enough—but that this kind of judgment is personally hurtful. Introverts are "discounted because of a trait that goes to the core of who they are." If you are an introvert trying to work in an extroverted world, you get daily reminders that extroverts are more successful, happier, better people.

So, we are made to think that extroversion is prefer-able, but in the art world the message goes even further than that: that extroversion is a *necessary and natural*

part of being an artist. I found this belief so strong and so ubiquitous that it made me doubt my own convictions and ask, *is it?*

THERE ARE CERTAIN BEHAVIORS that are considered the cliché of the artist: being dramatic, difficult, moody, intense, self-involved (and usually broke). But not only are these not always true, they also aren't descriptions of temperament. Extroversion may be necessary for success in today's art world, but is it a *natural,* intrinsic part of being an artist? Is it not possible to be an artist and an introvert?

The answer lies in an odd source: the Victorian portrait-of-the-artist novel. In that time, there was just as entrenched a cliché as there is now, but it was the opposite of ours. The artist was a sensitive, shy, troubled misfit; introverted, self-centered, and passive.

But Maurice Beebe, who examined the nature of the artist in the *bildungsroman,* says that even then this type was not shown to thrive: the conclusion always was that he had to adapt himself to society. "The adolescent hero ... sets out on his way through the world, meets with reverses usually due to his own temperament, ... makes many false starts, ... and finally adjusts himself in some way to the demands of his time and environment

by finding a sphere of action in which he may work effectively." Beebe says, "The goal of these books is to bring the 'I' of the artist into harmony with the 'others' of society. A few of the early apprentices to art retreat to an Ivory Tower, but they are not allowed to remain there."

Those of us who rather like it in the ivory tower should take note.

Now, it is very clear that the art world wants you to be an extrovert. We can see the extent to which society has taken the belief in the superiority of extroversion: an entire field has changed 180 degrees because of it; the cliché type of an artist is the polar opposite of what it used to be. The art world's requirements no longer allow the old type of person to be a successful artist. It might have begun with the economic need to market yourself, but it has ended in the requirement for an extroverted temperament.

Declaring yourself an artist takes a new kind of attitude; a *new kind of artist*.

So I had discovered the social, practical side of declaring yourself to be an artist. But, slowly, the bigger picture became clear: that society's influence on our creative lives has expanded—imperceptibly—from practical exterior issues to the psychological interior. It now goes deep

inside our minds to our ideas and intentions, where we would not expect—or welcome—its influence. What we have here is, bizarrely, social expectations and pressures on interior creative work. The art world is turning what happens in an individual's head into a social phenomenon by transforming it—burdening it—with expectations, beliefs, and assumptions.

You *can* be a sensitive, introverted artist now—but you will not be supported by the art world. Art teachers will throw up their hands and tell you you'll never make it—because "making it" has more to do with your persona than your product. Extroverted traits have been made necessary for outward success.

The minister-author of *Introverts in the Church* says that he wrote his book to spare others the inner conflict and self-doubt he felt. I felt the need to do the same thing, in the realm of art. He says that nothing will change if our culture maintains this extrovert ideal; he is right. But what to do for now? How can a confirmed introvert be a happy artist?

By being happy without the support of the art world.

Until that system realizes how many talented artists it shuts out with this requirement, we must just be aware of the pressures and do our best to ignore them. We must practice our own "intense self-belief" and remember that it is equally valid to make art in the way that feels right

to us as introverts, that is meaningful to us and hopefully even takes advantage of our strengths.

Cain advises that you find your natural personality and how to make the most of it; she wants to give you "a newfound sense of entitlement to be yourself." That is precisely what I'm suggesting, specific to making art: that you find, acknowledge, and respect your innate artistic self.

And what about needing validation? Artist Robert Genn has advice for how to survive the world of no external validation. "Pay no attention to what anybody thinks. Simply become your own jury and prize-giver. The real prize comes to the artist when the work is made."

I HAD A FAUX painting business, and I was painting. I loved the art, the clients were happy, the work was fulfilling, and I was making a bit of money... but somehow it was not quite right. I didn't really understand why, but I was unhappy.

It had been so easy to declare myself an artist that I still didn't believe it myself. I needed to find out if I was an artist. I decided to jump in the deep end and see if I could swim.

3

MY FIRST THOUGHT WAS, I couldn't believe the
amount of plastic. I was in a hotel conference
room in Indianapolis, at a faux painting workshop, and
every inch of the floor and walls was covered in plastic
to protect from paint splatters. (I understood the hotel's
concern, but the environmentalist in me cringed at the
thought of what would happen with all this plastic when
the event was over.)

In setting up Delicious Colors, LLC, I had learned
about IDAL: the International Decorative Artisans
League, the major organization to belong to if you're a
faux painter. One day, just when I was feeling particularly
down on myself, I got an email announcing the date of
the annual IDAL convention. There would be hands-on
workshops taught by faux masters, and an Expo: a huge
marketplace, complete with swag and (more importantly)
networking opportunities.

Ignoring my friends' jibes that "wow, there really is a
convention for *every*thing," I decided to go. I wanted to

see if I could play with the big boys. This would help me know whether being self-taught was sufficient, whether or not Delicious Colors and I were the real deal. My confidence was low and I needed to know whether, in this grand new plan for my life, I was doing the right thing.

I signed up for a full roster of classes and bought myself a plane ticket.

THE FIRST CLASS I walked into had long tables arranged convivially in a big square. We were given name tags, but they seemed unnecessary, as everybody else seemed to know each other. I took a seat and watched as people hugged and called out to old friends as they entered. I put on a tentative smile, trying to look approachable yet professional.

The teacher began. "So you'll find in front of you a board that I have basecoated for you in SetCoat matte metallic Champagne Toast. Please take the roller and…"

Someone whose name tag said Luciano broke in, "This is where Sebastian always messes up." Everyone laughed.

The teacher said, "Yeah, he did it again at the session that Kathy offered in the spring… Was anyone else there?"

"Oh, yeah! But it's not as bad as what *Daniel* did… Remember?"

"Jen wasn't here last year, she wouldn't know."

"Oh, you're right, she…"

And so on. I was clearly the new girl in school.

It was the same in the rest of my classes. People were friendly enough; I saw some people in multiple classes and chatted with them. I was privately grateful when one woman asked me to join a group going to lunch. When we were seated, she looked up from her soggy sandwich and said, "So tell me about you!"

I told her the story, that I had just started a faux painting business as a second career; that I had two young children at home, and that I adore faux, taught myself, and was so excited to have found the right thing for me. "Oh, that's great!" she said. "I wish you lots of luck." And she turned away to talk to someone else.

I had a similar experience with several other people, including a few of the teachers. While nobody was rude, my story got surprisingly little reaction. They seemed to somehow not take me seriously; they smiled, wished me luck, and the conversation moved on. It certainly did not turn into the kind of mentoring session I had imagined. I would have wanted to find out how they all got their start, to tell them about the obstacles I was running into, talk to them about the phenomenon of being a beginner. But that somehow didn't seem to be an appropriate subject, or what we were all there for;

this was a reunion for old friends to work together for a while and share war stories.

A lot of conversation in the classes, as we worked, was about the terrible economy, how hard it was to get faux work now, and how IDAL itself might soon shrivel up and die if nobody new joined.

"We need some young people in this industry! I'm getting older... it's getting harder to climb those ladders!"

"Rhonda fell off one and broke her hip, did you hear?"

"Ah, we're old dogs, but there's just nobody coming in. Nobody is learning faux. Our industry is going to disappear."

"We need to figure out how to get people interested in learning faux. IDAL would be such great support for beginners... if there were any."

I sat there, feeling bewildered, insulted, and invisible. *I'm* a beginner; *I'm* here. I'm *dying* to join your industry; I've been trying my damnedest for the last year to find a way to learn formally.

What was going on? As far as I knew I was the embodiment of what they were looking for, yet I seemed to be either invisible or for some reason not worthy of their support. What was I doing wrong?

On the last night of the convention, I went down to the Expo. The huge space was buzzing. I found the booth of my favorite stencil designer, and there she was in person,

a celebrity in this room. At one table they were giving away tiny pots of the latest metallic stucco; the FrogTape company had bracelets, buttons, and pens with their cute mascot, and I took some for my children. I lingered for a while by the buffet of chicken wings and wine, but in the entire bustling arena, not a single person spoke to me.

Early the next morning, while it was still dark, I carefully packed up my beautiful samples and got a cab to the airport. Even though I just had an early flight, I felt like I was sneaking out. I was sorely disappointed, with the event and with myself. I had not networked, I had not gotten support for my new venture; I had only felt left out and naive. As the plane took off and the sun rose, I couldn't wait to get back to my family, to be with people who loved me, whether I was an artist or not.

I SLOWLY BEGAN TO understand that being an artist comes with issues of social status. By becoming an artist, you are instantly subject to society's beliefs and assumptions about artists. But the status of an individual is intertwined with the status of the field in which they work, and for this reason it's important to know something about the history of the status of painting itself.

These days it is hard for us to imagine society having a general disdain for painting, but so it was. Classically,

poetry and music were seen as "high arts" and considered higher callings than painting. The "problem" with painting was that it was more mechanical than those more intellectual pursuits. A painter works with his hands. This meant that it was literally manual work, which was in turn seen as *menial* work; a painter is not far from being a "mere" craftsman. Poetry and music seemed to have more to do with inspiration and divine grace than did painting.

In the early days of painting, it was considered only a technical skill to learn; it was an admirable skill, to be sure, but one that anybody could learn. You just hired a painter to make your likeness; you were not hiring a particularly special person with any ideas of his own. Painters were hired hands—skilled, but still mechanical—to produce exactly what you told them to produce: a statue of the Madonna for your church; a portrait of yourself, milord, for your great hall.

The reputation of painting changed, slowly, along with changes in the status of the painter. The profession of artist had certainly improved greatly since, say, the Middle Ages—mostly in better working conditions, as well as a growing perception of painters as skilled workers—but it was only as of the Renaissance that their social status was something that artists actively worked to improve.

In the 1500s, largely in Italy, many things transpired to bring about great change in the status of artists. First was a matter of infrastructure: cities were growing, and citizens developed a proprietary pride. Cities vied with each other to hire the greatest artists to enhance the city's name and reputation by building magnificent churches. They competed for the services of renowned masters, which meant the masters could choose the commissions they liked and dictate their terms. "In earlier times it was the prince who bestowed his favours on the artist," says Gombrich. "Now ... the roles were reversed, and the artist granted a favour to a rich prince ... by accepting a commission from him."

Benvenuto Cellini was one artist very aware not only of this new environment but also of himself within it. In his autobiography, he says that "for him to be an artist was no longer to be a respectable and sedate owner of a workshop: it was to be a 'virtuoso' for whose favour princes and cardinals should compete."

Competition led, as it does, to improvement: it was incentive for the masters to outdo each other, a spur to greater achievement, to "compel the surrounding world to accept them, not only as respectable heads of prosperous workshops, but as men of unique and precious gifts."

Simultaneously there were discoveries being made in perspective and anatomy which led to an artist seeing

himself no longer as "a craftsman among craftsmen, ready to carry out commissions for shoes, or cupboards, or paintings, as the case might be," but one with interest in these more intellectual aspects of art, and possibly even ambitions of fame.

It used to be thought that art was only an imitation of physical reality; a painter was hired to make a likeness of someone or something. What this meant was that the artist was less important than his subject. But when art turned from pure representation to expression, and the artist claimed rights to his imagination and uniqueness, they traded places: suddenly the artist was the important part of a painting. Thus when the suppositions of *art* changed, the concept of the *artist* changed. Allowing in for the first time individuality and self-expression, painting turned away from being mechanical representation to a more mental, even intellectual, activity. This paved the way for artistic originality and the very concept of creative genius.

So we can imagine how artists saw that they were in demand, saw their work as more important than ever before, and began to see new potential for art itself... and yet their social status was not keeping up. Despite all of the above, painters and sculptors were still seen as menial workers. It is recorded that Michelangelo's own family regarded his entry into the artistic profession as humiliating. Gombrich says "it was natural that the

leading artists who had these ambitions felt aggrieved by their social status."

Something had to change.

EVERYBODY HAS HEARD OF Leonardo da Vinci, but most people don't know that among his great works was the *social work* of improving the status of the painter in society. His goal was to make painting an honorable pursuit, by giving it a scientific, theoretical foundation. He proposed a new educational plan in which students would first learn the mathematical subjects of perspective and proportion before starting to draw. This was the genesis of the art academy.

The goal was to change the perception of painting from a trade handed down from master to apprentice into a respectable subject, like philosophy or mathematics, to be taught in academies. It also changed the focus of art education: knowledge was now just as important as skill.

The academy did not entirely replace the old system of apprenticeship; for a long time, a student had to do both. The academy was for theory, an apprenticeship for hands-on practice; each was considered an equally important part of an art education. (And still is.)

The problem was that not everybody liked the academy. It was recognized as an authority in art, but was nothing

if not conservative. The academy imposed doctrine and rules of taste; it propounded the importance of grandeur of ideas and dignified subjects. Back then, as today, this made a lot of artists itch. The very same formality that was intended to make it respectable simultaneously made it something to rebel against, and rebel people did. Artists and scholars alike lambasted the academy. John Ruskin said, "Academy teaching destroys the greater number of its pupils altogether [and] hinders and paralyzes the greatest." Art critic F.G. Stephens called it "the patron of mediocrity and the enemy of genius," and William Morris "the worst collection of snobs, flunkeys and self-seekers that the world has yet seen."

Since then, *academic* has been a bad word.

Changes in the art market also advanced the reputation of painters. Historically, artists had been dependent on the church or wealthy patrons to give them commissions and thus allow them to make a living. In the 1700s, the general public started buying art, enabling artists to make and sell their work without the official backing of a patron. This made possible, financially, the idea of art being a self-sufficient profession.

This changed not only how you made your living, but also your social status. When your existence as an artist depended on the favor of a fashionable few, you were an entertainer, a servant, a fool. When the general public

became the market, it was easier to set yourself up as a valuable person doing specialized work.

The social status of artists was also affected by broader changes of the 1700s: the Enlightenment, the growth of humanism, and most importantly the rise of the bourgeoisie. This ruling class supported culture, with a particular appreciation of art. Their dominance in society combined with a positive attitude towards art meant that gentlemen and ladies started trying their hand at this thing called painting.

It was, however, a revolutionary act in a time of strict social rules. Even in the 1800s, the status of painting was still so low that it was not considered appropriate for a young gentleman to become an artist. William Makepeace Thackeray wrote a novel in the 1850s called *The Newcomes* (with the excellent subtitle "Memoirs of a Most Respectable Family") in which the son wants to be a painter, but faces the disapproval of his social circle. Someone says to his father, "Your son might look higher than to be an artist. An artist, an organist, a pianist, all these are very good people; but, you know, not *de notre monde*."

A few decades later it was considered gentle-manly—and even, eventually, ladylike—to paint, as it demonstrated one's idleness (although of course such a

person must never think of *selling* their paintings as that would indicate, shamefully, that they needed the money).

Slow as it was, this progress meant was that artists were no longer an entirely separate class to be looked down upon. Painting was moving on up.

ONCE ENOUGH TIME HAD passed after the convention that I could see straight again, I tried to figure out what had gone wrong. Why had the others not seen me as a new faux painter, eager to join their ranks? I was a beginner, sure, but they had said that's what they were looking for. I eventually realized that the problem was our respective definitions of the word *beginner*. They didn't see me as a beginner who was going to be a professional, but as an amateur. And it turns out there's a crucial difference.

When amateurs talk about being a beginner, what they mean—what I meant—is that they don't have many years of practice. But professionals use the word differently. What they saw in me was not someone with a simple lack of practice, but a dilettante. This has always been a bitter word, containing the implication that the person you're hurling the word at is pretending to know what they are doing. Dilettantes frequently commit the further sins of being rich (which itself has a long history of being hated) and of having no focus, no commitment, and, worst, no

need to do the work. The dilettante is the opposite in every way of the mythical struggling artist.

And to the faux painting professionals, that is exactly what I looked like.

Professionals and amateurs belong to completely separate worlds. I was coming to faux painting from the amateur world, with an obvious do-it-yourself approach, most notably having taught myself. I hadn't gone to any of the faux painting schools, hadn't met the important people; I hadn't done any of the myriad indefinable things you do to demonstrate your commitment. Teaching yourself was very DIY; it was from the other world. Without knowing it, I was trying to switch sides, and what I was running into was the wall between the two worlds.

What is the difference between an amateur and a professional, really?

The innocent Latin-derived word *amateur* did not originally have any negative connotations. *One who has a taste for some art, study, or pursuit, but does not practice it.* In other words, someone who participates in an activity but does not pursue it professionally. The problem seems to have begun when amateurs *did* start to practice what they admired.

What is a professional, then? Artist Sara Genn says, "Are you a professional? The simple answer is yes, if you're being paid for your ideas."

She goes on, "Besides the game changers of working every day, using quality materials and being vigilantly unafraid to trash stuff that doesn't measure up, professionalism emerges through refinement and intimacy developed over the course of a thousand conversations with your process. ... Professional work emits a kind of ineffable ease, technical deftness, an understanding of materials and attention to detail, a certain elan in shapes and brushwork."

Cezanne disagreed, crankily saying, "There is no such thing as an amateur artist as different from a professional artist. There is only good art and bad art."

JUST AS THE OUTSIDE world was lifting its prejudices and coming to accept painting, artists split amongst themselves, fostering prejudice against each other. We went directly from a case of the group status being decided by outsiders to two internal classes competing, judging, and ranking each other from within.

It was those bourgeois ladies and gentlemen that started it all. Once they began dabbling in painting, there were suddenly two very different groups of people doing the same activity. This created a dichotomy that hadn't been there before: amateurs and professionals.

The first time a bourgeois gentleman got up on a sunny Sunday morning and said, "I think I'll take my paintbox

to the park and see if I can't capture the light on the pond like that damn Constable does," the animosity between amateur and professional artist was born. Professionals had a reputation to uphold, not to speak of a living to make. The amateur was no actual competition for the accredited artist, but these bourgeois amateurs were of higher social rank, which prevented the professional from openly expressing his derision. But he could quietly seethe, as we see in a Henry James story from 1892 whose main character declares, "The ruling passion of my life was the detestation of the amateur."

Now that we no longer have to bow to the gentleman painting in the park, why do professionals still hate amateurs? Now there are new reasons on top of the old.

In case you haven't noticed, there has been a boom in the numbers of amateurs making art—so much so that the art world is changing in its composition. Amateur and professional are polar opposites forced to coexist in one "art world" that, to outsiders, looks like one thing but inside is the furthest thing from united.

A.O. Scott, the *New York Times* film critic, surveys the issue calmly (possibly because he's not an artist?) and puts his finger on the reason it bothers artists so much: "The elevation of the amateur over the professional trivializes artistic accomplishment." (I would amend this to say their elevation *to the same level as* the professional;

unless he meant simply by the numbers, in which case amateurs are today indisputably the majority.)

Judith Adler calls it a "plague of amateurism," such strong language undoubtedly reflecting professionals' feelings. She says, essentially, that you can't blame professionals for being frustrated with amateurs, because they didn't choose the whole social structure around the definition of the artist. Professionals are mostly doing what they've always done; it is the amateurs that have encroached on their territory, diluting the meaning of the label "artist" and expanding the world of art beyond recognition.

However, things don't look much better from the other side. Amateurs are jealous of professionals' success, and puzzled about what mysterious "talent" got them there. (Or was it sheer luck? or selling out? or sleeping with the head of the gallery? We hope there is some such logical reason, because otherwise the degree of randomness is unendurable.) We are told we are artists too, but we *know* there is a difference, there is *obviously* a differ-ence… but what *is* it? We desperately want to figure it out—hence the thriving genre of books about creativity. At the same time we don't really want to know, for fear that the answer is that they are simply more of a "real artist" than us.

The Art Olympics

The irony is that, however much the two sides hate each other, sometimes it can be difficult to tell the difference between them. The most literal instance of this lies in a surprising arena: the history of the Olympics.

From 1912 to 1952, one of the "events" at the Olympics was an art competition. (The works had to be inspired by sports.) Medals were awarded in architecture, literature, music, painting, and sculpture.

There was controversy from beginning to end: over who could submit works, which arts qualified as medal events, and finally over whether the artists should be allowed to sell their artwork at the end of the competition (for to profit from your work reeked of professionalism). But the biggest problem was that, as we know, the Olympics requires all competitors to be amateurs, and officials found it "incredibly difficult to determine whether or not artists were amateurs."

In 1949, a report was presented to the IOC concluding that practically all the contestants in the art competitions were professionals, and that

> the competitions should therefore be abolished
> and replaced with an exhibition without awards
> or medals... and the whole thing sputtered to
> an end.

A SUBSET OF THE game of thrones between professional and amateur is the battle of Art versus Craft. Their definitions and the difference between the two has been debated forever. There has never really been a verdict, but that's okay: we're not really interested in the *distinction* between art and craft. To be honest with ourselves, what we are really negotiating is which one is superior: which is more worthy of society's respect. We are looking for a determination of their relative social status. (This is answered, without any hesitation, by the public funding enjoyed by art but not craft.)

But even *this* isn't yet at the heart of what we're talking about when we talk about art and craft. What we are truly negotiating is the status of the *people* who make them. What we are really asking is, who is superior, an artist or a craftsman?

The battle for status between *artist* and *craftsman* might be one of the longest wars we have known. In the 1400s Leonardo pleaded that painters "dissociate

themselves from craftsmen"; in the 2000s the term *crafts-man* can still be used derogatively when it is contrasted with *artist*, for a craftsman's work is supposedly less inspired by genius than is art.

Peter Korn is a furniture maker who wears the label of *craftsman* with pride. His book *Why We Make Things and Why It Matters* is kind of parallel to Leonardo's work: a push for the higher estimation of craftsmen. He explains the Enlightenment concept of Cartesian dualism, which divided mind and matter into separate and unequal camps. Craft ended up on the lower rungs with matter and away from the mind. But Korn rejects the Cartesian divide, saying that the work of craft "harmonizes intellect, manual skill, and character" and that "when you add the creative component of design, craft becomes a fully integrated application of one's capacities."

A craftsman who simply does what he loves to do is making the strongest possible statement that he doesn't care about the opinion of the art world. And this, I believe, is true artistic motivation: work that is driven by an individual's creative need, not anything to do with society.

Of course, there is a large gray area between art and craft. Work that is not self-consciously one or the other will always have this dual quality, being beautiful as well as functional, like the pottery of classical antiquity—or, for me, faux painting.

When I started making paintings on canvas, I straddled the line between art and craft in a different way: I used house paint. Why not, I thought: I had lots of it, it was available in a perfectly fine range of colors and in perfect-sized sample containers. I had never really learned to mix colors, and with these I didn't need to. But I felt somehow guilty about it: I would never have told the guys at the paint store what I was using it for, nor would I have admitted to my fellow artists that I used Benjamin Moore rather than Winsor & Newton.

While I thought I was cheating, or, at best, inventing something, it turns out that plenty of artists have used house paint. Frank Stella and other postwar painters used commercial paint straight from the can. Robert Rauschenberg supposedly once bought some cheap, unlabeled cans of household paint and used whatever colors they happened to contain. There was a certain rebellious charm to doing this—as Philip Ball says, it flaunted their "escape from academic painterliness associated with oils."

I can't claim any such artistic principles in my reasons for using house paint, but I did share the technical reasons other painters liked it: house paint allows for an utterly flat surface that doesn't show brush strokes. I was more interested in the materials, and the possibilities of the materials, than in what you'd call "expression";

the smoothness of the surface I strove for is a matter of technique and skill rather than one of expression.

This happens to be the one aspect that people agree makes something craft instead of art. The focus of *art* is supposedly on expression, idea, emotion, while *craft* is the physical manipulation of material. By that definition, I was making craft. But what I was really doing was a funny hybrid that shows where those labels fall apart. If I use house paint and a stencil, but I put it on a canvas and sell it at an art show, is it art or is it craft?

I had a foot in each world, which makes both sides uncomfortable.

I GREW UP WATCHING my mother do a million artistic things.

In her life before me, she earned a living as a textile designer in Stockholm, and her love of pattern and design stayed with her for the rest of her life. Even in central Pennsylvania, where all this could not have been more out of place, she surrounded us with the epitome of design. She sewed long skirts for herself and exquisite little-girl dresses for me of delicate floral fabric from Liberty of London. I slept under quilts made of a blinding mix of Liberty and Marimekko; I watched TV from a sofa covered in dramatic William Morris.

In addition to constant sewing and knitting and a stint as an illustrator for Mister Rogers, my mother was a painter. She painted everything around the house from the chairs to the shutters to the Maine landscapes on the walls. (She said the rocky coastline reminded her of her childhood in Estonia.) She painted the dining table, and this is where it gets weird.

To make this table, my mother taught herself faux painting. She bought a large circle of unfinished wood and, following the instructions in a book, spent weeks applying dozens of painstaking layers of paint and gloss varnish, sanding and veining, until it looked like green marble.

What's sad is that I was so involved in my own life that what she was doing barely registered with me. What's weird is that thirty years later, I did exactly the same thing.

My mother made art simply as part of her life. No self-consciousness, no deciding whether it made her an "artist" or not. (In fact, in the face of all her endless creative activity it is especially ridiculous that on tax returns she had to put her occupation as "housewife.")

I think of her artistic activity as the original, authentic DIY. It was what I think real creative motivation looks like. The assumption that you can do anything artistic you feel like. The unspoken belief that the work—the process, not the product—is valuable in and of itself. You

are certainly not doing it for the money (because there never is any, even in the very best of circumstances); you are not doing it for anybody else, not even with anybody else in mind. You do it for your own creative satisfaction.

My mother's workspace itself quietly demonstrated the value she put on creative work, and the respect we should all have for our own. She transformed our basement into the most amazing workroom. She had everything she needed: a massive table where you could unroll a whole bolt of fabric; a tailor's dummy (an upgrade from the wire figure that freaked me out as a child); walls lined with corkboard where she pinned up sewing patterns and panoramic photos of Estonia. But the best part was that she decorated it to the hilt. She built a canopied bed, complete with a fabric ceiling like some Moroccan boudoir, drowning in red and pink toile from Pierre Deux; she covered a chair in dark pink linen and the floor in red Oriental rugs. I was green with envy.

Only now do I understand how important this room must have been to her. Space to spread out; quiet to think. And in view of that, it is all the more moving that I was always welcome there. I knew it, I felt it. In that unconditional welcome into her private space, I could feel her love.

I loved to sit with her while she sewed. I wasn't trying to learn, nor did she officially try to teach me; we just

loved being together. It was the warmest feeling I've ever had in my life.

DIY has come a long way since my mother. It's a funny social phenomenon because it has been taken up enthusiastically by people on all economic levels, in fact at the furthest extremes. There are people who do their own work because they can't afford to have it done for them, but there is a larger group of people on the other end of the spectrum—and this is the group that "DIY" has become associated with—who have taken it up as a hobby. Making art as a leisure activity: we're right back to the gentlemen painters of the 1800s.

And it is on their shoulders that the modern DIY movement has bloomed. Martha Stewart was only the beginning. There has been a massive boom in the numbers of amateurs making art; this evolution of the amateur class has changed the artmaking world beyond recognition. It has gone from a few bourgeois gentlemen being risqué to a socially supported full range of adult education students, paint bar enthusiasts, and, of course, DIYers.

And commerce has stepped right up to meet them. We are drowning in Hobby Lobbys and Michaels and Home Depots; at least here on the east coast, it seems every town has at least one drop-in artmaking place: the

paint-your-own-pottery place for children, the paint bar for adults.

Biggest of all these growth industries is adult education. The ranks are largely made up of women, often in my position of figuring out what to do after having children. Some are pursuing it for work, as I was; most are simply happily indulging their creativity. Robert Genn says, "Some [take] up painting the way others take up golf or bridge. In popularity, painting is only slightly behind photography and slightly ahead of goldfish."

Anthropology gives us a useful comparison. That field has shown us that adolescence is a relatively new concept in the human lifespan; it is a socially invented and supported phase of life. The phenomena of DIY and adult education are exactly like that: a phase of artistic development that didn't use to exist; an extended—and sometimes permanent—state of beginnerhood.

Now, HOWEVER, WE HAVE moved on from just two competing classes, amateur and professional, to a myriad of variations in the role of artist. There are *acres* of amateur artmakers staking their claim in the field of art. What must the pros think now?

Just as we said we can't really blame professionals for hating amateurs, we can blame them even less for

hating the DIY movement. The economy has made DIY an actual competitor, a real factor in the lives of professionals. Professionals want you to believe that what they do is very difficult, so you will hire them to do it for you; the DIY industry profits from the opposite, so you see all these faux products telling you how to do it in three easy steps.

But why does a professional have any argument with adult education, or even the innocuous paint bar? They don't threaten sales, don't tread on his toes at all. The answer takes us back to where we started: the reputation of *art*.

As the amateur world expands, we are extending the label of "artist" further and further from actual art training, all the way to people qualifying for the label simply by doing something with paint. It is now possible to call yourself an artist by making art that calls only upon your creativity and self-expression, and not at all upon any training. The more untrained the person who is called an "artist," the more resentful the professional is, because after years of blood, sweat and tears, they have the same title as the woman at the paint bar on a Friday night. And by extension, when amateur work is called "art," professionals fear not only for their own work but for the reputation of art itself.

Earlier, with the externally determined process of becoming an artist, everybody knew what he "was" and

where he fit. Now there is a lot of gray area. The system no longer explicitly defines the roles—no longer dictates your position in society—so we have to find our own place on the ladder. And the more uncertainty there is in the art world—whether you are really an artist, whether you have the right degree, the latest style, the best swagger—the more that ranking among artists is important. The more of a melting pot artmaking is, the more artists must jockey for status among themselves. And the farther apart the extremes of what the label of "artist" can mean, the fiercer the fight will be.

Derogatory Language

A surprising number of the names of artistic movements were first used with the intention of being derogatory labels, and only gradually lost their mocking undertone.

Impressionism was scoffed at in its early days because of its radical step away from the formality (in both technique and subject matter) of academic painting. Gombrich tells us that when Monet exhibited one of his works in 1874, the catalog described it as "Impression: sunrise" and one of the critics took this and referred to

the whole group of artists, scornfully, as "The Impressionists." But those artists took on the name for themselves, and between that and the roaring public success of their work, it quickly lost its original tone of mockery.

Gothic, *Mannerism* and *Baroque* were also originally derogatory terms.

Gothic was first used by the Italian art critics of the Renaissance to denote the style they hated, which "they thought had been brought into Italy by the Goths who destroyed the Roman Empire and sacked its cities." (The Vandals were another invading tribe, similarly leading to our term *vandalism*.)

Mannerism referred to the "affectation and shallow imitation" of which 17th century critics accused 16th century artists, who they thought had taken the Renaissance focuses of proportion, balance, and ideal beauty and exaggerated them abominably.

The term *baroque* was also a retroactive accusation. In the 16th and 17th centuries, architects began adventurously combining architectural styles, disregarding the strict rules of classical architecture. Renaissance critics who wanted to maintain the purity of ancient Greek and Roman

architecture called this *baroque,* meaning grotesque, absurd, to demonstrate that they thought this a "deplorable lapse of taste."

YOU MAY HAVE NOTICED that I keep coming back to the use of language. This is because it is through language that our modern civilized society plays the oldest game on earth: sociological jockeying for status among the other apes.

Language is powerful. A given definition of an "artist" determines how we think of ourselves, what we make, and our level of success—with a single word.

Language is simultaneously very subtle. Judgment of others is now demonstrated covertly. Instead of it being acceptable to say, "Oh, Portia, how *could* you have that painter at your dinner table?", we now convey our opinions and prejudices through the implications in vocabulary.

In our current ultra-civilized society, we think honest labeling is too blunt. On the surface, we use more and more generous terms for everybody, blending away the differences so it sounds like we are all the same. We are broadening the umbrella term "artist" to democratize the language for the expanding amateur class.

The question is the definition of an artist; the modern answer is the democratic but also the lazy way out. We wriggle out of the question by saying that *everyone* is an artist, and that everything anybody makes is art. The same terminology is used in talking about stay-at-home mothers doing DIY as about multi-million-dollar auctions of embalmed sharks.

There are such radically different kinds of art being made, for such different reasons and by such different people, that it's a terrible idea to use the same poor weak little words "art" and "artist" for all of the above. How about, instead of expanding our definition of "artist" beyond recognition, we find more specific names for the new kinds of artist? If we define the roles, instead of blending them, both sides will be happier: pros won't feel impinged upon, amateurs won't feel like impostors. We all want the word "artist" to mean *us* and, ipso facto, not *them*; new language could enable every kind of artist to feel recognized, legitimate, and proud.

SOCIETY CARES LESS ABOUT your job now; but the unofficial society around you—your fellow artists—is still acutely interested, and lets you know unequivocally where you stand.

Like any other human activity, making art generates pressure to prove yourself to be part of the in-group, by working and thinking the same as everyone else—and the group stigmatizes those who don't. Art can feel like a social game rather than a systematically directed career path.

Rather like in middle school, there is social pressure exerted on an individual to go along with how things are done and not stick out—to participate in the system. If you stick out, you get strong social cues that you are an outsider. Art is a big game of insiders and outsiders. We raise our own status by excluding others.

While in the real world there is more and more public support for self-declared amateur artists—such as glossy magazines for every aspect of craft which will nurture your self-applied label of artist—among professionals, being an amateur still carries a stigma. Amateurs are permanent outsiders.

And this is what I felt at the convention.

Outsider Art

Professionals will never welcome a self-taught amateur from the other world. Never... with one exception: an artist who they take under their wing and celebrate as an "outsider artist."

Outsider art is defined as art made by self-taught artists who are not part of the art establishment. An early version of this was by choice: in the Primitivism movement of the early 1900s, when some artists tried to leave civilization behind. The movement was artists' rejection of too much civilization, too much academic training. Paul Gauguin went off to Tahiti and made purposefully childlike, simplistic paintings; Henri Rousseau and Marc Chagall were two actually untrained artists who became famous for following his example. There was a "revolution in taste" as this became the new fashion. In a "strange race after the naive and unsophisticated," artists began to study the works of native tribesmen, just as academic artists studied Greek sculpture.

But normally, unlike these famous examples, outsider artists are *actually* outsiders.

Outsider art is a phenomenon that could only exist in the First World; supporting it has morphed from an act of anthropological interest into politically correct philanthropy. Interestingly, this change has occurred simultaneously with our growing prioritization of art over craft. Originally "outsider art" referred to

crafts made by people in developing countries. What it means today is art by a person who is marginalized in some way: either from a developing country (we still have room for those), a member of a minority group, or, most recently, mentally ill.

The *New York Times* Magazine ran a cover article about a group of mentally ill individuals whose art was formally recognized, shown in a gallery and sold for five figures. Yet if you paid attention, this case in fact served as confirmation of our comfortable social structure, rather than the denial it was supposed to imply. The people bringing these artists into the light apparently felt the need to legitimize the art by couching it in the right jargon. The director of the Creative Growth Art Center, where they make their art, says "The culture of disability informs the voice of the work"; the woman who puts together the Outsider Art Fair every year says "It is becoming more involved in the broader art-world dialog." Hearing this language that we associate with the insider art world makes us feel more comfortable about calling this art; possibly even sympathetic enough to buy some.

> The phenomenon of outsider art is a good illustration of the nuances within the taxonomy of insiders and outsiders. The artists at the faux convention made it clear I did not belong, while crying that they need new people to keep the industry going; on the other hand, outsider artists *literally* fit the definition of not belonging, but we hear insistence that they *are* real artists. It's dizzying, and discouraging.

WHEN I WAS GROWING up, my family did not fit in. I know every child feels that their family is weird, but in central Pennsylvania, ours was objectively in the wrong place. We were, among many other sins, strangely tall, smart, and foreign.

My mother was six feet tall and wore clothes she had made herself. She had an accent nobody could place, and when she explained that she was from Estonia, nobody had heard of it. She bought kale before it was popular, and made us eat porridge for breakfast.

My father was English, and as typical a Cantabrigian scholar as you could find, from the curmudgeonly attitude to the elbow patches and the pipe (I wished he

would at least smoke cigarettes like everyone else). To my teenage horror, he seemed to revel in not fitting in.

My brother and I did well in school and went to good colleges; we knew several languages and had been to Europe every year since we were born. But outside the family, these things had no value, were in fact strikes against us. Somehow the cred that I had was never the right cred; what should have made me feel good about myself actually made me feel the opposite.

It made me hypersensitive to not fitting in. I was primed to react badly to feeling different.

Once I "put myself out there" as an artist, I could feel that I didn't fit in there either. Nobody told me outright that I *wasn't* an artist, but because I didn't fit in with them, it seemed clear that they didn't consider me one. I wondered what it took to fit in, to be what others considered an artist. What was in people's definition of artist that made me *not* one?

THE FAUX CONVENTION HAD seriously damaged my ego as well as my artistic confidence. I was disproportionately hurt by how much I felt left out and ignored. I couldn't take their lack of reaction as simple indifference; it felt like judgment. Or worse, actually: they didn't even take

me seriously enough to judge me. They didn't see me as a beginner *or* an amateur; they didn't see me at all.

It made me angry. I felt wronged. With an artist mother and an art historian father, I felt as if being an artist should have been my inheritance, almost my right. Here I was feeling left out in a field where I should have belonged, in which I had more background than most people. So when the people at the convention didn't welcome me with open arms, I felt not only the sting of being left out, not only the toppling of my new career, but a groundless anger: what did they think made *them* so special?

I was angry at myself as well, for not being an instant artist. I felt like art should have come naturally to me, like writing did, and I was outraged that it didn't. I felt terrible about myself for not succeeding in this thing that should have been in my blood; disappointed in myself for failing at this thing that had felt so right.

I was also furious at myself for being so weak. I had spent my life covering up the true depths of my introversion, and now when it mattered most, I couldn't get it under control. Delicious Colors was failing, and it was all my fault. I loved the painting, but I wasn't marketing myself, and I wasn't getting jobs. It was a vicious circle that I could see clearly, yet couldn't escape.

I even felt, irrationally, like I had let my mother down, failed to make something of the boundless support she

had always given me. She did the same things all proud parents do—kept my childish tape creations on her shelf for years, framed my best drawings—but it was bigger than that. Her own artmaking made me believe that you can and should do anything artistic you feel like; her obvious but unspoken pride in my work made me believe that *I* could do anything. She never "encouraged" me, she just made it clear that she believed I could. And now I had failed.

I felt bad about myself from so many angles. My private venture was failing. I had announced to the world that I was a faux painter, and now I would have to admit that I wasn't. I thought I had found the work I was going to do for the rest of my life, but I was wrong. And, stupidly, it was all because I couldn't put myself out there enough to get work.

Last but not least, I was tired. As Cain says in *Quiet*, many people pretend to be extroverts in order to succeed in a society or a specific field where that is a prerequisite. This is what I was doing while I had my business: pretending. But such pretending is hard work. I was emotionally exhausted.

The more distance I got from the convention and understood intellectually what had gone wrong, the more upset I was by the experience. I had been using it as a test to discover whether I was doing the right thing, and

it made me conclude that I wasn't. I had thought that starting a business would convince everybody—myself most of all—that I was a real artist. It didn't.

A few months later, I put a Delicious Colors ad in our local paper and told myself that this was the final test: if I got a job from this ad, I would keep going; if I didn't, I was done.

No calls. I was done.

And the amazing thing is how relieved I felt. In theory, I had so wanted to have my own business, earning my own money again, being a real person again, doing creative work that I loved doing. But the psychological pressure of promoting myself and declaring that I *was* this thing that I was not actually sure I was, turned out to have been too much.

I quit.

MY INTROVERSION TRUMPED EVERYTHING else, even the strength of my love of this creative work. Okay, I thought, I guess faux painting is not for me. I needed to find a different kind of art, one that didn't involve people, in which society wouldn't be so involved in my work. I had to find a different way to make art, where I could use the strengths of my temperament without being hindered by the weaknesses.

I decided I had to become a "real" painter. I would start painting on canvas; real paintings, with pictures. And this time I would truly earn my position as an artist: I would take painting classes. I left the faux business world behind, and set off into the world of art education.

4

OETRY MADE ME AN artist once, when Archy &
Mehitabel led me to faux painting. Now I had quit
faux and started painting pictures, I was again inspired by
poetry. This time it was e.e. cummings. I didn't particularly
like his poems in a literary way, but I found them beautiful,
visual: each one brought a distinct image to my mind's
eye that I immediately wanted to paint.

Here's a verse from my favorite example:

> *All in green went my love riding*
> *on a great horse of gold*
> *into the silver dawn*

My paintings were purposefully simple, spare, sharp;
graphically oriented, with an abstract background and
either an animal or the poem itself stenciled on top. This
one was to be a dark blue night sky, deepening into
black towards the bottom of the painting, with a silver
horizon line cutting across the middle and a gold horse
stenciled on top.

The surface texture was crucial for me: the key to my personal style was an ultrasmooth background. Even the texture of canvas was too much; I used gessobord instead. I allowed brushstrokes to show only when I actually wanted texture; otherwise I aimed for no brushmarks at all. I wanted all the attention to be on the paint itself as a beautiful material.

My technique relied on the integrity of a single layer of paint; the perfection of the surface. Achieving this smoothness required skill and care, and allowed for no reworking. I loved making something flawless by hand in this era of easily achieved digital perfection.

In this painting, the horse was the only element with any texture. After a lot of experimentation with brush-work and different golds (the number of variations in color can be as much of a burden as they are creative possibility), I crosshatched the paint through the horse stencil in a way that made the light play from different angles, giving an impression of both fur and movement.

The tricky thing about this kind of work on top is that it is often a one-shot deal: it is almost performance art. Stencils are not forgiving; there is no reworking. The results of the stenciling will make or break the whole thing. My painting was largely a technical matter of getting the materials to fulfill my vision.

My painting style definitely had its roots in faux painting. Many faux techniques share this one-shot aspect. While there are some that do allow reworking, others require perfection, precision, and *still* are more up to the faux gods than you. I relished that challenge, and came to feel it was part of painting.

I sometimes worried about my reliance on stencils for my images; I secretly knew it was a cover for my lack of ability to paint a good picture. Occasionally I painted something freehand—some trees in the background, say—but almost always, if I wanted a non-graphical image, I would find a digital image and make it into a stencil. (I actually loved the process of cutting stencils: projecting an image to enlarge it, tracing it onto mylar, and spending many happy obsessive-compulsive hours cutting out the stencil with a heat knife.)

I rationalized that I enjoyed that work, and that graphical images and sharp outlines were more my style... but I couldn't deny the fact that I couldn't for the life of me paint a horse. I finally admitted that not being able to paint might be a roadblock in a career as a painter. I decided I should start taking classes.

I had a very clear idea of what I wanted to learn: formal, classical technique, in order to better execute my art. Quite simply, I wanted to get better at what I did. It didn't occur to me that art classes would try to change my art.

I REGISTERED FOR AN acrylic painting class. On the first day, I was nervous. I had assigned this move such significance in my own mind, and with a not entirely positive attitude: I was making a conscious shift from stubbornly doing art on my own, to (what I couldn't help thinking of as) asking for help.

The building was a warren of unnumbered large classrooms with no indication of which one was my class. I opened a door at random, and the level of activity and noise almost blew me down. Music was blaring; one person was doing a huge Jackson Pollock on the floor; another was gluing 3D objects onto a canvas; a third—wait—had she actually *punched through* her canvas? I intercepted the teacher as he strode around the room and asked if this was the introductory acrylic painting class. "Introductory? Ha!" he boomed. "This is *Supercharged* Painting, baby." (He might not have actually called me that, but that was definitely the vibe.) "You want Adam's class, down the hall." Thank God: I was in the wrong room.

Adam's class—and Adam himself—was much more laid back. He was good with students of all levels of ability and gave some valuable demos of basic painting techniques, like painting the shadows on and around spheres, pyramids and cubes. We painted from observation, and my freehand painting quickly improved.

But something was wrong. This was all very well, but the art I was making there was not my art. What I was learning did not apply to my art, for one simple but fatal reason.

The essence of my painting was the flawlessness of the single layer of paint: it did not allow any reworking. The core of painting instruction, on the other hand, is the belief and the assumption that you have the option of endlessly reworking the painting.

It is the foundational reassurance given to beginning painters: "Don't worry, you can always go over it." (There is a valid historical origin of this assumption: oil paint, which was used more commonly than acrylic until the 1950s, is reworkable for weeks.) Slap on the paint, all the teachers say: it doesn't matter what it looks like, it doesn't matter if it's any good; you can always go over it.

But if a crucial element of the painting is an ultra-smooth surface, you just can't get that on top of several thick layers of reworked ideas. This is a crucial difference that made the technique I was being taught frustratingly useless for me.

But it got worse. In this and other classes, in the name of trying to learn, I was constantly working in a way that wasn't natural to me. I knew I wasn't happy, but I was surprised when I found myself having a physical reaction.

It started in a portrait painting class. The teacher was male, middle-aged, curmudgeonly—one of those guys who believes that makes him charming. He would roam the room as we worked, standing behind you for a few moments before barking a criticism. "Get some *color* in there, wouldja?" I put in a dark green. Next time around: "That green is weird, get rid of it." I covered it up. A few minutes later: "Hey, whatcha get rid of the green for?"

But the contradictions were the least of it. "Slap it on!" he would yawp. "The bigger your brush the better! *heh heh!*" "Let yourself go!" "It doesn't matter what it looks like!"

Rationally, I objected because working like this clearly results in a certain style of painting. I thought: they really should be able to teach us how to paint a portrait without imparting a specific technique and style.

Emotionally, my nerves jangled. This was the polar opposite of my painting in every way. It felt physically, fundamentally wrong. Every time he bellowed another pearl of wisdom, I felt like someone was attacking me. I would go home after class and cry.

I had a visceral reaction to painting in this way that was not natural to me. It may sound melodramatic, but I felt like I was betraying myself. It was a reprise of what had happened to me with my introversion, only now in

the arena of technique: painting like this, I was trying to be somebody I wasn't.

What a strange thing to be a problem, I thought. How can it be that a different technique is not welcome, or even understood, in a field that is all about originality, uniqueness, being yourself? How can it be that there is pressure to *work* a certain way?

I fretted over how much society was involved in my art education, down to telling me how I should apply the paint. But I kept discovering more and more ways the real world affects our creative lives... down to the paint itself.

The History of Paint

I adore color. To be more specific, I adore *paint*. Liquid, intense, saturated, glossy. A large part of the reason I became a painter is because I get to use paint; the picture itself, the goal of representing something, is secondary. And the more the better: I much prefer pouring a gallon of paint to stingily squeezing a scant amount from a tube. My favorite part of painting is the moment when you pour the paint from the

can: it looks like liquid candy. (Metallic paint is even better.)

So I'm a huge geek about the history of pigments, and was ecstatic when I discovered the book *Bright Earth* by the chemist Philip Ball. He discusses not color, or the psychology behind color, but the chemistry behind paint: the original organic components and how they were synthesized into paints at different times in history. Reading it is a journey through the different technologies and attitudes regarding paint, from the extraction of ultramarine from lapis lazuli, to the artists who risked using new paints before their permanence had been proven... along the way showing you how an artist's materials influenced them in ways you wouldn't have thought of.

How you procure and prepare your materials affects your quality of life. Do you grind your own toxic elements, or can you go down the street to your local Dick Blick to buy a tube of cadmium red?

Bright Earth makes clear how the real world, through materials, shapes not only artists' daily lives but their technique and even the content of their art.

The history of paint is a story of increasing manipulation of materials: from using organic matter, to chemical transformations of same, to entirely man-made replacements.

In making their paint, cave painters used a more complex process than we might have guessed. They did not do actual chemical transformations, but they did "deliberate manipulation of natural materials" taken from the environment. For example, red and yellow tints used in cave paintings were created by the iron oxide hematite being crystallized with different amounts of water or oil. The painters also used natural extenders that, added to pigments, not only increased the volume but improved their properties as paint.

Artists' colors were (and sometimes still are) finely ground minerals: "metal-containing compounds pulled from the earth." Until the 18th century, most artists ground and mixed their own pigments (or had it done for them). Their materials required them to be practicing chemists. It was an era when, Ball says, "art required at least as great an attention to the mechanical and practical aspects as to the aesthetic and intellectual." To meet this need, the

19th century brought about the new profession of "colorman," a scientifically trained chemist who specialized in mixing paints for artists.

The first synthetic pigment (meaning, chemical transformation of minerals) was Egyptian blue, which has been found in artifacts from 2500 BCE. But it was in the early 19th century that synthetic paints blossomed.

Many paint colors were an unintended side effect of technological developments in other areas, frequently the result of industrial processes. Silver mining yielded the first artificial blues; textile dyeing developed Prussian blue; the soda industry gave us patent yellow.

Artists frequently had to travel for their education and their livelihood; they also had to travel to get pigments. The finest ones were often to be found only in major commercial cities. Venice was a central trading hub where many pigments arrived first; Titian took full advantage of living there, becoming famous partly thanks to his access to an unusually large range of pigments.

Equally important to paint as the pigment is the binder: the fluid used to hold the pigment particles together. The most common early

binder was egg yolk, the foundation of egg tempera, which was the most common kind of paint for hundreds of years. (The other predominant binder was water, used in painting frescoes.) One of the most significant developments in paint was, as you might guess, the invention of oil paint. It was a major development but, as with any change, not an entirely smooth one.

At first, artists did not like oil paint at all. The egg tempera they were used to dried in minutes, while oil took days or weeks—sometimes not being entirely dry for years. These days we assume faster is always better, but the longer drying time of oil was at first seen as an inconvenience. The other monumental problem was that some pigments—especially the treasured ultramarine—were no longer so beautiful in oil.

Oil and tempera coexisted for a long time, until the end of the 1400s, when oil won predominance for a very long time.

It was not until the 1950s that oil got a challenger: acrylic paint. This is the paint you usually use if you are either a beginner or a contemporary artist creating something other

than strict representational art. It, too, had a somewhat accidental beginning.

Way back in the 1830s, nitrocellulose was developed: the first "plastic." In the 1860s, it was improved to be more flexible, and called celluloid. This was discovered (ahem) to be explosive, and consequently manufactured in huge quantities during World War I. When the war ended, there was a surplus, and, looking for a way to use it, it was made into enamel paint; first for painting cars, but quickly adopted by ever-scavenging artists.

Acrylics have developed exponentially ever since. In 1953 they made the first acrylic that could be thinned with water rather than spirits. At first it was only house paint; then the Liquitex company made it into artists' paints. Reportedly, Roy Lichtenstein and Andy Warhol were personally involved in the development of acrylic paints: the Golden company expanded their range of colors tailored to specifications requested by Lichtenstein. Warhol was one of the first artists to try acrylic paint, but didn't like the runny consistency, so in 1963 it was reformulated to a thicker consistency to emulate oil paint, and artists took to it.

Acrylics are still developing without pause. Just over the last ten years, the expansion of modern acrylic products is mind boggling, into things that aren't paint anymore: gels, beads, fiber paste. (I have a good story about acrylic skins I'll tell you a little later on.)

Developments in materials affect what must be done on a practical level—such as mixing pigments from scratch—but they also change what *can* be done. Ball says, "Art follows directly from possibilities delimited by the prevailing chemical technology." Part of the reason artists have made such different things over history is the change in materials available to them; it's not only changes in taste, subject matter, historical context or personalities. Some things used to be impossible; much of contemporary art could not have existed before this century.

The size of paintings is affected by materials: all the huge-scale works by the abstract expressionists were only possible in "an age that offers affordable paint by the gallon."

Even the consistency of paint (which is a result of the binding medium) changes art radically. Jackson Pollock's famous technique was made possible by the paint he had available

to him; in fact all the experimental painting he and his contemporaries did was enabled by the current state of paint technology.

In addition to new physical possibilities, the materials used also affect an artist's technique, and eventually the content of art itself. New materials, for example, changed the look of an outline in a picture: tempera makes sharp contours, oil much softer edges. Most artists used to paint on panels; when they started using canvas, the coarse texture produced much less precise outlines than you get on a panel. Titian used this fact and did what might be called early Impressionism: using the grain to create optical mixing that occurs when the paint skips and shows the undercolors.

New materials create new channels for creativity; they allow for new fashions and movements in art—and since the art market is always looking for new kinds of work, the faster the materials evolve, the better for the market. But more on that later.

TECHNIQUE IS ONE OF those words that people use loosely, never thinking precisely about what they mean. The default meaning is a characteristic of the final product; it is used as a synonym for the finished style, such as Impressionism. This use has a weirdly passive sense to it, as if it is a quality of the painting's own, and not something that somebody did.

What I mean by technique is the actual act of painting: how a person applies the paint.

A famous example of application of paint is, of course, Jackson Pollock's dripping and pouring; but outside of that example, nobody talks much about the actual application of paint and its crucial importance to the work. In the same way as everybody has unique handwriting, I believe every painter has a unique painting process. In fact every aspect of your artmaking is unique: your generation of ideas, your composition, and your execution of your idea, among infinite other undefined details.

I EXPLAINED MY TECHNIQUE; I brought in a few of my own paintings to show. Adam called them "perfect one-offs." My first thought was that that description was correct, and that there was nothing wrong with that. However it was clear that while he was not trying to be disparaging—he was too kind for that—the point was

that mine were not "paintings" in the way one generally means.

Nobody heard me when I said that I couldn't go over a mistake. When I protested that my painting doesn't allow me to do that, I was met with a bizarre blindness and deafness. It was as if I was speaking a different language; I felt like an inmate in an insane asylum who shouldn't really be there, people nodding and smiling at me but not hearing my protests that there's been some mistake.

Worst of all, nobody understood my frustration. I felt like I was beating my head against a brick wall. I tried to explain my problem to Adam and get his advice, but he didn't understand what I was asking. He and everyone else thought, simply, that what he was teaching—that you paint and then go over it—*was* "painting technique." No one could understand why I felt it didn't apply to me. They apparently could not *see* the possibility of not being able to go over it. I was boggled by this blindness to difference, so neatly and clearly illustrated in their lack of comprehension; in the strength of the assumption that we all do things the same way.

Every painting teacher I encountered paid lip service to the possibility of individual technique, but when I (unintentionally) challenged them by *having* a different technique, not a single one knew what to do with me. They could not divert from the mantra that you can just

start painting, see what happens, and go over it again and again. My technique did not allow for this—and they did not allow for my technique.

In the same way as it was personally hurtful when my introversion was not understood or allowed for, I found it quite personally painful when my teachers didn't understand what I was asking, when my classmates didn't understand what the problem was. My technique was something that felt innate to me, and it was that aspect of *me* that made no sense to anybody. Their blank stares made me feel like something was wrong with *me*.

Peer judgment came across silently but unmistakably. Professor and artist Nell Painter, in *her* memoir of becoming an artist late in life, *Old in Art School,* expressed perfectly the way these unspoken verdicts are communicated. "The judgments spoke through the air, wafting toward me unbidden, issuing from mouths I could not see. Even though I always told myself that other people's expectations wouldn't hinder me, disembodied expectations gave me pause."

Weirder still, I was apparently the only one with this problem. Everyone else in the class worked the accepted way, thought the right way, made the right assumptions. No one else questioned anything. Not only did I have a technique that it seemed no one else did, but no one

understood my problem; they couldn't even understand my question.

In *Quiet,* Susan Cain explains the reciprocal connection between understanding and acceptance: if the group cannot understand you, they will not accept you; when they do not accept you, it is often demonstrated by incomprehension. And it was thus that I became, again, an outsider. In questioning the givens, and by my obvious unhappiness over *some*thing, I was making trouble: I felt my classmates start shying away from me. It was very clear how different I was. I was the misfit; I was the bag lady raving on the subway.

And yet—and this really did make me think I must be crazy—there *was* nothing wrong. There was nobody to blame: the teachers were teaching, the students were painting. And yet I was miserable.

I was also getting angry. What the hell was I supposed to do? Change my art in order to get something out of the training that was available? Change my art in order to work the way everybody else did? Change my art in order to be something—someone—that would fit into the system better?

No way.

IN ART CLASSES, I was different not only because I worked in a different technique but also because I was interested in technique above other things. It seemed nobody else cared about technique. Why not?

Not only in Adam's class, but everywhere I went, nobody talked about technique at all. People were much more concerned with squishier things like spontaneity, self-expression, originality, communication. I didn't care about those things at all; I wanted to learn technique, and not only were they not teaching that in a way I could use, but everyone was flapping on about these namby-pamby matters. Technique, it seemed, was not the point anymore.

How could that be? Technique was historically an indispensable part of an artist's training: technique used to be *everything*. It was key not only to an artist's training but to the development of art as a whole.

The academy and the atelier system are evidence of how all-important technique was considered to be in learning to become an artist. Simply, it *was* an artist's education. Incredibly detailed work, drilled in until it was second nature; copying the classics until you could do them in your sleep. Technique, technique, technique.

Every student started with Bargue drawing: copying highly detailed shades of gray. That's it. For years. Then you moved on to drawing plaster casts. For years. Eventually you made your way to drawing from life.

Only after years of drawing were you finally allowed to touch paint, and with that new medium you started again from the beginning—and not even in color. First you did monochromatic painting of forms, then monochromatic painting of plaster casts; monochromatic copies of master paintings (to learn how to translate color into value); a long time on still life, and finally the prize: painting the life model.

This was the kind of teaching I had envisioned. I wanted to learn technique only, not all this self-expressive stuff. I kicked myself for being born in the wrong century.

However, recently, like retro clothing, the atelier has been making a comeback.

A painter named Juliette Aristides started the revival, founding the Classical Atelier in Seattle. She says, "The grand masters of art knew the secret to enduring success depends not only on inspiration, but also disciplined application of vast artistic knowledge." Defending the need for the atelier to the *Huffington Post* in 2014, she explained, "Atelier education is like musical training at a conservatory—much of the artwork produced in the first years are exercises akin to practicing scales."

The revival of the atelier is in response to exactly what I felt: that technique has been pushed out by all the new focuses of art. Aristides and others are doing this work out of the fear that techniques honed over hundreds of

years will disappear. As she says, "Ateliers are monasteries of art keeping skill and technique alive." The retro atelier is actually a revolutionary movement that says, We will not participate in the new system that presents these other criteria as dominant; we still hold technique to be primary.

I'm with them.

TECHNIQUE HAS ALSO BEEN the crux of most of the big developments in art: the technological developments in the pursuit of painting realistically, the scientific discoveries that changed painting completely.

These changes all have to do with the opposition between painting what you *know* is there and painting what you *see*; in other words, the intellectual, memorized way versus how things actually appear.

The earliest, clearest example of this is in Egyptian painting of figures. They based their painting on knowledge: in a figure painting, they depicted all the body parts because they knew they were there. Greek sculptors of the sixth century BCE brought about a revolution when they stopped following the accepted formulas and began to use their eyes: no longer showing everything they knew to be there, they painted what they saw. "Once this ancient rule was broken," says Ernst Gombrich,

"a veritable landslide started. ... It was a tremendous moment in the history of art when, perhaps a little before 500 BC, artists dared for the first time in all history to paint a foot as seen from in front." This was the discovery of foreshortening.

The next watershed moment in the pursuit of realistic painting was the discovery of perspective. Filippo Brunelleschi, an architect in Florence in the early 1400s, figured out the mathematical law of perspective, changing painting forever. One of the first paintings to use it is a 1427 painting of the Holy Trinity which showed such realistic depth that, Gombrich says, it "seemed to have made a hole in the wall."

Leonardo da Vinci came up with a technique that further enhanced the realism of painting. This was *sfumato*, the blurred outline that leaves something to our imagination, which he used, famously, in the Mona Lisa. The sfumato in the corners of the Mona Lisa's mouth and eyes (the parts of a face that are the greatest indicators of expression) make her look alive *because* they are not sharp lines. Sfumato solved a problem that the best painters had been working on, trying to solve through representation—Botticelli tried to make his figures look less rigid by showing waving hair and fluttering garments—but the solution turned out to be a matter of technique.

Leonardo Dreams of Hyperrealism

Despite Leonardo's innumerable, multi-disciplinary talents and the advances he brought to art, he was never completely satisfied with it. He wanted to "achieve complete illusion," something he could conceive of in his genius mind but that was impossible in the real world. He was disappointed that all the combined powers of knowledge, artistry, and science could not achieve complete illusion—that it was "outside the power of painting."

I wonder, would hyperrealism have been enough for him, or did his mind's eye see something yet further?

PAINTERS' USE OF LIGHT is another area of progress in technique that it's interesting to trace. Piero della Francesca, from the mid-1400s, is known for his novel use of light (in addition to the new art of perspective) to show depth. And four hundred years later, the way the Impressionists painted light changed technique in several ways. Most people know that they painted outdoors, trying to catch the play of light on water, et cetera. But fewer people know

that making (and finishing) a painting on the spot meant no more careful mixing of colors, but rather a new technique of making rapid strokes of many colors to create an impression of relative light and dark, as we see in Renoir and Monet. Edouard Manet effected another change when he decided to ignore the painting technique so carefully taught in the academy, in which students learned to show color and light through gradual gradations of shading, and instead painted the actual harsh, strong contrasts of natural sunlight. Together, these things changed the work from painting as if everything was under artificial light in the studio, to depicting things as we see them in natural light. In this way technique played an important role in squelching accepted academic rules.

Last but not least, there is photography, and its interruption of the pursuit of realistic depiction and of painting itself. For centuries artists had made progress in painting the world more realistically, until in 1839 this progress was suddenly halted—or at least bumped off course—with the invention of photography. Until then painting had been the only way to depict the world; photography suddenly took that away, and painting had to find a new niche, new purposes, new things that it was uniquely suited to. Photography was a blow to the position of painters, who were until then the only ones who could record your face for posterity.

So I THINK IT'S safe to say that historically, technique was central to art and artmaking. But now, at least as far as I could see in my art classes, technique is no longer the point. Art seems to have moved away from technique. How is that possible? And why?

It started when, simply, technical skill became so common that it was valued less than other aspects of art. Painters were reveling in new challenges—such as demonstrating creativity and originality—and those things, more individual to the painter, became the things buyers looked for instead.

But a bigger reason technique faded was the rise of art as expression. Art became a place to express emotion rather than to pursue representation. Gombrich says that artists "longed for an art which did not consist of tricks which can be learned, for a style which was no mere style, but something strong and powerful like human passion." This was the death knell for technique; it paved the way for other aspects of art to become priorities.

Further bolstering the rise of expression over technique, popular art styles—beginning with Impressionism and never looking back—happened to lend themselves more to expression than to precise rendering of reality. Technique—especially traditional technique—had less and less place in modern art movements. It is particularly clear how it would have no role in, say, conceptual art,

where the idea was primary and painters wanted to get away not only from technique but from "materiality" entirely.

But most of all, technique has been killed by the belief that art is a social act. When you push the idea that the purpose, nay, the *core* of art is communication—that its focus is no longer the physical manipulation of material—you are deleting technique from the picture.

THE BANISHING OF TECHNIQUE has had a radical effect on art education. Art teachers used to do the obvious: instruct students in technique, model their own work, critique. Now, they are no longer there to teach you how to paint; they are there to teach you how to be an artist who is successful in today's market. And this involves just about everything *except* technique.

Teachers must educate students in the demands of the art market, which means partly content and partly style. They must teach students how to navigate the art world, which means confidence (read, extroversion) and other requirements like originality and artspeak (which I'll rant about more in a bit).

There are many aspects of the current world of art education that further aid and abet the disappearance of technique.

More and more, teaching technique is unnecessary. For a panoply of reasons, students now arrive at art school already experienced artists. They are there not to learn but to practice their art, and to learn how to use it to be successful. (There has been a subtle change of meaning here: students no longer only want their art to be admired and known, but to *use their art* to create for themselves a successful identity as an artist.) There is no training involved: the students are already artists.

Rapid change in the art world has also helped move us away from teaching technique. Art is all about the New; we are always grasping for the next thing that we haven't seen before, leading to breakneck speed of change in fashions in art. "The entire temporal dimension" around art has changed, says Judith Adler.

Part of this dimension is the new requirement for artists to establish themselves in the art world early, young—which compounds the impossibility of investing time in developing traditional skills. A young artist, says Adler, "anticipating rapid and unpredictable shifts in aesthetic fashion, [cannot] afford to take up a craft requiring years of practice."

Nor are they being asked to put in those years. The modern art curriculum fits neatly into and enables this new timetable: focuses like self-expression do not require technique.

Rapid change also leads to a new attitude towards teachers and, by extension, towards an art education. As soon as a teacher is old enough to have any kind of experience, he is a dinosaur: passé, thus not cool, and thus not worthy of respect. Even if a teacher is a successful artist, he would be inadequate, as he rose to success "in a world which no longer exists." This uncertainty about the usefulness of your teachers increases people's ambivalence about the MFA degree; and the fewer artists that go to art school, the less technique there will be in the art that is being made.

Part of the challenge for teachers is that the art world that students are going into is so unpredictable. There are no longer occupational standards to share with the students; instead, Adler says, the teacher can only try to predict the "route to a professional validation he is unable himself to bestow." Many teachers themselves don't have the core skills to impart; there is little agreement, anyway, about what the core skills are. "The very definition of who is to be called an artist and what is to be dignified as art appears hopelessly arbitrary," says Adler. She quotes a teacher of an advanced art seminar looking at a questionable piece of performance art and saying, "I don't know whether to call him an artist... but I guess he is one since he exists in the art world."

BUT THE BIGGEST JOB teachers have now is encouragement.

In the big picture, nobody in the art world will discourage anyone from going into the arts, because we know that the arts are struggling: it is an endangered field, and we need all the bodies we can get.

But in art school, there's a bigger reason teachers never discourage students: it is because art is no longer an academic discipline. Art education is no longer an objective, practical matter of training. Art is now so personal—you are expressing your*self*—that to deny or question that, or even to say that you need improvement, would be questioning *you*, your essence. In this way, teaching technique has become taboo.

Instead, teachers emphatically encourage, taking what Adler calls a "therapeutic approach," reassuring students that whatever they make is art. The teachers are there to boost the students' confidence, not to distinguish good from bad work, leaving what she calls a "pedagogical absence."

In fact judgment of any kind has become taboo.

When we look at art in an exhibit, our task these days is to studiously avoid any mention of good or bad; we talk about the art from every angle *except* judgment. The trick is to critique without being critical.

In my art classes, you couldn't miss how aggressively *positive* all the feedback was. Every single comment

started with "I like." *I like your use of color/use of black and white; I like how detailed it is/how wild it is; I like the blood on the floor and the green in your grandmother's hair.* It felt like a Montessori classroom.

And it is the absence of focus on technique that has brought us here. If art does not involve technique, there is nothing to critique. Self-expressive art is too personal to judge: you cannot tell someone that they depicted their dream wrong or interpreted their heritage weirdly. If you recall what we said about art as self-definition: if you criticize their art, you are criticizing the artist.

The Crit

A central part of an art school experience is the crit, or critique, in which you present your work to your teachers and peers for review. The group meets to discuss the student's work "with a mandate to understand it as deeply as possible"; but at the same time crits are "painful rituals that resemble cross-examinations in which artists are forced to rationalize their work and defend themselves from a flurry of half-baked opinions that leave them feeling torn apart."

Sarah Thornton attended a crit at Cal Arts and writes entertainingly about it in *Seven Days in the Art World*. She describes its rambling feel, how the presenters were not particularly presenting polished work but more putting ideas up for discussion. People brought their dogs, they knitted; they drifted off for a nap as the artist herself drifted off into a meditative silence. The students perked up only when the artist said "I guess I'm wondering about the viability of political activism in my work," and, finally, there was something to discuss.

The silences, interestingly, aren't uncomfortable. One student tells Thornton, "When there is nothing to say, that becomes the question, in which case that's a really interesting conversation."

Thornton confirms that the crit is at least in part a hazing ritual. It does not have as its goal so much actually improving the work in question as preparing you for a professional career full of interviews and dealing with critics. She quotes an art teacher who says that being put on the spot, as students are during a crit, "helps them develop thick skins and come to see criticism as rhetoric rather than personal

> attack." At the bleary end of a twelve-hour day of crits, Thornton says, "For a fleeting moment, the crit appears to be a weird rite engineered to socialize artists into suffering."

ALL THESE FACTORS CAME together to kill technique; the death of technique leads in turn to changes in art itself. When you change your focus as radically as art did—away from one essential core that held for hundreds of years, to a mélange of ideas all aspiring to become the new It Girl—the content of art must and does change. Beyond curriculum, meta elements of the format of education shape the content of the art being made.

We can find a clear example of this in the writing world. Have you noticed the revival of the short story form? Writing workshops are creating a whole generation of short story writers because short stories are the easiest thing to work on in the format of a workshop. The same thing is happening in painting. Because we tout the importance of self-expression and of spontaneity, the content of the art being made today is largely unplanned self-reflection in paint. There's nothing wrong with that in itself; the problem is that we are all being steered toward it by society's decision about what's important in art.

Yes, the market exerts pressure on us, but our response to that pressure is equally powerful. We cooperate with the market by perpetuating its demands as *values*, by expecting them from each other, and speaking of each one as an intrinsic aspect of art. We don't question them and—by means of social pressure to belong to the group—we don't allow anyone else to question them either.

The dominance of the extrovert is at play here too. Society now wants art to be made in the ways that extroverts themselves prefer to work: big and bold. It's not that extroverts are running the show; it's that our society believes so strongly in the virtues of extroversion that we are taught that it is better to behave like an extrovert in every possible thing we do. Isn't it bizarre that a societal preference for a personality trait has reverberations out as far as how I am supposed to apply paint to my canvas?

It's bad enough that they want to change my art; what I find more disturbing is that they want to change *me*.

Society changes technique, and training changes *you*. It seems too obvious to say that training changes your work, because of course it does: your knowledge and skill are enhanced through both theory and practice. It is, nonetheless, an influence of society on your work. It's not solely improvement; it is actual change, in technique and in content, driven by a fashion determined by someone else.

Art education changes the path you take through art. It's like going to the doctor: if you consult a medical professional, you are implicitly signing up for treatment. If we go into art education, we are signing up for training that will make us professional and/or "successful," which is an entirely different enterprise than just wanting to make art.

And art education expects you to be malleable, willing to change yourself and your work in order to be successful. As a student, you must be open to the feedback you get in class. Sarah Thornton quotes a young woman who says, "You have to have a mysterious blend of complete commitment to your decisions and total openness to reconsider everything." Entirely contradicting the general advice of *finding your voice* and *sticking to your guns,* you must also have, as Adler puts it, "a strong sense of nonentity."

I THOUGHT A LOT about this in my art classes: how much we were being steered and asked to change. I thought about innate tendencies: how we work before—or entirely without—influence from society.

One art class I took was the perfect window into precisely this. This class was not in painting but in book illustration, and it was unusual in its utter lack of direction. We could work on anything we wanted—given

complete freedom in medium, subject, style, size, everything—and it was striking to see the resulting range of styles and techniques. What I saw when I observed all the different ways people worked was that they made instinctive choices. These ranged from large abstract watercolor backgrounds to remarkable obsession with detail. One woman did incredibly intricate etching on scratch-art paper; another made full scenes, complete with background scenery and foreground figures, collaged out of tiny, hand-torn bits of paper of about ⊠". As for me, I was working on a Hirschfeldesque animal alphabet book.

Seeing the full range of people's natural tendencies in full, unfettered expression confirmed my beliefs about people having their own innate ways to make art. The beauty of their work (which I could judge objectively, unlike my own) proved that these different ways were all valid and good. And this helped me believe that my way—even if nobody else understood it—was also right.

We must not allow ourselves and our work to be distorted too far from the original. Not even in sneaky, seemingly trivial ways like telling us what brush to use. We must take pride in and hold on to our individual technique. This is crucial if we want the artistic fulfillment that we are all going for, which was in fact—remember and honor this—the reason we became artists in the first place.

5

LOOKING THROUGH THE COURSE catalogs for my next art class, I was depressed to find that they all sounded the same. *Discover more about yourself and your artwork. Define your personal imagery. Find and express your personality through your painting.* All the offerings made it clear that the point of art was your experience of it, what artmaking did for you, how it would help you get out your demons and improve your life. I was interested in technique, and all I found was worship of the self and the belief that self-expression is (yet another) key to art.

I was trying to find a class that would teach me what I wanted to learn: how to do *my* kind of painting *better*. Everyone wanted to change my kind of painting into their kind of painting. Maybe, I thought, I was taking the wrong classes?

I signed up for an abstract painting class, with the vague idea that they might focus less on self-expression and more on color and shape and the paint

itself—perhaps teaching us how to do the sharp-edged color blocks of a Mondrian, for example; something a little closer to what I was interested in.

It turned out to be the opposite. It was "abstract" only in that we were not actively trying to represent anything. There was no intentional abstraction, only absence of purpose.

We did "signature paintings": we signed our names on a large piece of paper, cut it up and reassembled the pieces into an "abstract painting" that "contained and reflected ourselves" in a way no other painting could. We made paintings using anything other than a brush. We covered a large canvas with the color that represented how we saw ourselves, then splattered on its complement to illustrate all of our potential ways of being.

Abstract painting class turned out to be all about self-expression.

And as always, nobody else objected; belief in self-expression and interest in the self seemed inborn. Like all fashionable ideas, it seemed to be in the water. The focus on the self was almost a religion, and I was the atheist in church.

How did we get to this navel-gazing focus? Where did it come from, and how did it grow to be this behemoth? And why did I hate it so much?

ART EDUCATION NOW FOCUSES not on the art itself but on *us*: what we feel and what we want to say; how we and our art relate to the world around us. Artmaking has come to be all about *ourselves* and *other people*. It's as if we got bored with art. We now find ourselves much more interesting.

Self-expression is now unabashedly the goal of art. It's talked about as so intrinsic to art that it's hard to believe that such focus on the self is a modern concept.

Before the individual was recognized as distinct from society, self-expression (at least outside the private realm) did not exist. Only once there was *awareness* of the self could we begin to develop our belief in the *importance* of the self. This was the beginning of art's focus on the individual, and of the idea of art as a psychological reflection.

But in the early days, even once it was recognized that art was made by an individual and that they brought their own touch to it, there was still no *self*-expression. Rules and conventions of art were so strict that artists had no choice in what they made; and, as Ernst Gombrich says, "Where there is no choice there is no expression."

Gombrich compares it to how we express ourselves with what we wear. When you choose what to wear, it shows something about your personality; when you

have to wear a uniform, there is much less scope for expression. Rules of painting were such a uniform.

When artists stood up for themselves and seized the freedom to choose their subject matter, the scope for expression increased; but even then, it was still not what we do today: artists were still not expressing them*selves*. "None of these artists was deliberately making his choice *in order to* express his personality. He did it only incidentally, as we express ourselves in everything we do—whether we light a pipe or run after a bus." The concept of making art in order to express your personality—the very importance of personality—was still one step away.

Post-Impressionism, starting in the 1890s, is one of the first examples of expression beginning to make itself visible. The pointillism by Georges Seurat, for example, required a simplified form that moved away from straight representation and towards expressive patterns. But it took Cezanne and Van Gogh to take the next step to making art that reflected what they felt about it.

By ignoring the rules of realism and distorting the image, they conveyed feeling about the subject. In Van Gogh's painting particularly you can see how he used paint to show his energy, his excitement. Van Gogh was friends with Paul Gauguin, who also painted very much in order to express feeling. Gauguin said that "all the

cleverness and knowledge that had been accumulated in Europe had deprived men of the greatest gift: strength and intensity of feeling, and a direct way of expressing it."

Once the artist started to express his feeling about his subject in his painting, it was only a small step to conscious awareness of the self.

This development was greatly expedited by the Dada movement. Founded in 1916, this started as a political protest but ended up being more influential in bringing attention to the artist's state of mind as he worked. Dadaist doctrine focused on the state of mind required to make art, and resulted in a new image of the artist: one who works with full awareness of his own state of mind and of his goal, as well as with consciousness of the effect of his work on the viewer.

Dadaism also took the next step: from awareness of the individual's state of mind to the assertion of the *importance* of the artist's state of mind. Dada artists were much more interested in the psychological under-pinnings of a piece of art than in the finished product. For them—and for the very first time—the product was not the point.

Gombrich says, "The idea that the true purpose of art was to express personality could only gain ground when art had lost every other purpose." Tradition lost its influence, skill and technique began to be taken for

granted, and people looked for new aspects of art to admire. People were fascinated by nonconformists, the cool, interesting "artistic" types, and self-expression by someone like that was intriguing.

Artists started to make art *in order* to express what they felt, and to express them*selves*. This moved us permanently away from the art and to a focus on the self—on *you*, and your intention in making art.

This is artmaking as we know it. Art has become a medium to express yourself: not just your "artistic voice," or even your personality, but your feelings, thoughts, and emotions.

This wasn't at all what I was doing in my art, nor what I wanted art to be for. Not only was this not what I wanted to learn, but it made me itch.

GROWING UP WITH MY father, I developed an allergy to emotions. Actually, I was afraid of emotions. I always left them alone, like a scary animal, not questioning too much why they were there or if there was anything to be done about them.

My father was classically British in every possible way, which some of you will know means more than elbow patches and a lovely accent. It also means an absolute dread of emotions.

He thought life should be about just the facts, and that how you *feel* about something is unimportant. If I told him that a certain teacher was mean, he would say, Who cares, can they teach? If I said I really enjoyed doing a project, he would say, That doesn't matter, did you do a good job?

Feelings made you weak. Talking about them was indulgent; expressing them was an admission that you were weak. Thinking about them was a waste of time. In fact any form of introspection was pointless: you're only going to find unpleasant things, and besides, you're not supposed to talk about what you find, so better not to do it at all.

My father scoffed at people who talked about themselves, and even more so anyone who thought an individual's personal story or feelings were interesting.

He was, in other words, not a fan of self-expression.

Despite vehemently disagreeing with him—and despite my mother being the exact opposite—this feeling about feelings somehow seeped into my being. Other people's self-expression made me impatient and a bit uncomfortable. Our family habit of not talking about feelings was reinforced by my introversion: I wasn't comfortable putting my thoughts out in public, and I didn't understand those who did. It didn't seem quite dignified, and it certainly—I now thought—isn't art.

THE ABSTRACT PAINTING CLASS was also a long-drawn-out exercise in spontaneity. We did paintings to music, to see if what we painted to the Rolling Stones would be different than what we painted to Vivaldi. We dashed off pictures "unthinkingly" (as unthinking as you can be when you are thinking about being unthinking).

"Don't work so *hard* at it!" the teacher admonished me when she saw me frowning. "Stop thinking and let it come. Allow your brain to relax. Ask it to come *play*."

Play has become the key principle behind all kinds of learning. In the early 1900s psychologists identified the benefits of letting children play freely; schools have taken this up (and occasionally put it down) as part of curriculum; but art has never let it go. Art is seen as "most true to itself when it flowers as free play." Which is to say, spontaneity.

The leanings of all my previous classes—to paint energetically, broadly, trying not to care how it looked—had been a growing struggle for me. Painting classes were making me sad; worse, they were making me angry. I didn't really know why, just that every word out of every teacher's mouth made me want to scream.

Now it was worse than ever. In searching for a class to teach me techniques that I could use, I ended up in classes where "technique" only went further down the road of free play. I did not *want* to play, to experiment, to "see

what comes out." But it was inescapable. Everywhere I looked, there was utter faith in the magic of spontaneity.

In art classes, in books, in our society in general, there is a pervasive preference for spontaneity.

Henry Miller said that "one is playing at the game of creation" when working spontaneously.

Sociologist Arnold Hauser writes, "It is part of the essence of art that its creations ... assume the character of aimlessness, immediacy, and spontaneity."

Andrew Wyeth said, "Painting is all about breaking the rules. Art is chance. It's like making love. Hell, you don't have a written book for sex; it's always spontaneous."

One day just for fun I googled "spontaneous painting" and got an avalanche of stuff that made my teeth hurt. Spontaneouspainting.com (because there really is a website for everything) describes it as "a way of expressing an immanent and transcendent reality, through the exploration of essential unconscious contents that aid in strengthening one's authentic Self identity." One woman described her discovery of spontaneous collage: how she "began to see all aspects of my unconscious mind in intriguing imagery and bright color"; that her collages helped her "to know myself more profoundly."

The goal is to "relax the constant chatter and critical voice of the rational mind, and contact hidden dimensions of one's inner emotional landscape."

The idea seems to be that you should sneak up on yourself, grab the reluctant, hidden parts of yourself and stuff them in a cage for further examination. Sounds to me like taking the cat to the vet.

I AM A PLANNER. However powerful the message that spontaneity is all-important, it never worked for me, because it has nothing to do with how I paint. I plan, then I execute my plan. It may sound uninspired, but I argue that it is just as valid a way to paint as any other. My painting process is best compared to a description I read of the creative process behind painting a mural: it is like writing a musical composition and then performing it on stage.

When I get an idea for a painting, I start by making sketches and notes. Then comes my favorite part: to see what needs to be done to make my idea actually possible. I think of it like an architect submitting his fantastical drawings to the engineer of a construction project, or a manuscript being passed from writer to editor to production to marketing: each step is necessary to get a vision closer to reality. And the best part is that I get to play all the roles. I am everything from the dreamer to the printer. I am the ideas guy, the practical guy who

shoots down the unrealistic dreams, the money guy, *and* the boss.

A crucial part of my planning a painting is to look at available canvas sizes and think about what would work best, both for measured content and for overall mood. (The size and shape of a canvas play a remarkably big role in the feel of a painting.) Often I have to do math, or rejigger my composition according to the canvas I decided on. I love that practicalities provide a shape for my creativity.

When I bring the canvas home it has the potential and excitement of getting a new puppy. I gather the materials, approach the canvas, and execute my plan: to get on canvas what I have so clearly in my head, as perfectly as I can.

So, no, that is not spontaneous, as in "I approach my canvas and let the painting lead me where it wants to go." But if it is not intuitive, I would like to know what is. It is also the most creative and satisfying work I have ever done.

WHY DO WE *LIKE* the idea of spontaneity so much? Why does everyone believe so powerfully that spontaneity is so great? The reasons range from the simple fact that

it feels easier to the feeling it gives you that you have something in common with God.

Spontaneity plays into our modern belief that the most important thing is our own pursuit of happiness. Spontaneity is advertised in the self-help literature as the first necessary step towards flow—"one of the most deeply satisfying human psychological states"—and thus to happiness.

We like it because we prize our experience of making art over the work itself. History took the first step towards acknowledging the artist as well as his product; we have taken that all the way to valuing our *own* creative experience over our work. As sociologist Arnold Hauser says, we value "urge and intention" over achievement; and this is what we still see in art education: your desire to do it is more important than what you do.

Most of all, we like spontaneity because it makes us believe that everybody can be an artist without any training. Spontaneous, "raw" work by a beginner (if we like it) seems more *talented* than something produced after careful planning by someone highly trained. In short, we like spontaneity because it nurtures our secret hope that we might turn out to be a genius.

The concept of genius, perhaps surprisingly, has not existed forever; it is not as fundamental, or as much of a given, as you might think. Hauser tells us that it was a

new concept in the Renaissance, going hand in hand with recognition of the individual (all of which eventually led to the concept of intellectual property). When tradition was crucial to art, skill played a role, but genius did not. Genius required artistic freedom in order to bloom.

When artistic freedom was new, artists made a show of "ostentatious genius" in order to demonstrate their autonomy. Hauser says that "to be allowed to be a 'genius' was a sign of a freedom which had scarcely been achieved." But now that our society is accustomed to free will at the easel, it's less necessary: "No longer wishing or having to be a genius is the sign of a condition in which artistic freedom is taken for granted."

That is us, now—theoretically. Many of us, though we may not actually claim to be a genius, still nurse the idea of genius: it is crucial to the mythology of the artist. The image of the eccentric, poverty-stricken artist who has renounced the world came out of the connection we make between those characteristics and genius. If you reject the world and its standards of civilization, you are probably a little bit crazy; and the crazier you are—from the old assumption that we can't possibly understand a genius—the more genius you must be. Art students (and some artists) still carry on the tradition of the boho/ grunge look, which is a convenient confluence of the

right look to show that they don't care with the fact that they usually don't have very much money.

In our attempts at spontaneous painting, it is that link to the crazy inspired genius that we are striving for.

Lastly, genius is only one small step behind the Divine. And it is something approaching divinity that many of us have in the back of our minds when we champion spontaneity.

There is an old idea that the artist is a "divided being"—a person and an artist—and that those two parts pull him in opposite directions: the person trying to live life normally, the artist desperate to be free from the demands of life. Maurice Beebe explains two literary traditions that depict each opposing presupposition about art: the Sacred Fount tradition and the Ivory Tower tradition.

In the first, art is equated with experience. Experience is the source of art; art is the re-creation of experience. The true artist lives fully, intensely, passionately; he (for in the old days it was always a he) *feels* more intensely than others.

But the latter—the Ivory Tower tradition—exalts art, and the artist, above life. Art is equated not with experience but with religion, and the artist with God. It draws an analogy between creator and Creator.

Under the sovereignty of religion before the 19th century, this went only so far as to see the artist as *like* God; "he is a kind of secondary god whose power comes *from* God." The 19th century saw a gradual collapse in religious faith, and it changed the "artist-as-God" concept. Beebe says, "When the artist loses his belief in God and can see in the universe no evidence of a divine plan ... then he no longer considers himself a secondary God, but a successor to God."

So SPONTANEITY HAS A fine pedigree. However, if you look at history, you will see that for the longest time the preference was for the opposite. Traditionally, planning was absolutely key to great art.

If you know your classical art, you will know what an important part composition played in painting. It was the foundation, the structure upon which a painting would succeed or fail. It was the hardest but most important aspect of painting for a student to learn. Jacques Villion, the brother of Marcel Duchamp, said "The framework of art is its most secret and its deepest poetry."

Many of the developments in art that I've mentioned altered the task of composition. As paint itself developed, composition, traditionally a spatial affair, started to be done through color as well. (Titian famously broke the

compositional "rule" that the Madonna must always be placed centrally, and used color to give the picture visual balance, if not religious propriety.) The discovery of perspective undeniably changed art for the better, but made the challenge of composition much harder than it had been before, as it now had to be mathematically precise. But math had already been involved for a very, very long time.

Mathematical Composition

Pythagoras, the ancient Greek mathematician (born 570 BCE), working with strings of different lengths, figured out harmonic ratios in sound and thence discovered the musical scale. Then came the radical perception that the same ratios that are pleasing to our ears are also pleasing to our eyes: there are the same harmonic ratios in design. This idea was passed on from Plato to Vitruvius and finally to Leon Battista Alberti, whose *Ten Books on Architecture* was widely circulated among Renaissance artists as a basis for composition.

In *Classical Painting Atelier*, Juliette Aristides explains how these ratios are used in painting:

with the "armature of the rectangle." This is created by dividing the rectangle of a canvas with fourteen diagonal lines, which delineate harmonic divisions: lines along which placing key elements of a painting makes it unconsciously, almost mysteriously, harmonious to look at. All the "great art" you know of was made with such harmonic divisions. Aristedes gives examples, laying the framework over many famous paintings, and it's fascinating to see how perfectly it works.

On top of the armature you can layer squares, circles, Golden Ratio forms; circles within squares; even a second set of forms inset into the first that have the same proportions as the whole. All of this is what Aristedes calls "the musical scale of composition."

These divisions not only make the picture aesthetic, nor simply lead the eye to the most important elements, but lend lots of symbolism—if you know how to read it. A circle was supposed to represent heavenly space, a square our earthly world; using a circle within a square was meant to depict a reconciliation between the two. Titian's famous (and enormous) *Assumption of the Virgin* uses two circles that intersect

at the center of the painting; at this intersection is the Virgin Mary as she rises above the people and ascends to God.

Why do we find paintings composed this way so beautiful? One theory is that it is a proportion, a system of order, found everywhere in nature, including the human body itself, and thus we find it instinctively pleasing. Its universality is taken to show that it is a principle of good structure and design. Another idea—more strictly about painting—is that when looking at these proportions, our eyes are continually measuring the relationships, and that this work gives the mind exactly "the challenge or dynamic feel it enjoys."

THE MERITS OF PLANNING versus spontaneity have in fact been debated for centuries. It started with access to paint.

Venice was for hundreds of years a major hub of trading, and the first place in Europe where exotic pigments from the East were available. Venetian painters of the Renaissance (most famously Titian) took full advantage of this, to the envy of their greatest competitors, the Florentines. Philip Ball tells us that paintings by the

Venetians had more layers—a more "complex paint surface"—than those of Florentine painters, not only because they could experiment with more colors but also because they had enough paint to dare to compose as they went. "Many of these works were extensively altered while being created—an indication that the Venetians did not always carefully plan and draw their designs first, as a Florentine artist would have done, but composed as they painted." Because they had more access to paint, they could be freer in their work, and make spontaneous choices as they went.

Probably stemming from their differing access to materials, the two sides believed different aspects of art to be more important. Florentine artists insisted on the importance of skillful rendering of form, and saw color as secondary, while in Italy, Titian and others were becoming world famous for their use of color. This debate over *disegno* versus *colore* was never resolved, but morphed into our modern difference of opinion over the merits of planned versus spontaneous composition.

The tradition of classical composition, along with so many other traditions of the past masters, has been pushed aside. Juliette Aristides, the founder of the atelier school in Seattle, says that people now rely on intuition to arrange figures in the frame, but that this is not enough

to achieve mastery. She believes that we can, and should, use the old knowledge and apply it to our creative work, "furthering, without repeating, a great tradition."

WHERE DID THE IDEA of spontaneity come from? Well, as he did in so many other areas, Leonardo da Vinci changed the world on this front as well.

Gombrich tells us that before Leonardo, the goal was to draw the perfect line the first time. There was no sketching to work out your ideas. Drawing served a different purpose "in a world where the artist was so much guided by traditions and patterns"; where creativity was not expected.

Leonardo introduced the possibility of sketching as a creative step; the concept of developing ideas as you go, without having to make everything a finished work. He made imperfect, rough sketches, focusing on capturing movement, purposely to gain inspiration through sketching. To a world that believed in strict rules of art, he said that "what concerns the artist first and foremost is the capacity to invent, not to execute." He believed that what was important was invention—the *mental* quality of art—over pattern or craftsmanship. Invention, changing your mind as you work: this is spontaneity.

The sketch was now, as Gombrich says, "no longer the preparation for a particular work, but part of a process which is constantly going on in the artist's mind."

This concept was actually part and parcel of Leonardo's work to raise the status of painters. Comparing an artist's sketches to a poet's rough draft puts the two pursuits on an equal footing. Thus Leonardo's sociological intentions also had the practical consequence of radically changing how artists work.

Leonardo himself used free drawing as meditation, for inspiration. He loved studying the indeterminate, like shapes in clouds, saying that it "has to rule the sketch to stimulate the mind to further inventions." This preoccupation led to his invention of sfumato—the blurry lines at the edges of a figure that allow the viewer's mind to interpret so much more—which had an inexpressibly huge impact on art.

One important thing that this brought to painting was the possibility of making mistakes. Leonardo called them *pentimenti* (Italian for *repentance*, which I think is a wonderful bit of linguistics: that a painter *repents* what he has done).

The fact that artists started making alterations as they worked also had a significant effect on the study of art history: we can look at the traces of earlier marks underneath a finished painting, and learn a lot. We get

a clue as to the artist's process and what they thought of a painting as they worked; if they reused a canvas, it tells us something about their finances. All this and much more can be seen (originally through X-rays, and now by making a three-dimensional model of the painting with terahertz reflectometry imaging) in this evidence of an artist's changes of heart.

We can't go far without again seeing the influence of Dada. It was the beginning of many of our modern ideas, including spontaneity. The Dada painter Hans Richter wrote about the movement: "Absolute spontaneity, chance regarded as the intervention of mysterious and wonderful forces, pure automatism as a revelation of that store of hidden reality within the individual over which consciousness has no control—these were the techniques that opened the way to a more comprehensive view of the relationship between the Self and the world."

Dada made chance itself an expressive element in art. In addition to the insistence on the autonomy of the self, the two things Dada "regarded with uncompromising seriousness" were spontaneous impulses and chance as an "expression of pure reality." Spontaneous creation was unalloyed by any consciousness; undefiled: pure.

But before Dada, chance was not such a positive thing. For example, the Renaissance artist and critic Giorgio Vasari said of Tintoretto, disparagingly: "His

pencil strokes show more force than judgment and seem to have been made by chance." Gombrich says, "It is a reproach which from that time onwards has often been made against modern artists."

BEFORE WE CONCLUDE THAT planning is simply the old-fashioned way and that any self-respecting cool modern artist works spontaneously, inventing as they go, let's look more carefully at Jeff Koons and Damien Hirst. They bring a new wrinkle to the discussion of planning versus spontaneous creation.

Hirst and Koons—and many artists in a financial position to have multiple assistants—plan their work and then pass it on to assistants to execute. Delegating work to assistants by definition separates the creative process from execution, requiring what can only be described as planning.

They rely on the conceptual art conceit of the *idea* being the crucial part of a painting. Sarah Thornton says "artists have become 'ideas people' liberated from manual labor." This division of labor brings up interesting ambiguity around authorship.

Koons plans his paintings on the computer, and his assistants execute them. From an old-fashioned point of view, these are not Koons' paintings. (We won't even

touch the hornet's nest of the definition of "painting" and how the digital age has changed the work.)

There is new terminology involved in this kind of painting, which skirts the issue of authorship and the traditional act of "painting." The artist now makes a "gesture"; the talk is of responsibility and control. Koons' dealer, Gagosian, reassures us that although Koons doesn't make the work himself, he's still very much in control: "You cannot control anything more than Jeff does—from the idea to the computer through the assistants to the fabricator."

Takashi Murakami is even more known for his complete delegation of execution. He has two thriving studios full of assistants, one in Tokyo and one in Brooklyn. He plans his pieces and then sends the studio digital sketches—"which may make Mr. Murakami the first major artist to paint by email."

Murakami's art consists of an "obsessive technique, which involves layer on layer of acrylics applied to create a flawless, seamless surface." (I wonder if my teachers would tell *him* to just go over it!) Creating this requires not only exquisite technique but "endless sedentary hours." Murakami, being the new kind of artist for whom the title includes so much more than just making the art, does not do this part of it: he is "simply too busy."

I WAS NOT HAVING a good time in my art classes. Neither my teachers nor my peers understood why I had a hard time painting spontaneously; even less did they understand why I would want to plan a painting. I tried to talk to my teachers about it, and they couldn't even understand my question. We are teaching you the best way to paint; why are you so worried about what you'll produce? Relax, let go; don't you know you can always go over it?

Suddenly painting was making me miserable, for I was surrounded by incomprehension—in class, in books, in the whole society which evangelized spontaneity. And I wasn't miserable because they didn't understand; I was miserable because their incomprehension came with palpable judgment.

Incomprehension is the textbook way that a group demonstrates their lack of acceptance of a difficult member. Such incomprehension is not neutral. They weren't communicating a simple lack of understanding but an actively negative response to the way I worked— and because my way of working felt natural to me (as well as apparently being unique to me), the response served as actively negative towards *me*.

Similarly, our conviction of the benefits of sponta- neity has mutated from being simply pro-spontaneity to *anti-planning*. Why does our focus on spontaneity, more than other things we've decided are crucial to artmaking,

make this leap to the actively antagonistic? Multiple things sowed the seeds for it.

It is a remnant of the historical dislike of the academy from the 1800s. Resistance to traditional teaching methods transferred into resistance to traditional technique and working methods—in other words, planning. The cool of the anti-academic rebel has a direct connection to spontaneity... and that's a force that cannot be outdone.

Furthering the cause of anti-planning, the combined effect of Dada and Freud in the early 1900s led to a disdain for, or at least mistrust of, conscious thinking, that we have not gotten over. Freud advocated the benefits of bypassing our waking minds to let the child and savage in us take over. Dadaists spoke passionately of "mysterious and wonderful forces," the "revelation of that store of hidden reality within the individual over which consciousness has no control." This makes people think that if you allow in consciousness, you cancel out these wonderful forces. People equate planning with consciousness, and like to say that self-consciousness is the death of art. This is why planned and careful work is rejected as *not art*.

But even more powerfully, the distaste for planning is deepened by the extrovert ideal. Spontaneous painting has a lot in common with extroversion, and planned painting with introversion. Spontaneity requires the

quick decisions, ebullience (like using a big brush), and fearlessness about making mistakes that are typical of the extrovert; planned painting allows for the slow, deliberate, careful concentration of introverts.

Our society loses so much by not equally supporting introversion. Creativity is *provably* enhanced by introversion. Solitude can be a catalyst to creativity, and introverts prefer to work independently. However much we think our society encourages creativity, it actually teaches the exact opposite. We insist that creativity "come from a gregarious place"; that art, like everything else in our lives, is a social act.

OBVIOUSLY THERE IS NO harm in an individual expressing themselves, and I'm the first to say that making art is the best possible way to get out your feelings and figure yourself out. There is, however, harm in the art world's valuing self-expression over all else. Self-expression itself is an outward-turned phenomenon; introverts do not feel such an imperative to put what is going on in their heads out into the world for others to see.

Self-expression and spontaneity are the culmination of our prioritizing ourselves. But they are actually in service of an even bigger goal of the art world: originality. I had learned about that many years before.

6

THE SUMMER AFTER COLLEGE, trying to figure out
what to do with my life, I thought briefly that I
should become an architect. I have an uncle who is a
successful architect, and I always enjoyed drawing build-
ings—when I was trying to sound cool I called it "urban
sketching"—so I thought, why not? That could be me.

I signed up for a six-week summer program at the
architecture school of, let's just say, a highly respected
educational institution in Boston. We were given hypo-
thetical sites and asked to design buildings for them. We
made drawings of the floor plan, site plan, elevation and
cross-section, and built 3D models of our buildings. I
had a great time, living in the dorms with a pile of new
friends, making field trips to the art supply store for more
and more of the creamy vellum that was so delicious
to run a 2B pencil over, staying late in the studio to hot
glue my model as the sun went down outside the glass
walls of the architecture school. It was creative, hands-on,
satisfying work.

I designed buildings in the style that I found beautiful: symmetrical, simple, solid; classic.

"But that looks like every building in Washington D.C.," one teacher said contemptuously. "It looks like... like... *Monticello*."

"Be a bit more imaginative," said another. "Have fun with it! See what Sara has done over here? The scalloped roofline, the pilasters made to look like feathers, the pavilion lined in colorful rubber tiles. That's *fun*. Let yourself go; make something no one has ever seen before."

Why did they want me to make things no one had seen before? I didn't understand, and nobody explained. I thought such wacky features were silly, insubstantial, distracting. I thought it was just a matter of taste. I came to discover that there was much more behind it; an art history's worth of reasons.

There were two problems. One was that what I wanted to do in this program was not the same as what the program wanted to do for me. I wanted to draw classical, symmetrical, beautiful buildings and learn something about the history of architecture along the way. The program, however, was designed to teach you what is necessary to become an employable architect. And those two things, it turns out, are not the same.

Learning to become an architect did not include gently surrounding your dilettante self with soul-nurturing

symmetry. Instead it meant dreaming up the craziest building you could imagine that would still (hopefully) stand up. Those of us who would do well, who would actually become architects, were the ones who produced buildings that looked like nothing anyone had ever seen before. Those of us who wanted to be all classical could go off and sketch Monticello and never come back.

I went in hoping for an idealized atelier experience: to learn by copying, emulating, paying homage to and appreciating the past. Instead it was more like a brainstorming session at a dot-com in the nineties: the more radical ideas you could spit out, the more genius people thought you were.

The other problem, I eventually realized, was that I was failing at Art Tenet #1: if nothing else, be original.

ORIGINALITY SEEMS TO ENJOY the highest priority of almost all requirements in art. Our belief in the primacy of originality is everywhere. The purposely bewildering nature of conceptual art is nothing but in-your-face originality. Contemporary art is, almost literally, nothing but originality. You can do anything you want, the exhibits seem to say, as long as it is indisputably original; and if you can make it a little shocking, that doesn't hurt. Uninteresting (or unidentifiable) content, iffy technique:

a thousand sins are forgiven if the conclusion can be "Well, it's original."

In thinking about self-expression I had come to see how real-world pressures change the content of art indirectly; in originality, those pressures influence art directly. Now, the need for original content has become not only a prerequisite of art but a tenet of artmaking.

Originality is a central focus of art education because, as we saw in the last chapter, the new job of teachers is to teach you how to meet the demands of the market; and the market demands originality above all else.

What's interesting, however, is how unspoken this tenet is. None of my architecture teachers ever said explicitly, *That is not sufficiently original.* They just praised the crazy stuff like crazy and ignored me, making me see that I wasn't cut out for this but not really understanding why. Nor did they explain to us why we *should* make buildings funky. Nobody ever said that these days, you must be manifestly original to serve current market demands. It seems that originality is so presupposed that people are no longer conscious of it.

Artists are expected to make what will sell; that seems almost too obvious to say. But examining this closely reveals two interesting things. One, that originality is a relatively new idea—which weakens the power of the assumption that it is an intrinsic part of good art. Two,

the irony that by doing something radical that no one has ever done before, you are simultaneously doing what you are told.

WHY ORIGINALITY? BECAUSE OF market demand. Why the market demand for originality? Because of our preference, bigger than any matter of style, for the New. We are attracted to originality because we are attracted to the New.

Wait, you say, what's the difference? The answer goes back to the distinction between the artist and the product. The New has nothing to do with the person; it is an art world phenomenon, a social goal for art. Originality is an approach the individual artist takes to satisfy that social goal. It is in this way that the market tells you what to make, in exactly the same way as your teachers do.

So what is our fascination with the New? We could hypothesize that it has a foundation in human evolution: sure, we are primed to be interested in the novel. But specifically as viewers and consumers of art, why would we be attracted to the New?

The simplest answer has to do with successful marketing of rapid change. The framing of art as a constantly changing body of work gives it the same character as fashion and commodity: something you need to get

before it disappears. (Takashi Murakami's genius lies in recognizing this connection and capitalizing on it: he sells his art as part of literal commodities such as handbags.)

But Tom Wolfe, in his hilarious classic *The Painted Word*, proposes a more complex answer: the sociological motivations underlying our pursuit of the New.

We are aware that we get more conventional and conservative as we age. If we could somehow avoid that trap and stay just as radical and carefree as we were when we were young, why, it would be the fountain of youth. This leads some of us to look for ways to pretend (to ourselves and others) that we actually still *like* the unconventional, the radical. And one of these ways—says Wolfe—lies in the art that we say we like. To say you like counterculture and in-your-face Original Art is to demonstrate your youthfulness.

Art collectors reap further benefits from being bene-factors of the arts. Wolfe says that spending your money on art is a "kind of salvation from the sin of Too Much Money. ... That is why collecting contemporary art, the leading edge, the latest thing, warm and wet from the Loft, appeals specifically to those who feel most uneasy about their own wealth." And it is still true that hanging out with artists gives the collector the "peculiarly modern reward" of feeling like he is in the vanguard too. Asso-ciation with them gives him undeniable cool.

Art critics, says Wolfe, have an extra layer of motivation to support the New. "To be against what is new is not to be modern. Not to be modern is to write yourself out of the scene. Not to be in the scene is to be nowhere."

Why the Critics Will Never Criticize

Critics famously prefer to avoid making a judgment on art until enough time passes that they have a chance to see in which direction public opinion goes. They claim that this gives the distance necessary to be able to talk about the art intelligently, and I'm sure this is true. However the deeper reason is an embarrassing story from history.

When the Impressionists started their radically new style in the 1870s, the critics of the day made the mistake of ridiculing it. A passage from a newspaper of 1876 covering one of the first Impressionist exhibitions reads:

"An exhibition has just been opened ... which allegedly contains paintings. I enter and my eyes behold something terrible. ... These would-be artists call themselves revolutionaries. They take a piece of canvas, colour and brush, daub a few

patches of paint on it at random, and sign the whole thing with their name. It is a delusion of the same kind as if the inmates of Bedlam picked up stones from the wayside and imagined they had found diamonds."

They were, of course, proven wildly wrong. Gombrich says, "Criticism suffered a loss of prestige from which it never recovered. The struggle of the Impressionists became the treasured legend of all innovators in art, who could always point to this conspicuous failure of the public to recognize novel methods."

And that is why critics will never again state an opinion before they are sure they won't be made to look ridiculous.

Art critics are frequently real players in the destiny of art (both singular objects and art as a field). Gombrich says that now that things change so rapidly, critics can be only "chroniclers of events" and that they cannot risk the stigma of conservatism (for a serious offense that would be). To avoid this, they must preventatively admire anything that looks abstruse. The harder a piece of art is to understand—or like—the better it must be.

And artists themselves have to play the originality game if they want to succeed. Wolfe parodies the extremity of the situation, saying of a hypothetical artist: "He had to keep one eye peeled for the new edge on the blade of the wedge of the head on the latest pick thrust of the newest exploratory probe of this fall's avant-garde Breakthrough of the Century…"

It is clear that artists must produce original work if they want to be successful; creating the New has external benefits. But this does not mean that originality has any inward benefits for the artist, nor any significance to art itself. In fact, as I kept finding, artistic objectives over history had been the precise opposite.

My father the art historian was a very big fish in a very small pond. His specialty was Byzantine art, with a further specialization in ivory religious objects. (As part of the war against the ivory trade, he was often called upon to determine whether something was made of ivory or bone.) He traveled the world to examine and photograph these objects, going from churches in tiny Italian villages to the great museums of Turkey and Greece. When I was a teenager, my father took me with him on research trips around France, Germany, Italy, and Switzerland. He showed me the churches and the art—not

as an art history lesson per se, but just as exposure to the great things of the world. There was a sense of awe that he didn't need to explain: this was great art. And in the great art of the world—or anywhere in the art history I was learning—there was no notion of originality.

For most of history, artists were going for the opposite of originality. While they were learning, the goal was to copy and emulate the master; they were trying to squelch as much of their own imprint as possible. In the days of the academy, painters also had strong motivation *not* to be original: selections for inclusion in the Salon exhibitions had to be traditional; anything radical or new had no chance.

In the art market, there was always strong motivation to make art that looked familiar: the public wanted art that was reassuringly similar to what they thought of as art. Even within their own oeuvre, artists were rewarded for being predictable: buyers wanted, and expected, more of the kind of art the artist had made their name making. "A Picasso" was supposed to be a painting that looked like the Picasso already on your wall; the point was what kind of painting would fulfill the prerequisites the buyer had in mind, *not* what Mr. Picasso felt an urge to make. (Picasso, of course, famously changed styles radically and regularly; this frustrated buyers who wanted him to have

what we now call a signature style. Luckily, he withstood the pressure and made exactly what he wanted.)

Today the required style may be the exact opposite of the past, but the limitations on what is acceptable are as strong as ever.

How DID WE GET to this insistence on such a specific concept as originality? Where did the idea come from?

The fundamental origin of originality—the enabler, without which it would not exist—is the recognition of the individual. When art was not thought of as something made by an individual, there was no possibility of it being "original" work. Originality as a concept was impossible.

But neither did the recognition of the individual instantly *cause* originality; even after individual artists started to make their mark, the goal, for a very long time, was still predictability. How, then, did we shift from that longstanding tradition to the opposite? It started with one period that changed everything: Romanticism. Hauser calls Romanticism "the most profound artistic upheaval the modern West has undergone."

Romanticism itself was a reaction to the Enlighten-ment, a time of Reason and Rationality, intended to counteract all the darker times that had come before; a time when people challenged faith, the monarchy, and

other unprovable fixtures that had been absolutes for centuries.

Romanticism—at its peak between 1800 and 1850—was a reaction against all this rationality, a protestation that reason cannot explain everything. People turned to intuition, to nature, to emotion over rationality. Emotion began to be seen as a source of aesthetic experience. Artists prioritized their emotions and feelings as a source of not only inspiration but content. Painters started going for emotional impact.

And emotional impact could not, they felt, be made while following the academic rules that dictated what a work should consist of. Not only academic rules but also the influence of other works was considered to interfere with the artist's own imagination; thus for true art to be made, originality was essential.

So the idea of originality became solidly established in the Romantic era... two hundred years ago. Why did it not fade away or change, like styles, like everything else in art?

It is because there was no reaction against it, no anti- or post-originality. All the art movements that came after only supported and strengthened the same priorities.

The first and biggest phenomenon that reinforced the idea of originality was Bohemianism, which made itself felt after the French Revolution. It started as a

sociopolitical matter—the bohemians fighting to get out from under the stodgy thumb of the bourgeoisie—but the result was fundamental change in artists' lives and in the art they made. How does a social issue lead to a desire for originality? It's not that it creates a desire for it, but rather that scandalous originality is the perfect way to express your difference, your radicalness. How better could art express angry political feelings than by being shocking and throwing expectations back in the faces of those holding you down?

The Boho Dance

Before the French Revolution, the artist was the Gentleman (not yet the Genius) who got work by courting wealthy bourgeois patrons at salons. The Revolution, however, made artists feel the need to demonstrate that they were separate from the snooty bourgeoisie; to do so, they had to noisily declare their poverty and other deprivations. The classic image of the bohemian painter is the one starving in an attic in Paris. It was so "cool" that artists cultivated that image even if they were not actually starving (nor living in an attic, in Paris or elsewhere).

This idea persists, of course, today. It is an ironic image to cling to, however, if you think back to the hard-won status that Leonardo helped us achieve. As Hauser says, "The artist's prestige has described a remarkable circle to get back to this zero point."

Artists wanted to subvert the "cozy bourgeois vision of reality." But the problem was that they couldn't completely ditch the bourgeoisie: they had to romance them, because in their deep pockets is where success waited.

This is what Wolfe calls the Boho dance, or, more snarkily, the "art mating ritual" between Bohemian artist and bourgeois patron. In their words and their art as well as their political values, the artist had to be determinedly revolutionary, anti-bourgeois; but success lay only in being chosen by that very bourgeoisie. "No matter how many times he closed his eyes and tried to pretend otherwise ... success was *real* only when it was success within *le monde*." (Wolfe calls such success—being chosen by the bourgeoisie—the Consummation.)

In what Wolfe calls "psychological double-tracking," the artist had to be "a sincere and committed performer in both roles. He

could close his eyes and try to believe that all that mattered was that he knew his work was great ... and that other artists respected it ... But deep down he knew he was lying to himself." He had to sincerely dedicate himself to anti-bourgeois values, but at the same time "keep one eye cocked to see if anyone in *le monde* was watching. *Have they noticed me yet?*"

LIKE A CHILD TESTING its boundaries, art experimented with greater and greater originality until it hit a point at which everybody knew it had gone too far. This happened in the late 1900s with the rather mind-blowing "de-definition of art."

This was a hypothetical "post-art" state of affairs in which a physical piece of art was seen as an unnecessary object. Instead of making artworks, artists dealt in *essences*: movement rather than dance, sound rather than music, space rather than painting. Meanwhile the artist himself was bigger and better than any tangible product: he had "passed beyond art and become an artist in a pure state"—with the convenient result that every single thing he did was, by definition, a work of art. (Andy Warhol affirmed this when he was asked why one

of his outlandish films should be considered art, and he answered, "Well, first of all, it was made by an artist, and, second, that would come out as art.")

Conceptual art similarly wanted to erase the physical artwork. This was the *idea* itself standing in for the art; it was what they called "liberation from the object," or the deconstruction of painting from an object into a concept.

As Wolfe explains, artists removed one thing after another from art. They dispensed first with realism, then with representational objects: the painting itself became an independent object. They eliminated the third dimension, then any visible brushstrokes, and eventually paint itself. They got rid of frames, then of the predictable rectangularity of a painting by making shaped canvases. They abolished (what Wolfe called) the "sweet bourgeois idea of hanging up pictures" by painting directly on the wall; then they obviated the wall by making standalone installations. They circumvented the museum by doing Earth Art; and finally killed the idea that art needed to be a visible object at all. They wanted art to not have to include a visual experience. A paragraph was a work of art; art theory was a work of art.

Conceptual art came in two flavors: things you could see, but not for long (for which the accompanying text is called the *documentation* because it's fleeting), and things you couldn't see at all.

You probably won't be surprised to hear that I hated conceptual art. All that self-consciously shocking people, all that rolling around in the meta question of "What is art?" It seems the epitome of making art *only* with other people in mind.

I never liked it, was always just irritated by it, but never thought about why. Then I read a monograph on the subject by Ursula Meyer (called—wait for it—*Conceptual Art*), and I had an epiphany. Ms. Meyer explained to me that what I felt about that art was *exactly what I was supposed to feel...* and suddenly I no longer hated it.

Conceptual art plays on the importance of context and the definition of the word *art*. As one artist explained, "The art consists of my action of placing this activity in an art context." The fatal misunderstanding is that when traditionalists call something *art*, they mean it is great, or beautiful; while the conceptual artists mean it more literally: this is an artistic act/gesture/idea. If I call a toilet art, it is art because I am putting it in that context; I am not claiming that it is beautiful, or even interesting—and if you accuse me of deceiving you because you feel misled because you don't find this toilet beautiful or interesting, you have no one but your own narrowminded self to blame for your own cliché expectations.

If you see an object hung in an art gallery, you generally assume the intention is as art. But when there is

no indication of any underlying concept—which is to say, when you can't see why this random thing should be art—it leaves you confused, frustrated, and irritated at the lack of fulfillment of what you expect. Which is the point of this art, and the artist's goal and intention. Conceptual art is an *act*, a testing of the boundaries, *only*; not anything to do with a piece that you study or enjoy, except to ponder it as an uncomfortable poke at the definition of art and at your reaction to it.

Conceptual art and traditional art are like apples and oranges. I realized that I had been trying to see an apple the way I look at an orange, and was irritated because it didn't work; I had been annoyed because my apple tasted like an orange.

Acknowledging the difference between apples and oranges changes everything.

Now that we have moved on (mostly) from these extreme experiments, why do we *still* believe in originality so powerfully? (It seems ironic that an insistence on things being endlessly new has stuck around for so long.) It is because, still, nothing in the modern world, economy, or social structure has challenged it. Just like successful art movements, everything feeds into and supports it.

Not only that but—just like pro-spontaneity becoming anti-planning—the art world doesn't just defend originality but is actively hostile to the traditional. Hauser explains that originality is "not so much the assertion of what is new and spontaneous as *the negation of* what is old and conventional." He says, "It means not only that everything in the present must give way to something in the future but also that what prevails *is inferior to* what is coming."

This has entirely changed how and why art history is taught in art school. First of all, a modern art education need not include much art history. When it *is* taught, it is not so it can be emulated, but so that any repetition can be avoided. Adler says that one of the occupational skills a teacher must now impart to the student is "academic familiarity with 'everything that has been done.' The history of art must be known by the art student in the way a mine field must be known by a soldier who has to pick out a safe path for himself."

New Art History

The study of art history itself has been powerfully affected by the need to be anti-traditional: this takes the form of what they call "New Art

History." It is an attempt to show art history in a modern, newly aware way, paying particular attention to social aspects; in this way it bears some similarity to anthropology. It also takes inspiration from sociology—although it prides itself on *not* being an enhancement of art history in the way we have seen that sociology is, but being, rather, *anti*-art history.

New art historians want to be revolutionary: they call Gombrich "tradition personified." (And you know that's not a compliment.)

I can't possibly explain it any better than the new art historians themselves. Rees and Borzello's *The New Art History* describes it, quite intimidatingly, as *"A capacious... title that sums up the impact of feminist, marxist, structuralist, psychoanalytic, and socio-political ideas on a discipline notorious for its conservative taste in art and its orthodoxy in research."*

Further,

"Fuelled by strong social and political beliefs which they wave like banners above their heads, the new art historians are led by a self-consciousness about their own points of

view to question the claims of earlier historians to produce objective scholarship. ...

"In discrediting the old art history, words like connoisseurship, quality, style and genius have become taboo, utterable by the new art historians only with scorn or mirth. ... The presence of the new art history is signalled by a different set of words—ideology, patriarchy, class, methodology, and other terms which betray their origins in the social sciences. Behind them lies a new way of thinking, one which sees art as intimately linked to the society which produces and consumes it, rather than something mysterious which happens as a result of the artist's genius."

Make of that what you will.

To an artist pressured to always produce something new, the traditional becomes something to be avoided at all costs. And something to be avoided at all costs easily starts to feel like a bad thing. As Hauser says, the artist feels "burdened and hindered by every form of tradition. ... Anyone who wanted to preserve his self-respect had to avoid anything which had existed previously."

This is why, back at the architecture program, the teachers reacted so strongly to my Monticello: this was insupportable.

So originality has become a popular core of art— what's wrong with that?

Our focus on originality gives a great big middle finger to history. In saying that originality is so important, we are discounting not only centuries of art but the method of learning from the masters that was practiced for centuries—which I searched for in vain as I was becoming a faux painter.

Writer Michael Lind says unreservedly that originality is killing art. "Originality has killed one once-flourishing art form after another, by replacing variation within shared artistic conventions with rebellion against convention itself." As he says, plenty of artists have had their own distinctive styles, but always within convention. Now we kill conventions for the sake of killing them.

It is the high value we place on originality that is the true problem; our decision to insist upon it as a necessity of art. We focus so much on being original that other aspects of art fade away. Originality itself has become the point of art, the challenge that artists are working to meet. In order to succeed, artists now must solve the problem of how to be original. Gombrich wrote, "Their solutions of the problem are sometimes of a wit and

brilliance not to be despised, but in the long run this is hardly a task worth pursuing."

Ironically, originality is itself a convention. Hauser calls it "the most crippling of all conventions: the pursuit of originality at any price." If you think you are a genius of originality, you are not: you are actually working within a new tradition that itself has rigid conventions. This is good to remember: we are not freed by the idea that we can make whatever we like; rather, we are hampered by the strict rule that we be original. Robert Rauschenberg said, "Having to be different is the same trap as having to be the same."

Originality is an artistic mirage. "Originality" is dressed up as artistic freedom, but in fact, in the insistence on originality, society is requiring the artist to fulfill its preferences in the product. Originality is a demand that the artist fulfill a social goal instead of her own.

Our insistence on originality is part of the current outward focus of artmaking. With it, we are saying that the important part of art is what other people have done and what other people want from our art. The focus is on *other people,* not yourself, your ideas, or your creative needs.

It is understandable for there to be fashions in what the buying public likes, and for there to be pressure for artists to fulfill them. But because originality is so

intimately connected to the artist's process, this means there is now a fashion in how artists should *work*. It is in this way that society has begun influencing artists beyond the usual external ways, and bulldozed its way inside, into our process, into our thinking about art.

7

I'M EMBARRASSED TO SAY that even if I had done well in the architecture school, I probably still wouldn't have become an architect.

My uncle is an architect, and also a remarkable artist. When I was a child, we went to visit him in Sweden every summer, and at the end of a day we all spent at the beach, he would come home with gifts of art: seashells for me painted ingeniously to look like little animals; a boat for my brother intricately carved from driftwood; a detailed ink-and-wash painting of the coastline for my mother.

But his professional art—his architectural drawings—impressed me in a different way.

Architectural drawing is beautiful: like faux painting, it requires both creativity and precision. I saw the plans my uncle had drawn (which, not trivially, became some of the most admired public spaces in Stockholm) and thought, that could be me. But when I briefly considered architecture as a career choice, I found that I couldn't bring myself to talk to him about it.

It was partly that I was too shy to say to this professional that I was also serious about his subject. (I, who he had seen as a squalling baby; I, who had already professed seriousness about multiple fields and succeeded at none of them.) But my emotional shortcomings went further than simple shyness, or (as I thought) just wanting my own territory. I was back in my dysfunctional internal storm over identity.

If I had announced my intention to join him in his field of expertise, while obviously being entirely inexperienced, I felt it could only have been seen as a cute idea. And if my ambition for my career had gotten the same reaction as a child's painting, or a girl who announces she's going to be a veterinarian when she grows up, I wouldn't have survived the mortification.

The author Michael Cunningham gives the perfect example of what I mean. In his novel *The Hours* (based delicately on Virginia Woolf's *Mrs. Dalloway*), three women are all trying to make the best of their domestic lives while wanting much more, knowing they are capable of much more. When one of them decorates a cake, her catty neighbor-housewife shatters her by describing it as *cute*. She realizes her attempt was "sweet and touching in its heartfelt, agonizingly sincere discrepancy between ambition and facility." This is exactly what I was terrified of (with my uncle! my gentle, compassionate uncle!): I

couldn't have stood any kindly coddling of my "ambi-
tion" while both of us knew that there was this glaring
discrepancy.

Because for some reason my brain did not allow
for the stage of being a beginner. For some reason, the
thought of doing something without being good at
it was humiliating, to the point that I couldn't do it.
I wanted whatever I did to be something that showed
me to be successful and smart; something that I could
proudly assert I was good at. Because of this, I never
wanted to look like a learner; before anybody saw me
doing anything, I had to be an expert. And to avoid ever
looking like a learner, I couldn't choose a field in which
I knew someone who was already in it: they would see
that I didn't know what I was doing, and I couldn't stand
that thought.

The woman in *The Hours* isn't so bold as to actually
have ambitions, but she knows she is "full of vision, full
of rage." She tries to feel pleasure and success in being a
good housewife; tries to not feel like a failure because she
has not achieved more. "It isn't failure, she tells herself.
It isn't failure to be in these rooms, in your skin, cutting
the stems of flowers." This is how I felt when people
would tell me that being a dilettante is so great. Their
well-meaning assurance did not even acknowledge the
possibility that I could be more than that.

And to me, being anything less than professional was not enough, because I knew I *could* be at the top. And because I knew I could be, I felt that I *should* be—in a complicated sense of both responsibility and deserving.

Like the women in *The Hours*—like so many of us—I wanted to *be more* than I had ever made of myself.

If I had told my uncle that I wanted to be an architect, he would have encouraged me. And there's nothing I hated more than being encouraged. I couldn't get away from the fear that it would never be honest. I assumed it to be condescending, and it made me feel like a child. I didn't want encouragement, I wanted respect.

Another woman in *The Hours* says wistfully, "I am trivial, endlessly trivial." This is precisely what I worried about when I say I was looking for respect. I was looking to not be seen as trivial, but almost more importantly, to not *feel* trivial; to feel important.

That is what my mother did for me. And the way she accomplished it was by *not* encouraging me. Encouragement is *telling* someone that they can do something (whether it's honest, a lie, or as in many cases, simply unfounded); instead she *showed* me that my work was important.

The best example of this occurred when I was about twelve years old, and still convinced I was going to be a writer. My family was on vacation; it was a sunny

morning and we were all about to go out and explore the town, when suddenly a story leapt into my head. Sometimes, with certain kinds of inspiration, you know that it's a matter of catching it: you have to sit down and get it out immediately or it will disappear. This is what I felt. And my mother, seeing that glint of creativity (probably verging on panic) in my eyes, made the whole family wait while I wrote, and wrote, and wrote. Nobody went anywhere until I was done. What she showed me that day was not only that *art* was important, but that *my work* was important. I have never, ever forgotten that day.

BUT EVEN OUTSIDE OF my own personal weirdness, encouragement is a phenomenon in the art world that we need to be careful with.

Art education has become one big behemoth of encouragement. It is a natural consequence of the need to never discourage, the pointed lack of judgment, and the ultra-personal nature of art that I've been talking about. The focus on self-expression leads to the encouragement that *everyone can do it* and that, in fact, everyone *should*.

The assurance that *everybody can do it* echoes the general tone of our culture these days, the democratic reassurance that you can do and be anything you want. We want desperately to believe that we "ordinary people"

can be artists too; and there are plenty of people who want to help us believe it.

Art and writing are both artforms that are easily accessible to amateurs (in that you can just sit down and begin), and those who would profit want you to equate ease of access with ease of success. They try hard to erase the mystique around the work, and assure us that there is nothing special required to do it. (This is even bigger business in writing than in art; apparently more people think they can write than think they can paint.)

And the easier the better: I recently got an ad for a "self-publishing success summit" that promised, "You'll learn how to easily and effortlessly write your first book *fast*... even if you're an awful writer."

This exposes the paradox at the heart of this endeavor. When people look for art to be demystified and made easy, we don't really know what we are asking for. We want it to be *both* an amazing, mystical thing *and* for it to be possible for us to make it too. If it was not amazing and mystical, we wouldn't admire it and crave the ability for ourselves. John Gedo explains this as an inconsistency in our minds: we want to say that everyone is creative, yet we also idealize and rarify creative genius. I'm afraid we just can't have it both ways.

Everyone can do it leads very smoothly to the next claim: that *everybody is an artist*. Already, and in

everything we do. Like Andy Warhol, we want to believe what the old aesthetics philosopher R.G. Collingwood said: "Every utterance and every gesture that each one of us makes is a work of art."

Our desire to believe this is reflected in the record-breaking popularity of Elizabeth Gilbert's *Big Magic,* a veritable bible of encouragement to be creative. Gilbert magnanimously tells the anxious (but predisposed) reader that "if you're alive, you're a creative person."

Even outside the self-help books, the paint bars and craft stores, our culture fosters this belief in places we wouldn't think to find it. Our current business model enables the idea that everyone can be an artist: there are many fewer middlemen, such as publishers or record stores, getting in the way between you and your immediate self-made success as a writer or a singer. Reality TV shows ordinary people becoming famous for nothing, and makes you think that you too could be a star. This feeling transfers easily into art, reinforced by our ideas of spontaneity and genius. The message is that one day you might sit down and suddenly, unsuspectingly, produce a Picasso. Even you didn't know you had it in you.

Our online lives hold many opportunities for easy accomplishments in creativity. Posting your writing or art takes a single click; even "curation" of other people's

images is considered a kind of creative act. Soon we will call anybody who works to make their Instagram profile aesthetically pleasing an artist.

Which brings us back to the significance of our definition of the label "artist," and the important role language plays in art.

This assurance that *everyone is an artist* relies on the wordplay of the literal versus the implied meaning of the phrase. That's what is so usefully deceptive about the statement: it sounds like *anybody can be a great artist,* while all that is literally true is that *anybody can use a paintbrush.* It hangs on our interpretation of the word *artist,* and in turn, *art.*

In an online debate about what qualifies as art, an anonymous but clever person wrote, "The interchangeable use of the word *art* with doing something excellently is a cultural virus. Cooking is not art, hair-styling is not art, being creative is not art, producing media by-products due to sickness, brain-damage, trauma, dementia, therapy, social engineering, political conviction, and so on have nothing to do with Fine Art. These things are Art like praying is medicinal."

Even Mihaly Czikszentmihalyi, the guru of flow, distinguishes from creativity activities that he calls "creativity with a small *c*": "great ideas for clinching business deals, new ways for baking stuffed artichokes, or original ways

of decorating the living room for a party." This kind of thing is, he allows, "an important ingredient of everyday life, one that we definitely should try to enhance"—but nonetheless a different animal from what we are talking about when we talk about artistic creativity. (Virginia Woolf and I would agree. This is why it is not creatively fulfilling to be a housewife.)

A little while ago I talked about the problem with not distinguishing between categories of artists, and how when we do that, amateurs and professionals both lose. This is what happens with the assurance that Everyone Is An Artist. However you feel about encouragement, this statement devalues the meaning of the language, to the detriment of both sides. Professional artists lose value by being lumped in with everyone, and aspiring artists are misled by being pandered to. The vague language encourages amateurs to think they can easily be/do the same as professionals, and that is not true. It blends professional and amateur art as if they are the same, while they are distinctly not the same. One is not better or worse than the other, but they are different animals, and—as I found at the faux convention—the two worlds do not mix.

And it is, of course, just not true that everyone is an artist. The encouragers defend this claim to the end, saying that somewhere deep down, everybody is

creative—but that is also untrue. Most of the members of my beloved family-in-law don't write, don't paint, don't want anything to do with the creative world, and they are perfectly intelligent, fulfilled human beings.

But worst of all is that our loose definitions of "art" and "artist" allow it to be uncomfortably *true* that everyone is an artist. If art is nothing but self-expression, if picking up a brush makes you an artist, then of course anybody *can* do it, and, ipso facto, our wishes are granted.

THE LAST STOP ON the encouragement train is the notion that everyone *should* make art.

We have progressed from 1) art can be made by an individual, through 2) art can reflect what you feel, and now to 3) you should make art in order to express your feelings: it's good for you.

Creativity is the new low-carb diet, the ten pushups every morning, one of the habits of highly effective people. It is marketed as a model for self-fulfillment. "Unlocking your creativity" has become the latest mantra of personal growth and career success.

Creativity is being linked to mindfulness. Think of the explosion of Zentangle and adult coloring books; even the Mayo Clinic recommends the benefits of painting

and ceramics. Making art is, in other words, good for your health.

Adult education and DIY are booming in this atmosphere. We talked earlier about the economic reasons for their success; here we can see them as the embodiment of the creativity movement.

Paint bars and craft centers bring in any stragglers, generally non-creative people to whom making something is foreign. Those of us who make things regularly can forget that many people don't; creativity is not part of many people's lives. Which makes all the businesses drool over the thought of all these as-yet-unconverted people.

And creativity has spread beyond the art world, to a much larger audience. There are nearly as many books on using creativity in business as in artistic pursuits. "Creative problem solving" is the watchword of the business world. An article in *Forbes* says, "Creativity ... is no longer just something those 'art people' do. ... Harnessing your own creativity can be the difference-maker for you and your company." Creativity also blurs into the hot topic of innovation, in books such as Tina Seelig's *inGenius* and *Insight Out*.

Widening the market even further to the growing population of seniors, creativity is supposed to be good for your memory and other problems associated with

getting old. Julia Cameron, author of the bestseller *The Artist's Way,* has come out with a new book called *It's Never Too Late to Begin Again: Discovering Creativity and Meaning at Midlife and Beyond.* (Talk about a gold mine of a niche.)

With these books, as well as *Big Magic,* the subject of creativity has literally moved into the self-help aisle. Art is now therapy. I'm a big believer in working through problems in paint or in words, but the therapeutic benefits of art should not obviate other reasons to make art.

So what's the problem? What's wrong with encouraging people to do something, with making people hopeful? Why am I being such a grinch about it?

The problem is that encouragement is actually harmful in several ways.

With indiscriminate encouragement, there is no way to know whether you actually have talent or not. I know it is impossible for everyone in my painting class to be great, so when the teacher (or Elizabeth Gilbert, or society) says that each of us is so good, I know that when they say it to *me,* it is meaningless. They are not actually evaluating; they are only encouraging.

The democratic statement that *everyone can be an artist* directly contradicts the popular dream that

everyone can be a star. One is a belief in equal distribution of talent, the other in the singularity of genius. They can't both be true, but we want it to be so, so we speak as if it is.

Such encouragement too often leads to a rude surprise and disappointment. The real art world has not actually changed: it does not welcome amateurs.

The truth is that not everyone can do this; but we say they can, with the result that if they fail, they believe they are failing from some weakness of their own. With the goading statement that everyone can do this, when something doesn't work out you can only doubt, question, or blame your own abilities and (thanks to our strong identification with our work) your *self*. It would be much more humane to say *This in fact takes a special talent, and you might or might not have it!* It would be less democratic, sure, less magnanimous, and we're not used to this kind of talk, but—it would be kinder in the long run to the individual; it would be better for society; it would certainly be better for art itself; and it happens to be true.

Lastly, encouragement can feel like a lot of pressure. One of the ideas that I find most threatening is the insistence that you must never give up. Liz Gilbert talks about how you have to "stay in the game" even when you are rejected; you mustn't quit just because it's

not working. She unknowingly detracts from her own argument when she tells a story of a man at a reading she attended who asks for advice from the author, and begs, "Please, sir, whatever you do, don't just tell me to persevere, because that's the only thing people ever tell me to do, and hearing that makes me feel worse."

This is exactly the kind of desperation that all this empty reassurance makes me feel.

Encouragement relies on a lot of linguistic sleight of hand. But as I discovered in my next art class, even more serious alchemy happens in another art world phenomenon: artspeak.

8

*T*HERE IS AN AMAZINGLY cool thing you can do with acrylic gel. Say you have a photograph you love that you wish you could put in a painting. There is a method called image transfer, in which you cover the photo with acrylic gel, let it dry, peel off the gel and there you have your photo on an acrylic "skin," which you can then "glue" into your painting and alter however you want.

I taught myself how to do this from a book, of course. But when I saw a workshop offered on image transfer, I jumped at it: I thought it would be good to learn how to do it officially, maybe learn a few advanced techniques.

As it turned out, I learned less in this class than I have in any class since first grade spelling. It was taught by a punky young woman who was at some undisclosed point in her art school career, majoring in photography and, apparently, B.S.

She regularly arrived half an hour late. (The vibe was that we were all just meeting up around 7 p.m. to hang out.) Her demonstrations regularly didn't work. (If it

had been me, I would have crawled under the table in mortification, but she was not fazed in the least.)

When she demonstrated the technique, it was the opposite of what I expected: she used the low-tech, outdated, homemade version of what I had learned from the book. It was a little like listening to a 1950s housewife telling you that she had discovered that you can use Vaseline to get gum off the cat's fur. We could buy the official clear acrylic gel medium, or we could use, for various parts of the task, CitraSolv, Purell, and Ben Gay.

I'm sure these would work, and I'm sure they're cheaper; but when I take an art class, I'm not looking for tips and tricks for products that I might "have around the house." I'm there to learn the right way to do it, the way that artists do it.

In the first class, she brought out a huge disgusting tube of Ben Gay and spread it messily, carelessly, over the back of a magazine image. It didn't work. "Oh, well," she said, "sometimes you have to spread it on the front." She did that; it didn't work. "Well, you can also spread it onto the paper itself, maybe that would work better." She seemed to be experimenting with it all for the first time in front of us.

The second class was on Polaroids. She wanted to show us a slideshow on the history of the Polaroid. We spent at least half the class cringing while she discovered

her laptop battery was low, then struggled to get a wi-fi connection, tried to project onto the wall, and so on and on.

All of this would have been fine if I wasn't already impatient and unimpressed. I was, after all, paying good money for this class, and if I was really the kind of person who would get excited because I could use Ben Gay at ninety-nine cents a tube instead of the product from the art store, I would have pointed out that the time I waited for her to get the slideshow going had cost me about thirty-five dollars.

The third class involved her lugging in and almost dropping an inkjet printer, some bent transparency film that you have to get at an old-timey camera shop, then a few hours of watching her unsuccessfully scrape wet paper off the back.

I was done. The frustration and vicarious embarrassment of sitting by and watching things not work got to be too much, and I decided I could stay home and use my time more productively.

But in hindsight, I realized that I had learned one very important thing: the priorities of the art world. The teacher may have been useless at the art, but she excelled at the artspeak.

Transferring images, she told us, changes the context of the image. Altering the image size fundamentally changes

the way the viewer views it. Mechanical reproduction of images "changes them as it publicizes them to the world." There was talk of signifier and sign. Our projects would reflect our own personal vision, our authentic expression, within our sociopolitical something-or-other.

Each class, after the failed demonstration of the day, she would take us up to the contemporary art gallery, and here she would blossom. Testing us on this part of our education, she would ask us what we thought "this piece is trying to say," and when we didn't know, she would tell us. This one "signified the absence of being"; that one "provocatively involved the viewer with the making process."

She showed me that the only indispensable qualification for being an artist, these days, is fluency in artspeak.

WHAT IS ARTSPEAK? Broadly—nonjudgmentally— *artspeak* simply means language about art. It often refers to language about *all* the arts, including dance, theater, and writing. But *artspeak* is also a judgmental term used to deride the language the art world uses about art, in the same way as we snicker at business jargon. One definition of artspeak is "a pejorative term [referring] to insular forms of language."

"Insular language" is, of course, the definition of jargon: specialized vocabulary that is used in a specific field. Just like *artspeak*, you can use the word *jargon* with this straightforward meaning, but it is more commonly used caustically—which is also the more interesting version.

The importance of jargon in art is its social value: it shows belonging. The purpose of an artist's statement is much less to actually describe the work than to prove that the artist knows the vocabulary of the trade. They are literally demonstrating that they know the password, and more than that, that they know the importance of using that language.

It serves the same purpose as the language used in job interviews. When you say that this job would "take my career to the next level," the phrase itself doesn't have much meaning—and both sides know that—but your awareness that you need to say it is what qualifies you for the job. The words are "tokens" you must drop in order to be taken seriously. Artists' statements use language in exactly that way.

Hence the importance, the necessity, of artspeak. The content of your statement is not the point, rather that by using the right words, you demonstrate your awareness of how the art world works. That awareness is what shows

the world that you are an "artist"—and, increasingly, is what qualifies you to be one.

Artspeak makes declarative statements about a work of art, usually phrased, anthropomorphically, as a statement about what the work of art is *doing*. A work of art *interrogates, questions, subverts* and *explores.* In other words, artspeak ascribes theoretical powers to an object.

But before we jump to criticize, we must hear the other side: there is also a good defense for artspeak. We live in a time when art is *expected* to be more than a formal exercise. This is a time (unlike ye olde times) when most people believe art does not have any functional purpose, and so we want art to *do* something; we want it to have a purpose and an effect. (This takes us right back to Leonardo da Vinci propping up painting as a worthy, classy activity.)

Artspeak is a symptom of the need for artists to justify their existence. As an artist you are forced to say *here's why* I paint, say, the existential confusion of catfish *(Am I a cat or a fish?)*, and why my study of it might have a transformative effect (on... something). A good piece of artspeak is supposed to make you feel the importance of art and what artists are capable of doing for the world.

The problem is that using artspeak is a social act.

Language is of course a social phenomenon; we use it in order to communicate with others. Thus

artspeak—language about art—ostensibly has communication as its goal. But the twist is that communication is *not* its primary goal; its mission is in fact to impress, to stake a claim. While pretending to be a description of a work of art, or an artist's statement of their philosophy, artspeak achieves something different: a declaration of the writer's belonging. Artspeak is a social use of language, with a social purpose: to show that you belong and, ipso facto, that you are superior to those who don't.

Even this would be unobjectionable, except for the fact that fluency in artspeak has become, in this outward-oriented art world, a prerequisite to being considered an artist. This fundamentally social behavior has become a requisite part of artmaking. Talking like an artist is now possibly the most important part of being an artist.

WHERE DO YOU FIND artspeak? The place most people encounter it is in the museum, in wall text.

Wall text began as the little white card on the wall near a painting that tells you what it is; it has grown up into large paragraphs emblazoned on the wall itself at the entry to an exhibit.

Wall text is more complex than you might think. It is a kind of art itself, certainly a graphic presentation. It is a carefully executed writing form: a Google search brings

up guidelines for writing good wall text, and makes the strong implication that it can be poetry.

Museum curators are the ones responsible for how art is presented to the public. They get to decide how much and what to say about it, whether it's a little white card with a title and date, or a piece of art journalism with a definite point of view. In the days of conceptual art, curators were left the job of making meaning out of some pretty impenetrable art. But why do they use artspeak?

It might be in order to cement the importance of their own role in the art community. They are authors, and artspeak is their authorial voice. Everything they write serves an immediate practical purpose of describing a work of art, but it simultaneously has the much bigger purpose of advertising the intellect, knowledge, and *belonging* of the author.

Martin Waldmeier is a curator and writer who studies the role of language in art, in particular the language of curation, how it developed and why it persists. In a lecture, he tested his audience by reciting the following paragraph and asking who could tell him what it means.

"Taking a critical approach to the ideologies behind the development of these optical instruments of guidance and surveillance, the artists consider how imperial gestures of discovery, revelation and possession are embedded

in associations between seeing and understanding, light projection and enlightenment."

The response was, of course, nervous giggles.

Waldmeier says that artspeak creates an international common ground for curators; it supports and enables an intellectual tradition; it is "a unique dialog that naturally accompanies the discussions of like-minded people."

As an artist, where you invariably find artspeak is in artists' statements. This carefully crafted bit of prose is your calling card. When I was trying to set myself up as an artist, this was one of the first things that made me feel different from everybody else. Artists I met wrote that their work was "an exploration of the interiority of aliveness" or "radically questioned the is-ness of objects in their particularity." (And these are relatively tame.)

It's not only the word choice but the crafting of the sentences that makes it undeniably an Artist's Statement. This is simultaneously so difficult and so producible that there are now online random generators that will do it for you. These generator sites are equally good for a laugh as for serious use. (Such is the state of art.) In the same way, the serious version is indistinguishable from the joke.

Generator Quiz

The *Huffington Post* ran a quiz to see if people could tell the difference between actual quotes from an art magazine and some from an online generator. Try it yourself. Which of these is "real"?

A) "As a consequence of the reductive parameters of these conservatisms, such as rigid canons, fixation on objects and absolute field demarcations, activist practices are not even included in the narratives and archives of political history and art theory, as long as they are not purged of their radical aspects, appropriated and co-opted into the machines of the spectacle."

OR

B) "Helmut Kremling's work investigates the nuances of vibrations through the use of stop-frame motion and close-ups which emphasize the mechanical nature of digital media. Kremling explores abstract and correlative scenery as motifs to describe the idea of cyber-intuitive artifice."

(Flip to the endnotes for the answer.)

The ridiculousness of artist's statements is proof that this language is only for other people. If you make art only to fulfill your own creative need, you do not use artspeak, for it is irrelevant for the individual. Artspeak is pointless without an audience. You would never use it for yourself, which is why artists' statements—phrased as if it's the artist just musing about their motivations—feel so artificial.

But the place you run into artspeak the most, especially if you are an aspiring artist, is in art school itself. There, you learn it, are yelled at in it, dream in it, have it mixed into your food. It is inescapable, fundamental, imperative; and your facility with it will determine your entire career.

So, ARTSPEAK IS ONE of the requirements of a modern artistic life. Where did it come from?

For most of history, the "meaning" of a work of art was conveyed by the painting itself, not by words from the painter or critic. A Renaissance painter, for example, would frequently be making a political statement of some kind in his portrait of a king, but the statement was made not by what he said *about* it but by the fact that he made the king even uglier than he actually was.

The first step towards a need for writing about art was the radical art of the Bohemians, who, as we know, made their art as inscrutable as possible in order to flummox and frustrate the bourgeoisie. People simply didn't know what it was they were looking at. This is where art critics stepped in.

Art critics began, naturally, by critiquing art, but by the time of abstract expressionism and conceptual art, their role quickly turned into explaining what the art was about. As Wolfe says, a lot of it was "inapprehensible without words."

A few lines of explanation became a necessity. Hauser said that the audience needs a translation of the symbolic language (in this case the painting itself, not the artspeak) in art just as much as they need music to be performed if they can't read music. Or as Thomas Hoving, director of the Metropolitan Museum, puts it, you have to tell people what they're looking at.

And why do they make it artspeaky? Because, by now, it is what people expect. Martin Waldmeier did informal studies that show that people prefer the artspeak over the plain. Audiences have been conditioned to expect intriguing, mystifying language around art. Such palpable expertise can also be reassuring in the face of a puzzling work of art: "One turns to didactic texts with a feeling of quiet inadequacy to make heads or tails of an inscrutable

object, moving towards the wall label like a floundering person swimming to shore."

WHAT'S WRONG WITH ARTSPEAK? As they say, who is it hurting?

By using artspeak, we lose precision. A knowledgeable description requires precise language, but a ramble about *interrogating the potential* doesn't require much but chutzpah and a bit of flair. As Gombrich says, "To talk cleverly about art is not very difficult, because the words critics use have been employed in so many different contexts that they have lost all precision."

We lose meaning. It is easy to use words loosely, to be both vague and grand, with words like *intention* or *universal*. But every time we use words like *concept*, *curate*, and *artist* imprecisely, it dilutes the original specific meaning, and eventually the definition of the word is reduced to the nonspecific meaning. Vague language may feel easier to use but it is less powerful.

And then there's the use of artspeak, rather like advertising, to mislead. For example, when an artwork is labeled "Collection of the Artist," it really means that nobody wanted to buy it.

But the biggest problem with artspeak is that it excludes.

Its goal is to maintain the high profile, the social and market value, of art and artists. It achieves this by simultaneously demonstrating their high status and excluding everyone else. Artspeak plays a crucial role in the semi-conscious game, so important in art, of insider versus outsider. It allows professionals to sound and feel superior—or, to put it more generously, *professional*, as contrasted with the amateur. There must be an audience for the language—other artists, or the public—to be impressed by it; if there were no outsiders, nobody to impress, such language wouldn't have to exist.

Sometimes the one we want to impress is ourselves. The label of *artist* is itself a bit of artspeak, carrying with it the exclusive nature of art, which we amateurs hate and but also kind of treasure. We *want* it to be an exclusive term so that it raises us up when we apply it to ourselves; this is why we perpetuate the image and support the exclusion even though it more frequently hurts us.

So, artspeak is exclusionary in its reception, as intended, but it is also exclusionary in its production. Simply: artspeak is easy for extroverts but difficult for introverts. Artspeak functions as a measure of your social skills, and weeds out those who can't (or won't) use it.

Artspeak refers not only to vocabulary but to the skillful use of the patter. The vocabulary is the part that shows your insider status; the patter demonstrates your

verbal—and thus social—abilities. This falls fully in the wheelhouse of the extrovert.

In *Quiet*, Susan Cain has lots to say (no pun intended) about the power of talking. "People's respect for others is based on their verbal abilities. ... You have to be someone who speaks well and calls attention to yourself." Talking leads to power. In a group, when you speak, the group members direct their attention to you and by making them do so, you become increasingly powerful. When you compound that power by using the jargon of your field, you demonstrate your insider status and rise even higher. And those who feel the weight of that status the most are those who do not have it themselves.

This carries through beyond the art world, to the development of new words, and the power behind using the latest language that others don't know. If you are powerful *and* baffling, it increases your status exponentially.

And that, my friends, is the magic of artspeak.

This is, I need not repeat, all outward-oriented. If art were allowed to be inward-oriented, words would be utterly unnecessary. (And wouldn't that be a blessed relief?)

Artspeak is a show of verbal ability. Proficiency in speaking is a crucial element of success (not only in art!), and an extroverted trait. And if fluency in artspeak is

a prerequisite to being considered an artist, then again, extroversion is a prerequisite to success.

I couldn't do it. I didn't want to insult my work by speaking about it so meaninglessly; not to mention that I couldn't bring myself to utter such words. I feared I would laugh out loud.

Which may be why I'm sitting here writing a book rather than running a corporation.

I WAS TRYING TO be a painter while I had young children. Going out on jobs was tough because I had to find child-care; but in some ways, making art at home was harder.

On the job—once I had arranged for Grandma to pick them up at 3:00 and told her how to get to the playground and to go easy on the marshmallow fluff this time—I could let that all go and concentrate. Once I was painting, it was the only thing I needed to do.

At home with them, however, I had to first set up something for them to do that would last as long as possible, or figure out how to narrate what I was doing at the same time as trying to keep my hand steady, or, hardest of all, try to concentrate while being pummeled by the guilt I felt for shutting them out. I quickly discovered that being an artist while parenting is a challenge that brings out your deepest, darkest art monster tendencies

that you swore you would never pass on to another generation. For it was not lost on me that I was, quite literally, recreating what my father did to me.

I had uncomfortable moments of empathizing with the art monster.

At the same time, I knew that there was a crucial difference between my father and me: I felt guilty, while as far as I could tell, he never did.

Mothers have to make a choice that fathers (generally) do not. For women with young children, the question of pursuing art or not always includes a choice—whether to focus exclusively on their art or to try to also be a present mother—as well as (not insignificantly) the responsibility for their choice. As women, if we are brazen enough to have a family while also wanting to do creative things with our lives, we are, from the moment of childbirth on, faced with the struggle of finding a balance we can live with *and* the permanent uncertainty of whether we made the right choice.

And in our culture, our choice of mothering versus working is often equated to being a good or a bad mother. It comes down to what Marissa Korbel called the martyr/monster dichotomy. And it feels this black and white, this binary, precisely because it's pretty damn impossible to do both.

In making this choice, we not only worry about our children; we also worry about our art. Claire Dederer, who has written a lot on this subject, formulated the questions that we lose sleep over. Am I a monster? Or am I perhaps not being enough of a monster? We assume that working makes you a less good mother, but does motherhood make you a less good artist? We fear that it does, because we sense that art, done properly, is all-consuming. As the writer Rufi Thorpe says, art is "something that must consume you entirely"—in other words, that *requires* you to be a monster.

Interestingly, my mother never seemed to feel either guilt *or* artistic frustration. She had clearly made her choice, and we children were the winners. Certainly, incontrovertibly, she never fulfilled her potential, but she never showed frustration. It is possible that she was so accustomed to subsuming her own needs that she didn't question what she had to do—though I hope not. She must have figured out either how to do both, or how to not worry about it, or at the very least how to not take it out on us. However she did it, I hope she was happy with her choice.

IN ART CLASSES, NOT only was I apparently the only one who couldn't speak artspeak, but I seemed to be the only

one to object to it. I seemed to be the only one to cringe, the only one to laugh; everyone else around me took it extremely seriously. How was that possible? Was I really such a rebel (or a freak?) that it bothered me and no one else? Was I the only one to hate it?

Finally, for once, the answer was no. One beautiful day I found vindication, in the form of "International Art English," or IAE: the name that Alix Rule and David Levine, two artist/linguists, coined for the language of artspeak. After naming it, they conducted a serious linguistic study of IAE as if it was its own complete language (which, strictly speaking, it is) and published their analysis of its grammar and social uses. Ingeniously, the linguistic analysis, while free of any overt bias, showed artspeak to be ridiculous.

Rule and Levine created a linguistic corpus of thirteen years' worth of press releases in order to find patterns of usage. Their goal was to name "this particular weirdness of language around art today," so that we would have a way to study and talk about it that we didn't before. They found that it makes people uncomfortable to define artspeak too precisely (which in itself would be an interesting point to investigate), so they had to "break that unspoken rule" to describe its features in detail.

What they found is that IAE uses a distinctive vocabulary. Common words are open-ended things like *space,*

proposition, and *tension.* Work *interrogates, encodes, transforms, subverts,* and *displaces;* but, usually, only *serves to* or *seems to* do these things.

It makes everything possible into a noun: *visual* becomes *visuality, potential* becomes *potentiality.* It loves prefixes: *para-, proto-, post-,* and *hyper-.* Because it's usually talking about something visual, it loves words related to space, like *intersection, parallel, void,* and *platform.*

IAE has its own grammar, including double adverbial phrases *(playfully and subversively invert);* pairing of terms *(internal psychology and external reality);* and using as many dependent clauses as possible *(By suggesting that...; While seeming to...),* which "embeds the action deep within the sentence, effecting an uncanny stillness."

The origin (what the authors call the genealogy) of artspeak is surprising. Rule and Levine tell us that the art journal *October,* founded in 1976, published translations of post-structuralist texts by French philosophers and critical theorists, thereby introducing into the English-speaking art world a scholarly French writing style, which IAE continues. Using the suffixes *-ion, -ity,* and *-ization* (instead of *-ness*) is French; using definite articles, as in *the political* or *the space of absence,* is French; so are "sentences that go on and on and make

ample use of adjectival verb forms and past and present participles" (*broken rules, confusing imagery*).

All of these are trademarks of artspeak.

The original editors of *October* used this language extremely precisely, but the language trickled down from their magazine to *Artforum*, to artists' statements, exhibition guides, and wall texts, and is now used by every artist, professional or "emerging." Everybody wants to, as Rule and Levine put it, "sound to the art world like someone worth listening to."

The authors wrote, "Some will read our argument as an overelaborate joke. But there's nothing funny about this language to its users. We are quite serious." It made me feel so much better to have someone confirm that it wasn't that I had X-ray vision, but that this emperor *actually* has no clothes.

Levine and Rule conclude with the thought (or is it the hope?) that IAE might be going out of fashion. "Now that competence in IAE is almost a given for art professionals, its allure as an exclusive private language is fading." But I believe that artspeak will not go away anytime soon because, just as we saw with originality, everything in our society supports it.

International Art English is so successful, so attractive, partly because it has the same pull as the Bohemian credo: the language "insists on art's subversive potential."

Wolfe said that art needed to be mysterious, and IAE is a new way to "muddy the waters around the meaning of a work."

Because it is a crucial part of the art world, artspeak has become a crucial part of art education; it is in fact given most of its power by its central role. It is a self-fulfilling circle. Your art education teaches you how to use artspeak and why it is so important, at the same time as the use of IAE grows due to the "heavily theoretical and text-influenced nature of much current art-making and education."

And in art school (and beyond) there is enormous pressure to use artspeak if you want to succeed. In fact there seems to be a more absolute, unforgiving prerequisite to use artspeak than any of the other ways you are pressured to conform. By using it, you are playing the game, and demonstrating that you belong; that you are an insider.

Use of the language signals not only your belonging to but your willing participation in the system. Remember the comment about using "tokens" in a job interview: the importance of knowing that you need to use this language. Demonstrating that you know this is a requirement almost more important than using it.

Circularly, again, the use of artspeak to show that you belong developed because of the new need to

demonstrate that you belong. As we saw earlier, artists must prove their belonging in order, seemingly, to justify their existence.

But most crucial of all to artspeak's takeover is the fact that it is going mainstream. The fact that it is all over the art world makes people on all tiers of artmaking use it. The (crème de la crème) art magazine *ArtInfo* says that IAE is changing from "something pretentious and elitist into a more widespread linguistic tic."

Artspeak thrives because of the social motivations to use it. So the only way to fight it is to remove those motivations, by changing attitudes and expectations. A few people are trying.

The Rule and Levine linguistic study was the beginning, getting people to at least recognize the phenomenon. (Helpfully, the article was controversial enough that discussion about it went on for several years.)

Curators could be influential, if they chose to write and speak clearly about art. Curator Lauren Cornell is working on it, saying that she pointedly asks artists for a formal description of their work instead of a theoretical one. Using plain language in art not only helps stop IAE from taking over the world but, as she points out, is in fact a radical move in itself—because there's so little of it.

The online art magazine *Hyperallergic* has also taken a stance: they forbid artspeak in their publication.

Their submission guidelines say "If your pitch contains artspeak, it will be deleted. Immediately. Don't say we didn't warn you."

But it's not only the supporting roles that need to change. Artists themselves must resist the pressures to use artspeak. To start with, use plain language in your artist's statement, or even don't write one at all.

Be the change you want to see.

THE IRONIC THING IS how much we insist on using obfuscatory artspeak to talk about our art, and at the same time believe that art is for communication.

Communication, by linguistic definition, is cooperative. There is a linguistic principle of conversation which holds that the speaker must do their best to make themselves understood by the listener. If their speech is opaque, abstruse, baffling, or entirely fails to be understood, it is not the fault of the listener; the speaker has failed to communicate.

But that's not all: the principle also states that the listener can assume that the speaker is *trying* to be understood. Logically, if you are trying to communicate something to someone, you want it to get across. Linguistically at least, there is no reason to make your communication confusing. This is why, when language is

purposely baffling, it violates our subconscious, stubborn beliefs about communication, and makes us confused and angry.

Artspeak breaks both of these rules. And so can art.

Technically, language and art are the same thing: a system that uses a convention of symbols that can be understood by the viewer. Both are subject to the same rules, and subject to failure in the same way. The opaque language of artspeak, and the ultra-personal "language" of self-expressive painting, obscure understanding. In other words, our current mode of both making art and talking about it does not succeed in communication. And yet, when we make art, communication is said to be our strongest motivation.

Which brings us to the last, most important question: why do you make art?

9

ONE PAINTING CLASS AFTER another showed me that I didn't fit in. I didn't work or think or express myself the way I was supposed to. Where the art world preached the gospel of spontaneity, I planned my paintings carefully. Where everyone else spoke of divine inspiration, I knew how my ideas formed and gave myself full credit for them. But I kept going.

Each time I signed up for a class, I was excited and hopeful that *this* one would be right, that the teacher would finally see who I was and what I was doing, that what they taught me would finally match and heighten my love of making art rather than throwing it to the paint-splattered floor and stepping on it. And so it was that I went to class one day, with no suspicion that this was my last.

The teacher said, "Painting is a great way to express your emotions. To show what you feel passionately—positive or negative. That's what we're going to do today. We are not painting a *thing*, we are painting an *emotion*.

First, think of something that brings you *joy*. The best, deepest, warmest feeling you've ever had. Bring that into your mind, and then put it on the canvas."

I immediately thought of my mother. The safest, warmest, best thing in my life—who had died five years before. She would never know about my painting, would never know that I had learned from her example and done something with it. It would have made her so happy.

I started to paint my mother. Despite the portrait painting class, I was still terrible at painting faces, but I did it anyway: her high Scandinavian cheekbones, kind blue eyes, fine gray hair pulled back in a tiny bun; her lips, in that half smile she always had, showing reserve to people who didn't know her, humor and welcome and love for those of us who knew how to read it.

"Our time is almost up," the teacher suddenly announced right behind me, startling me so my brush jumped. "Ah," she said to me, looking at the beginnings of my mother. "Very nice. But the assignment was to paint an emotion, an abstract. You are too literal-minded! Take that overthinking and let it *go*. Maybe this next challenge will bring it out."

"Okay!" she addressed the room again. "Now we are going to take it to the other side, the *dark* side." She gave what was clearly supposed to be a wicked smile. "Let's paint the negative. The anger, the fury. The failure, the

frustration. Paint it. This is your chance—this is the best way possible—to let it all out."

Again something came instantly to mind. It was painting itself. Or rather, my experience of painting, of trying to become a painter, and what all these people had done to it. The people at the convention, the teachers who hadn't heard my questions, the fellow students who had all played the game so well and left me feeling like a freak.

But how could I paint *that*? I tried to think how the teacher would say I should do it. I tried to think how Picasso would have done it. Interesting question, I stood there thinking. How would—how *did*—artists over history paint their anger with the art world? The fury and frustration that they must have felt a thousand times more than me, and weren't allowed to show—certainly not invited to summon it and express it. *They* would all have had a good idea; all I could think of was taking a gallon of red paint and hurling it at the canvas.

It was so ridiculously out of proportion, so inappropriate, that I started to laugh. And then almost simultaneously, I burst into tears. I suddenly saw all of it: everything I had done and tried to do, hoped to do. All the frustration, lack of understanding, feeling weird, feeling stupid, feeling alone; all the feeling bad about myself for who I am. Trying so hard to do what I loved so

much, but apparently always doing it wrong. It all came flooding in, and I realized I just couldn't do this anymore.

WHAT MOTIVATES US TO make art?

Historically, an artist's motivation was never at issue, simply because nobody asked what the individual wanted. Art was not for the artist. The purpose of art was to achieve social goals, such as passing down religious stories. Was an individual painter motivated by the thought of helping an uneducated person feel closer to God, or did he simply want to put food on his table? I hope that some artists took on the social goals as their own—for these were the only ones that would ever have been fulfilled.

The objectives of art have shifted along with the general cultural shift in focus from society to the individual. Historically, the issue was always the purpose of the *art*; now it is the purpose of art*making*.

Now that we are (perhaps overly) focused on ourselves, we can ask, what about artmaking is personally motivating and fulfilling to each individual? We no longer have to achieve society's goals for art. Why does a person make art? There are as many reasons as there are artists.

An easy one is the desire for success. To make a living, or even just a name for yourself, doing something you

love is an incredible bit of luck that comes to one person in a million.

Some people want the label of "artist." This label is an identity that can go to your head. People dream about the myth of the artist, and they want that identity. But the cruel irony is that if that's what you're focused on, then, ipso facto, it's not true. If you are actually interested in the work—in painting rather than *being a painter*, or writing rather than *being a writer*—then you don't care about the label. You will do it whatever people label you, or even if (as is most likely) they ignore you entirely. Novelist Colum McCann warned, "Don't ever call yourself a writer: you are only what you have written."

Another motivation can be the thrill of being the first to make something. Robert Mapplethorpe said that what he found most exciting about making art was producing something no one else had done. And Neil Gaiman said, "The world always seems brighter when you've just made something that wasn't there before."

Some people feel a connection to the divine in their motivation as well as in their inspiration: "Creativity is a gift to the creator, not just to the audience."

Freud believed that some people—by which he meant some men—are motivated by the Oedipus complex (the wish to possess the mother and eliminate the father). Artist Stephen Newton applied this theory to art, saying

that to deal with these feelings, to subsume them, men have a desperate urge to paint. In his inflammatory article "Why Women Can't Paint," he wrote that this "intolerable conscience that in reality may lead to murder or patricide, in the creative process can be the catalyst for great art."

Another motivation for making art is to counteract a painful life situation. French dramatist Antonin Artaud said, "No one has ever written or painted, sculpted, modeled, built, invented, except to get out of hell."

Art as Therapy

John Gedo writes about artmaking as therapy in a way we don't usually think of it. He tells the stories of famous artists whose creativity helped their mental health.

Van Gogh's creative achievements did not prevent him from eventually committing suicide, but did raise his self-esteem from his previous life of "an unbroken succession of failures"; his work allowed him to focus on something other than his emotional problems. Even during his successful, intensely creative ten-year period, he got worse "whenever he turned away from work to interact with people."

Francisco Goya suffered from a severe neurological illness that reportedly changed him from "a pleasure-loving, extroverted man … into the first great introspective painter who plumbed man's inner depths." He dealt with his illness by repeatedly painting the symptoms he was experiencing: dizziness, loss of equilibrium, and sensory disturbances—recognizable in some of his most discomforting work. Gedo says that his paintings "are analogous to the recurrent dreams of victims of traumatic neuroses."

Working through trauma by repeatedly depicting it is a well-known therapeutic phenomenon. Roxane Gay says she wrote endless stories about sexual violence in an attempt to understand what happened to her; many of us have felt better for writing about something upsetting in a diary. As Gedo puts it, "By repetition what has been overwhelming may gradually be mastered."

The case has even been made for a similarity between painting and psychoanalysis itself. The claim is that both painting and psychoanalysis have the goal of changing you, either artist or patient. Stephen Newton says, "At the heart of the painterly process is what might be described

as a 'therapeutic nucleus', a creative core which forms the implicit potential offered by painting to effect a psychic rebirth. Painting, in its essence, is about healing and psychic development."

Feel free to take as many grains of salt with this as you'd like.

IGNORING EVERY OTHER ISSUE—FORGET expressing yourself, forget the audience, definitely forget success—there is joy in the work itself. Mihaly Csikszentmihalyi says, "Even without success, creative persons find joy in a job well done." This was true for me. I enjoyed the physical achievement of making art. The object I make is precious to me because it is an embodiment of the feeling of the creative experience. It is a record of my abilities of the moment, proof of what I got the materials to do. Technically this is called the *pleasure of effectance:* as Gedo defines it, "the joy to be had through the sheer exercise of competence."

Proud furniture craftsman Peter Korn emphasizes the joys of materiality, saying that many of craft's rewards come from the focus on material and the exercise of skill. The fact that craft is the most *tangible* of all the arts means it provides the clear goals and immediate feedback

that Csikszentmihalyi says are crucial elements of flow; or as Korn says, gives you "a centeredness that touches upon the very essence of fulfillment."

Even business gurus understand this: "The only lifelong, reliable motivations are those that come from within, and one of the strongest of those is the joy and pride that grow from knowing that you've just done something as well as you can do it."

It's a matter of extrinsic versus intrinsic gratification. For some reason people tend to focus on extrinsic rewards; however: not only is art is much more geared toward intrinsic satisfaction, but if you are not looking for the intrinsic rewards, you will miss out on the greatest pleasure creativity has to offer.

So people come to art for many different reasons. But the one motivation that everybody seems to agree upon is that we make art to communicate.

PERHAPS YOU BELIEVE THIS yourself. It is a widely held assumption. Where did it come from?

The idea that art is for communication originated in the idea that art is a language. Art and language are subject to the same rules: they both (usually) use conventionally-agreed-upon symbols that are supposed to mean something to the listener/beholder. Language came out

of a need to communicate, and the assertion is that art did too. Karl Marx said that "art has its origin in the need for intercourse with other people."

Hauser claims that the "forms of organization and the sense contents of the language [i.e. the symbols used in the art, the system of signs] have their reception in view from the beginning"—meaning that the symbols used *imply communication* by the fact that they are the symbols agreed upon by society for transmission of ideas in this form.

There is an entire castle built on this rocky, debatable assumption.

The claim that we make art out of a need to communicate with other people leads to the assertion that we all make art for an audience. Since the best way to bolster an assumption is to claim that it happens automatically, not by choice, that is what we say: there is an audience there whether you want it or not. Hauser says, "Art is never entirely expression, but always address as well. Rhetoric is one of its essential elements." In other words, you are engaging with an audience even if you don't intend to.

John Gedo says that people tend to "assume, without much evidence, that while doing her work even the solitary creator has a potential spectator, audience, or reader in mind." He says that because art must (or at least is expected to) use the symbols and traditions that others

understand, "the artist can therefore never overlook the requirements of communicability without lapsing into a solipsism that will be unacceptable to any potential public."

We might tell ourselves we have an audience waiting simply in order to be less lonely in a lonely profession. Gedo: "The muses may be invoked to mitigate the isolation of creative work precisely because such solitary activity cuts the creator off from all human ties." Maybe the entire house of cards, insisting that art is a social activity, was built for this reason.

It also relates to the old issue of wanting to be accepted. Communication is an indicator of our connection to society, which (as we've said) has always been a central part of acceptance by society. Belief that what you make in your too-quiet studio every day is the first step towards getting people to like you is a great motivator.

Many people believe that artists cannot function without an audience. Hauser says that no one makes art "without wishing to make it visible to others"; that in fact "the most primitive and embryonic artistic idea is already concerned with communication." In Tom Rachman's novel *The Italian Teacher*, an artist's daughter says, "I've never met an artist who didn't worry what everybody thinks. Or what are they doing it for?"

We then take the communication metaphor further and say that we make art not only to communicate with others but specifically to take part in a dialogue. Hauser references the philosopher Hegel, saying that a work of art is essentially a question, and that "the question demands an answer and is put in the expectation of one. The persons addressed by the artist are not merely recipients ... but partners in a dialogue."

He puts forward the logical argument that an "I" who is speaking is necessarily addressing itself to a "you." He continues, "An authentic work of art is not just expression but also communication. It is also not just address but a discussion. Nobody talks to himself in verse."

THE PROBLEM IS THAT these declarations are simply not true for everyone. Essentially, in the same way as you *can* talk to yourself, you can make art for yourself.

The idea that because art is made up of symbols that are used in communication, it exists in order to reach someone else, may be true sociologically speaking; but I argue that each of us as individuals uses the words we know and the visual representations that mean something to us, without that use necessitating any implication of a recipient. In the same way as we use numbers when we do a quick calculation on a scrap of paper, or words

when we scribble down a shopping list, we can use symbols without intending them to reach anybody else.

Traditionally, an artist needed an audience, in order to buy his work, so he could make a living. But we are living in a time when our definition of artist has changed, and so these old assumptions need to change as well. Why, for example, should amateurs be at all concerned with an audience?

The old issue of artists' freedom is relevant again here. An artist's social position directly influences the degree of independence with which they can approach their work; the degree of freedom they have from the pressures of society. Working in our current time—and enhanced by the fact that, like most amateurs, I am not trying to earn a living from my art—I have full independence. Artists who speak the artspeak and fulfill all the social expectations do not. They are giving it away.

Over time there have been a few attempts to break this law that there be an audience. The composer Arnold Schoenberg wrote in 1918, about music: "I hold the view that a work doesn't have to live, i.e. be performed, at all costs... [As for the listener], all I know is that he exists and insofar as he isn't indispensable for acoustic reasons (since music doesn't sound well in an empty hall) he's only a nuisance."

As part of the 1960s bid to break away from all restrictions, artists repudiated the idea that art needs an audience. Adler says that at that time, the rejection of an audience, or "the denial that artists should concern themselves with providing any sort of service whatsoever, [was] proudly taken as a sign of their final ascension to professional seriousness." (You can hear, in this, proud echoes of people working to raise the status of artists.) She quotes a critic of the time saying that "art has become as 'serious' as science or philosophy, which doesn't have audiences either." It was a renouncement of the role of artist as the court fool, entertaining royals and supplying whatever they might demand.

But the power of the idea that we make art for others was apparently too great, and we are right back at it.

It sticks because, like encouragement, we like it. The belief that there is a built-in audience, that every stroke of your brush is a dialogue with the world of art, makes us feel that we and our work are important. Artists love to say that with a given piece of art we are "taking part in the dialogue." Unfortunately, this is almost always only an exercise in self-belief. It makes artists feel we are a part of something, that there is an audience waiting for our contribution. It implies that our work is important enough to be seen and responded to. It has a lot in

common with declaring yourself an artist: the need to proclaim, and believe, that you are great.

WHEN I MADE ART, I made it for myself.

I taught myself faux painting because I thought it was beautiful art and I wanted to know how to do it. When I began doing it for other people, it was simply an extension of the same work, only raising the bar for myself with the challenges of a new context, a new scale—and greater consequences if I messed up. I now see that I was also looking for validation that I was good at it. If I hadn't felt I needed that validation, I probably would have continued doing it on my own.

When I then started painting pictures, it was even less socially motivated. I painted the e.e. cummings pictures because I thought a poem was beautiful and I had an urge to represent it visually. It was a creative exercise, to explore how my mind had interpreted the poem. It was the same as the original Archy and Mehitabel: I didn't care if anybody ever saw it; I found it beautiful and I wanted to have a visual reminder of it.

Other painting I did was motivated by the sheer pleasure of using the materials. I reveled in the physicality of paint, and loved things like using a squeeze bottle to draw with metallic paints, or making acrylic pours, in which

you make pools of molten color and let them dry into flexible sheets of kaleidoscopic plastic. (An acrylic skin of gorgeous shimmering colors will make you appreciate paint's material beauty more than any painting.)

Taking art classes was an attempt to learn more in order to follow my own creative urges with more skill, so that I could feel more confident, enjoy myself more, and feel that I really was an artist.

Artmaking was for me, and I didn't want it to have anything to do with social rules. One of the things it takes to fit in in art is the same as what is required in the rest of life: to make yourself appealing to other people. I didn't want to have to do that in artmaking; artmaking was supposed to be for *me*, a private place where I didn't *have* to play that exhausting game.

These feelings were so instinctively obvious to me that I couldn't understand people who were motivated by anything else. I couldn't imagine why anyone would feel the need to have other people see their work and talk about it, who would swathe themselves in artspeak and adopt the techniques and attitudes of their teacher, all for some external goal. All to satisfy—who?—someone else.

The only motivation I cared about was my own. And I would defend it to the death.

THE IDEA THAT YOUR art is destined for other people has segued into the belief in the need to put your work "out there." Not only can you comfortably assume that there is a recipient waiting, but they are said to be even more influential than we think.

The claim is that the recipient first plays an indirect role as an expectation in the artist's mind, and then once the work is received, they play a direct role, literally changing the work of art as they take it in. Not only do different people have different experiences of the same work of art, but—the idea goes—each person makes a new work of it, in that their personal interpretation turns it into a different thing. John Dewey, in his classic *Art as Experience*, says "The actual work of art is what the product does with and in experience." Thus the recipient is part of the creation of the work, both before and after they see it.

From this belief, people extrapolate that once you put your work out there, it no longer belongs to you—in fact, it never did entirely.

Hauser says that a work "is partly a living, partly a coagulated form; it is thus only partially the creation and property of the individual who created it. It belongs to him psychologically because he willed it. Yet ... it owes neither its origin nor its completion to him alone."

Elizabeth Gilbert says the same thing: that once you've produced it, it's out of your hands. She describes a woman who came up to her at a reading of *Eat Pray Love* and thanked her... for something she had entirely misinterpreted. Gilbert says, "I submit that this woman has the God-given right to misread my book however she wants to misread it. Once my book entered her hands, after all, everything about it belonged to her, and never again to me."

One step further and we arrive at the hypothesis that if you don't put your work out there, it doesn't exist. Hauser claims that art which is not received—specifically, books that are not read—"do not exist sociologically, just as a musical score which is not played ... is not music but merely notes. The artistic process consists of address and discussion; it has no ontological quality as reverie or unreciprocated monologue." In her book on writing, *The Forest for the Trees*, Betsy Lerner speaks of writers as having "stopped writing" if they don't publish.

It's a scarily short trip from this to the idea that an artist must put *themselves* out there or *they* may as well not exist. Art teachers, who know that advertising yourself is crucial, will give up on you if you cannot perform that element of your education. Again, introverts lose: they *do not exist* for a society that does not value inward-turned, self-contained people.

This is yet another example of our extroverted society and its blind assumption that we are all, of course, outward-oriented.

The real problem is that people—especially extroverts—tend to think of everything in a social context; which is to say, they cannot conceive of something existing without one. Hauser—a sociologist to his last breath—says that the recipient changes "what was purely a psychological process and a mere technical accomplishment into a dialectical, historico-sociological happening." We're back to debating the definition of art. Is a painting not art if it's not a "historico-sociological happening"? (I guess I'm out of luck.)

But sociology is not the best lens through which to look at art, for not all art has a social basis. Sociology is too narrow to help us fully understand art and artists. If we are looking for the irreducible core of the creative urge, the sociological is a layer on top which can be stripped away, and must be, if we are to understand the motivation of the individual artist.

Not all of us make art with other people in mind.

PEOPLE ASSUME THAT PUTTING your work out into the world—publishing, showing, selling—is the point of making art. But it is not actually integral to everyone's

motivation to make art. I make art in order to get an idea out of my head into a physical form, not "out into the world." It is absolutely possible to make art for yourself without wanting to share it.

There is a singular, beautiful instance of support for my position: Vivian Maier, a photographer who kept her work exclusively to herself. She is all the example you need to see that it's possible to make art without a thought of audience or communication.

Maier worked as a nanny in Chicago in the 1950s and 60s, kept to herself, and nobody (not even the family she worked for) knew anything else about her. Only in 2007, when she couldn't make the payments on her storage space and the contents were sold at auction, did it come to light that she had taken over 150,000 photographs. Three collectors purchased the crates of negatives and prints, without knowing anything about the photographer, and it was only posthumously, and with great puzzlement, that she has become known.

What I find the most interesting part of the story is not that she was such an introvert, but people's reactions to her not showing her work—utter incomprehension, complete inability to imagine her reasons—and the strength of their reaction.

The excellent 2013 documentary *Finding Vivian Maier* traces her history and interviews people who knew

her. It gives a full picture of her introversion, followed immediately by everyone saying, "WHY would she have kept these to herself?!" Even people who knew her are flummoxed, asking *why* would she take pictures if she wasn't going to share them? Well, I know exactly why: she was making them for herself. To us introverts, it makes perfect sense. She did the work for herself.

Why is that so hard to understand? It is only because of our ultra-social, extrovert society. In people's disbelief we see the presupposition of outward orientation. In the strength of people's reaction, we see the power of the social pressures and assumptions I've been talking about, that everybody does it the same way.

Some people say that art is not an end in itself, only a means towards bigger things—such as a connection with people or doing good in society. I believe they are not only wrong, but missing out on a lot of the joy of making art. It can indeed be a beautiful, meaningful, rewarding end in itself, and as Peter Korn says, is better for it: "There is great satisfaction to be found in work that engages one as an end in itself."

Vivian Maier is dead, but the furor over her work goes on. Now that she is famous, there are lawsuits galore. People are exercised over an estate with no heir, over copyright issues, et cetera—but even these warring parties all agree that it's shocking that she never showed

anybody her work. There is a shared vehemence, almost a tone of feeling wronged, in their repeated demand: *WHY would she do that?*

Elaine de Kooning, an artist who fought for recognition of her own work next to her husband's fame, seemed to understand. "Women can also be creative in total isolation. I know excellent women artists who do original work without any response to speak of. Maybe they are used to lack of feedback. Maybe they are tougher."

SOCIETY HAS ALWAYS INFLUENCED external aspects of artmaking: what systems are available for us in which to learn, our status in society, even what we will be taught if we go to art school. It started going inside our heads when it told us how we should work and speak about art. Now there is pressure to consider other people in the most personal, interior aspect of artmaking: our motivation. Society tells us why we make art. We are told that our innate personal drive to make art is to communicate; that our art actually has a social focus.

So, you might ask, what's the harm in society holding these beliefs? What harm is done by these expectations, this framing?

It sends yet another conflicting message to artists. We are told to express ourselves, to make art that reflects our

inner selves; but at the same time that we're doing it for other people, that there is an audience waiting, that it doesn't really belong to us at all. For me, at least, these two things cannot coexist.

It is a false assumption that what is true for many is true for all. Everybody has personal reasons for making art. However much the extroverts won't believe it, for me it has nothing to do with other people.

The biggest harm lies in the way that society enforces unity: judgment. It's exactly the same kind of hurtful problem as extroverts not understanding introverts. But it goes beyond just not understanding; it makes us feel abnormal when we are told we should feel this electrical connection to other people but we do not. The insistence on a social focus makes those of us, to whom the link between art and other people doesn't make sense, feel different and alien.

You can analyze it as much as you want and "prove" that, subconsciously, we all have other people in mind. But it is nonetheless harmful for society to hold this belief—that *of course* you are doing it to communicate with other people—because if you're not, it makes you feel one of three things. Either you're not really making art, or you're doing it wrong, or at the very least you're an isolated loser. Take your pick.

Worst of all, it makes us doubt our own art. Remember the introverted evangelicals who report that people's reaction to their way of being religious—not shouting it out to the world—makes them question their "experience of God" and wonder if it is as strong as that of other people. People's reaction to my way of making art made me question: is my art as strong, as valid, as good as that of someone who claims to be "growing the dialogue"?

I LEARNED A LOT from my mother, things far beyond how to knit or sew or even paint. Most of all I learned things that can't be taught. I'll never forget her example that it's okay to do things differently than everyone else, to *be* different. The goal is to do the work that *you* find satisfying and meaningful. The work—the process, not the product—is valuable in and of itself. You are not doing it for anybody else, not even with anybody else in mind. You do it for your own creative satisfaction. This, I believe, is true motivation for making art.

I Would Do It Anyway

You may have heard of the Italian writer Elena Ferrante, author of the bestselling *My Brilliant Friend*. That is not her real name. She uses a pseudonym because she refuses to become part of the package of success. She writes about how a book can and should stand on its own, doesn't need its author next to it "as if it were a little dog whose master I am." She talks about how our society cannot handle a work of creativity without its maker—"the experts stare at the empty frame where the image of the author should be"—and rants against "the self-promotion obsessively imposed by the media." As she points out, we know nothing about some of our most beloved classic authors, and so "Why would anybody be interested in my little personal story if we can do without Homer's or Shakespeare's?"

When she was first being published, she wrote a letter of apology to the publisher, saying she knew the difficulties this reticence would present them, but insisted, saying "It's not at all necessary for me to publish this book."

> And that's exactly how I feel. I didn't care if this book got published: I was going to write it anyway. I didn't care if I didn't sell paintings, because I would have made them anyway. Even now I don't *really* care that nobody understood what I was painting: just like this book, it was what I needed to make at the time.

If you ask a writer why they write, the answer will usually be something along the lines of *I have no choice.* Most serious artists will tell you that they could not live if they didn't make art. Their creativity forces its way out. That's what happened to me, once my brain had processed my mother's death and at least begun the transition of power from totalitarian rule by maternal instincts back to a semblance of my old self. I hadn't done anything creative for so long, that part of my brain was practically sitting up and begging.

You might say that such a takeover by creativity sounds splendid, or that at least it would be easier than writer's block, but there are definite downsides to it. The very lack of choice in the matter is part of the reason it's so painful to fail in art: wanting to make art is such an innate, subconscious, unsolicited urge, and if your effort

founders, you don't need a bully to beat you up: you can take care of that all by yourself.

Nor is having creative work force itself on you always peaches and cream: such work "isn't optional, and often isn't even fun—it's as important as breathing."

Carl Jung said that "art is a kind of innate drive that seizes a human being and makes him its instrument."

Even Liz Gilbert says so: "If your calling is to make things, you have to make things in order to remain sane. Possessing a creative mind ... is something like having a border collie for a pet: It needs to work, or else it will cause you an outrageous amount of trouble."

Sometimes the thing forcing its way out is telling you what you are good at. As Patti Smith and Robert Mapplethorpe were experimenting with different kinds of art, each of them kept telling the other that they should do more of the thing that they ended up being famous for. She wanted to be a poet, but he always pushed her to sing. (She ended up with what we should all hope for, which is a way to do both at the same time.) He didn't want to do his own photography, saying, "Oh it's so much trouble, I can't be bothered and the printing would cost too much money." But Patti Smith now writes, "You should take your own pictures, I'd say. I said that over and over."

I believe there is something perceptible when you do the thing you are "supposed" to do: an ease, an

unselfconsciousness. The right kind of art will come naturally.

If you consider yourself a creative person, you probably have one kind of art that you turn to, unthinkingly, when you have an idea. Some people write, some people paint, some write music, some dance. I like to think of them all as different media, different ways to get out your ideas, similar to choosing between acrylic or watercolor for a painting, or whether to make your poem rhyme or not. The right one is the medium you use, not to "express yourself" but to get out something at the core of you. It is the medium that feels to you like language.

You probably know your natural medium, and have since you were little—at least that was true for me. It is an instinctive thing.

My creativity comes out in words. I started writing stories before I can remember doing so. Ideas grab me at inopportune times and insist I sit down right then and there and write. I have no choice. I am much more of a writer than a painter (which is why you are reading a book instead of looking at a painting in which I tried to express all of this). Writing is at my core, at my heart: it is the medium I think in.

I know I'm not a dancer or a musician because I have never had the urge to dance or an idea for a musical composition. I am in bewildered awe of composers, and

honestly I don't understand how creativity can come out in movement. The only medium that held any kind of second place for me was art—probably because I was surrounded by artists, so it was a language I had heard, even if I wasn't fluent in it myself. It was a thing that I *half* felt came naturally to me. The other half was that I loved the paint.

I painted largely for the material aspects of painting. There was for me a great tactile and visual pleasure to it. Remember how I used the word "delicious" in my company name? That was metaphorical only by a very small window.

I painted for the mechanical challenge. I loved learning the mysteries of how paint functions—the chemistry of mixing colors and media, how they go on, how they react with each other, how they dry.

I painted for the mental challenge: learning a technique and then applying it to different colors and patterns and contexts seemed to scratch an itch in my brain.

But much as I loved painting, I had to think about it, plan to do it. I could live without it. Painting is not at my core in the way writing is, yet it still likes to pop its head up as the right medium for certain creative ideas. When an image comes into my head, I paint it; when there's a story to it, I write it.

Perhaps this is the inevitable combination of all the writers and artists who came before me. Whether they nurtured me or messed me up, they all made me who I am. And I think each of them would be glad to know that I am myself, and that I appreciate and protect this complicated, independent, introverted artist.

Does that mean that I now believe that I am an artist? I still don't know. But what I do know now is that I don't have to declare myself an artist, to myself or to anyone else. All I need to declare is that I love making art, and that I will do it my own way, for my own reasons and, most importantly, for myself.

Epilogue

I WROTE THIS BOOK three times.

When I quit—first my faux business, then my art classes and this whole adventure—I had concluded that art was not for me. By deciding to let it go and move on, I believed I was doing the right thing; but I was very disappointed, sad, and angry.

I was disappointed that my plan to become an artist, which had seemed so promising, had failed. Sad that our society had proved to be so inflexibly conformist. Angry at the system that hadn't let me in, at the people who had looked at me with incomprehension, and at myself for not being able to transcend it all.

I also had a thousand questions.

How do you know when you are an artist? What *makes* you an artist, anyway?

Is extroversion really a natural, intrinsic part of being an artist?

How did we get to the farce that is artspeak?

Who decided, and why, that things like self-expression, spontaneity and originality were so very important? Where did all these ideas come from?

But most of all I wanted to know, why did I think so differently about all these things than everyone else? It was obvious that I hadn't fit in, but was the problem with the system or with me? Who was right and who was wrong? *Is* there a right and a wrong?

To answer my own questions, I started reading about the history of art education—and quickly discovered that there was so much more behind each question than I had ever imagined. The history also showed that the art world was radically different at different times in history, which told me that however popular a belief may be, however strong the social pressure to do something a certain way, it is not necessarily the right, or best, or only way.

History made me feel better about the fact that I was working and thinking so differently from everybody else around me, for it proved that today's artistic dogma is just another in an endless line of possibilities. My way was not *wrong*, in the way I'd been made to feel it was. As Olivia Laing says in *The Lonely City*, history "release[d] me from the burden of feeling that ... I was shamefully alone."

I decided to write a book to share the history I'd learned—partly just because it was fascinating, but especially because it disproved so many of the things we take for granted about the art world. I had uncovered the surprising and sneaky ways that society influences our creative lives, and I wanted to forewarn others in my situation of these surreptitious systems, assumptions and pressures.

So I did: I wrote a book explaining how each of these topics were thought of over history, and what it meant about our contemporary art world. But I could feel that my conclusion—that society influences us in ways we aren't aware of—was insufficient and unsatisfying. It was an explanation of the system, why it works the way it does; but I could feel that I hadn't actually figured out why these things bothered me so much. Rationally, I had been reassured, but I was still resentful.

Something was missing, but I had no idea what it was. I put the book in a drawer.

BUT IT WOULDN'T LEAVE me alone. I kept wondering how it could be that I was apparently so different from everybody around me. Nobody else had had any objections, let alone the stormy emotional reactions I had.

Thinking about all the issues that had bedeviled me so, I started to see that there was a common thread. Each one was an aspect of art that we are now told has to be social; and each of my objections boiled down to the fact that I'm an introvert. It all came down to the problems that introverts have in an extroverted world. There seemed to be a fundamental, irresolvable incompatibility between me and society.

This felt like the right answer, because it showed that there was in fact something about *me* that made my experience different from everybody else's. I realized that my bad experiences in art had all been related to the ways I was expected to work with and think about others; me trying to fit myself into the construct that art is for other people; me trying to make art out in the world. It all fit.

At first I resisted this conclusion, because it meant that I would have to admit—would have to *talk* to people about!—my introversion. I was so used to hiding it that to shift gears and voluntarily declare it would take a herculean effort.

I rewrote my book, examining each subject through the lens of Introverted Artist vs. The Extroverted Ideal. I blamed our culture for its treatment of introverts, and for not allowing me to become an artist.

I rationalized a lot to convince myself that this was the explanation for my experience. I told myself that, after

all, I had tried to become an artist *in society*. I believed that it didn't work for me because I didn't want the things I was supposed to want; what I took pleasure in had nothing to do with society's measures of why we make art. Other people's priorities simply were not what I was in art for. I had stuck my nose in the door to see if I could join, but they were doing it too differently, and I didn't want to change in order to join them. I could go on making art by myself; and since in fact this was how I liked to work anyway, I wasn't sacrificing much.

I didn't *like* the feelings of being an outsider, of disagreeing with everyone, but I was okay with it, in a hermit-crab, introvert-making-the-best-of-an-extrovert-world kind of way.

I thought the introversion issue explained why I was angry: because art did not welcome me as I was. When you are introverted and the rest of the world doesn't understand it, scorns it, and tries to make you be other-wise, it's insulting—as well as infuriating because you know you have everything you need to do the work.

Even though my introversion seemed to explain what had happened, I was still angry. And all this conclusion achieved—despite the support of Susan Cain's book—was to make me feel worse about myself. It always came back to acknowledging that I didn't fit in, that I was the weird one, the wrong one, and that the only solution was

to change myself. I hated that the conclusion was that *being who I am* was what was stopping me from being happy doing the thing I loved to do.

I put the book back in the drawer—this time with the added despair that this writing gig was yet another thing that I thought was going to be perfect for me, and I'd failed at it, too.

I WAS PUZZLING OVER how being an introvert could be *so* wrong, so deviant, that it was truly the explanation of why I had had such a hard time while everyone else was fine. It couldn't be. There must have been something more, something else I brought that was about me personally, not just me in society.

The issue of introversion, painful as it was, also didn't explain the strength of my reactions to the way the art world works. My introversion was what made me not fit into the art world, but it wasn't my introversion that made me unhappy; what made me unhappy was that I was angry and upset.

What I needed to analyze was not my fit in society but my emotional reactions to my art experiences. In the book to that point, I had been probing what was behind my difference from other people, but I didn't think about why *I* was having the reaction, what it must mean about

me. What I actually needed to ask was the simpler but harder question: Why did these things make me angry?

I had been myopically examining art history and sociology and language, when all along I should have been looking at myself. Therein lay the *real* answers to the questions I had *really* been asking. In subconscious fear of admitting anything to myself, I had been avoiding the real issues. The different versions of the book weren't working because I wasn't yet telling the real story.

I brought the book out again, and started rewriting for the last time.

I HAVE ALWAYS FIERCELY wanted to be my own person, doing my own thing without the help or experience or influence of anybody else. And although I didn't realize it, this included—or perhaps meant especially?—my parents. I was proudly myself, not an amalgam of others. But in examining myself now, in writing, I saw for the first time that that is exactly what I am: a composite of my parents, their talents and their faults. When I thought about *them*—and just as importantly, my feelings about them—I suddenly understood my strong reactions to my art experiences.

More than we know, our feelings about our adult work reflect our childhood. Poet Nadia Colburn says

that early rejection of her work hit her really hard, and she didn't know why. Eventually she came to understand that rejection made her feel *unseen*, and that being unseen, particularly *around her work,* "brought up unprocessed early childhood experiences of being unseen and unheard." In exactly the same way, my struggles around my work—forever trying to find the thing that I was confident at and proud of, that defined *me*—went straight back to how I felt about myself as a child. Every night that I had to knock at my father's study door to say good night, and wait to be admitted into the creative sanctum, cemented in my mind the belief that I was an imposition, quite literally an interruption of work that was, patently, more important than me. I embodied the interruption of serious creative work, never its creator.

Even though I now understand—I now know that if you're in the middle of writing, you sometimes need to scribble down an important thought before you can be interrupted—that self-image has never left me. I have a hard time seeing myself as the one inside that study, making the art, and fear that if I claim to be, people will laugh. I will always be the child, the one to be patted on the head so she will go away and let the adults work. The one not really expecting to be taken seriously but trying anyway.

As soon as I saw the connection between my father and my feelings about art, my anger about the art world suddenly made sense. I resented my father so much that anything which brought up my difficult feelings about him made me angry. Each of these issues around art, which all came down to matters of identity and social status, brought up how I felt about myself in the world. They made me uncomfortable, made me want to fight back, in a way I could never fight back against my father.

Luckily, I could never be angry about the artmaking itself. That was always nurturing and soul-satisfying; that was entirely my mother.

Writing about my own work, I realized how much of my creative self came from my mother and, more, how closely I associated her with my creative work. She is still part of everything I paint, knit, write, probably even think.

But thoughts of my mother brought up distressing emotions too. I'm still angry about the fact that she was taken away from me. And on top of the personal pain of that, because my artmaking was so intimately related to her, her death meant psychologically convoluted things about my art.

Interestingly, I realized that the anger I felt about my art experience had just as much to do with her as with my father. It was a defensive anger; at the time I

thought I was simply fighting for the way I wanted to work, but when I recognized how thoroughly I associated my artmaking with my mother, I felt that much more defensive of it. I was defending *her* creative work, retroactively, when I defended my own. I was expressing anger on her behalf, too late, about her art, about her marriage: that she was always in the role of supporting the art monster and never got to do enough with her substantial talent. Because she never expressed any anger about it, and now she *can't*, I feel fiercely protective of her—as well as of the artmaking urge inside me that is the only thing I have left of her. In my anger against the art world, I was avenging my mother.

WHEN I DECIDED TO be an artist, it felt like the thing that had been waiting for me all along. It felt so obvious, so predestined, that I thought, *this* is finally going to work out; this is, finally, what I *am*. It didn't hurt that starting a business felt really cool: it felt so good to earn money again, so good to act like an adult again. I had ridiculously high expectations of this work to *be* my new identity. I wanted it to rescue me; I wanted to use it to reclaim, regenerate myself.

And then it all went wrong. When the art world turned out not to be what I thought it would be—worse, when

people made me feel that not only was it not right for *me* but I wasn't right for *it*—it was a much bigger deal than just some hobby that turned out not to be fun after all.

I had put everything into this one basket. Not only was I in the middle of the identity crisis that is motherhood, but I had in fact been searching for this my whole life. I wanted art to be something that defined me; something for which I would be respected. I thought it was the trifecta of something I was good at, loved doing, and got paid to do. I wanted it to be work that would finally allow me to *be* something; that would transform me from a silly dilettante into a grown-up who had an answer to that awful question at parties: "So what do *you* do?" And even, privately, I wanted to succeed in order to honor my mother and the other artistic ancestors who had given me everything I needed to do this—if only I could make it happen.

All of this added up to the magnified emotional reactions that nobody, least of all me, could understand.

Art turned out to be, for me, all about finding my own identity. But it took writing this book three times to figure that out. I started writing it to figure out what had happened when I tried to become an artist, and I ended up with much more than that: I figured out a lot about myself.

I understood myself only when I admitted to myself how much I am made up of both of my parents. I'm the perfect cross of the two of them, both in talents and in emotional strengths and weaknesses. I got the art history and the writing, the art and the craft. I got the maternal instinct but also the selfish creative pull. I treasure my children beyond belief and put them *way* before my work (for better or for worse), but I can feel definite art monster tendencies lurking underneath, just waiting for their chance.

I carry it all with me. Everything my mother taught me, both consciously and otherwise. Her unconditional love, and her warmth that will never leave me.

I also carry what I got from my father. It is less absolutely good, but still a part of me. And there are strengths within the faults that I wouldn't trade for the world. Part of the tendency towards art monsterhood is a *drive* that cannot be taught. Even my defending my way of doing things derives from my father's uncompromising dedication to doing what *he* loved. Complicated and flawed as I may be, I am proud of what I am, and a large part of that pride and stubbornness is from him. In a way, by defending myself, I am defending him too.

WRITING THIS BOOK PROVED to be a necessary final stage in my adventure of becoming an artist. It turned out to be more of an education than my art education itself. Writing it allowed me to resolve, or accept, or at the very least understand my anger about so many things: the system that told me how I should work and talk and think; the society that reinforced those pressures. The incomprehension of my peers and the stupid games of status. The death of technique and the rise of self-expression, spontaneity, originality, encouragement, artspeak, and art-as-dialogue.

My father.

Myself.

I did not become a professional artist, but that's okay. I believe I didn't become a painter because I'm not, really, a painter. I knew at some crucial deep level that art was not, so to speak, my spirit animal. I found satisfaction in it, but it was not the key to my soul as the best kind of creativity is.

As people say, it's the journey that matters, not the destination. I went on the trip of a lifetime with cool techniques and delicious materials, and rediscovered what the real goal, the real pleasure, of making art is.

Best of all, my unhappiness with painting led me back to writing—what paper artist Helen Musselwhite called

"the medium that was patiently waiting for me all along."
And now I am right where I should be. Now I paint, draw,
sew, knit, quilt—but most of all I write.

For—as I knew at the very beginning—it is through
writing that I understand myself. In any creative work,
"one is trying to make a shape out of the very things of
which oneself is made." By going on my painting journey,
and by writing this book, I can now see what and who
I am.

Endnotes

Note: All citations from Ernst Gombrich's *The Story of Art* are from the 16th edition unless otherwise specified.

Chapter 1

glorious designs of fruit and vines This was the now-vintage *Ultimate Stencils* by Althea Wilson, 1990.

I fell head over heels in love with Patti Smith's romantic book *Just Kids*. If you get interested enough, as I did, there are two other excellent books to read. One is *Inside the Dream Palace* by Sherill Tippins, about the Chelsea Hotel and all the other artists living this same kind of life. The other is Mapplethorpe's full, authorized biography by Patricia Morrisroe. It's fascinating to read as a comparison to *Just Kids*, because of the different kinds of information we get in one and not the other. The biography gives a *much* less romantic picture than Patti Smith's memoir (though it's hard to accuse her of being squishy and starry-eyed). For example, she does *not* tell us the

extremely pertinent fact that Mapplethorpe *always* got high before making art.

"**unable to distinguish the greater hunger**" Patti Smith, *Just Kids,* 2010, p. 56.

"**One day we'll go in together and the work will be ours.**" Smith, p. 48.

"**touch them and get a sense of the paper and the hand of the artist.**" Patricia Morrisroe, *Mapplethorpe: A Biography,* 1995, p. 108.

women did decorative arts. Arthur Efland, *A History of Art Education,* 1990, p. 1. There was no formal education involved in the decorative arts, due—surprisingly to us—more to society's attitude toward that kind of art than toward its practitioners.

the definitions of art and science were in flux. Did you know that the definition of these have changed greatly, in fact have switched places exactly? For a fascinating discussion of Renaissance ways of thinking about these, read Gombrich's "Leonardo's Method for Working Out Compositions," from "Norm and Form" in *The Essential Gombrich,* ed. Richard Woodfield, 1996, p. 219.

divisions of the neon art department. James Elkins, *Why Art Cannot be Taught,* 2001, p. 49.

"The way that the visual arts are taught today was conditioned by the beliefs and values regarding art held by those who advocated its teaching in the past." Efland, p. 1.

"no one asked him to be original." Ernst Gombrich, *The Story of Art,* 16th edition, 1995, p. 65.

statues of idols Gombrich tells us that nearly all of these idols are gone, because they were destroyed at the time of the victory of Christianity over paganism. The sculptures we see in museums are copies made in Roman times. Gombrich wants us to be sure to imagine them as they were originally: 36 feet high, covered with gold, ivory, and colored stones. (Gombrich, p. 84.)

made it seem as if the viewer was inside the painting. www.artble.com/artists/giotto_di_bondone

"Nothing like this had been done for a thousand years." Gombrich, pp. 201-202.

"From his day onward the history of art … is the history of the great artists." Gombrich, p. 205.

"as soldiers on parade" Gombrich, *The Story of Art,* 13th edition, 1978, p. 482.

"the longest tradition humankind has ever known" Jean Clottes, *Cave Art,* 2010, p. 25.

forty-one different categories According to the table of contents in Amy Dempsey, *Styles, Schools & Movements*, 2011.

apprenticeship didn't exist before the Renaissance There were apprentices in guilds as early as the 1100s, but apprenticeship is generally said to have begun in the early Renaissance of the 1300s.

Michelangelo and apprentices Even though Michelangelo definitely used apprentices, he famously worked entirely alone on the commission of the Sistine Ceiling. Reportedly he first protested that he was a sculptor, not a painter, but then suddenly shut himself up in the chapel and worked for four years, entirely by himself. Arnold Hauser says that Michelangelo was the first to "express the decision to carry out a work single-handedly from beginning to end." (Hauser, *The Sociology of Art*, 1985, p. 156.) Gombrich makes us consider not only the artistic achievement of it ("the wealth of ever-new inventions, the unfailing mastery of execution in every detail, and, above all, the grandeur of the visions") (Gombrich, p. 308) but also the physical: imagine lying on your back on a scaffolding every day for four years.

more choices than ever in ways to become an artist. A large part of the issue is that the definition of what an "artist" is has loosened/expanded enormously.

the modern atelier There are a growing number of ate-
liers in the United States. One of the first was The
Classical Atelier in Seattle, run by Juliette Aristides,
who has also published several spectacularly beautiful
books on the classical approach to learning to draw
and paint.

The phenomenon of adult education Kathy Lynn Scott,
"The History of Adult Education in Art in 1930s
Delaware" in *Visual Arts Research,* Vol. 37, No. 1
(Summer 2011), pp. 54-66.

now you can even be completely untaught. Nearly as
bottomless (and equally unsolved) as the question
"What is art?" is the question "Can art be taught?" I
won't even venture an opinion but instead steer you
to two books that approach it in interesting ways.
The first is *MFA vs NYC,* edited by Chad Harbach,
2014: a book of essays on the pros and cons of getting
an MFA versus just getting on with your work. The
second is *Why Art Cannot be Taught,* by James Elkins,
2001: you might think you need not read further
than the title itself, but it is actually a wide-ranging,
fabulously iconoclastic analysis of art education.

Chapter 2

The word "delicious" came into my head every time. The
poet David Biespiel would understand. In describing
the physicality and sensualism inherent in writing

deeply, he says, "I could have licked the blue ink."
David Biespiel, *The Education of a Young Poet*, 2017,
p. 167.

redoing her half bathroom. Many faux painters find
bathrooms to be a pain, but I think they are the per-
fect venue for unusual, detailed decorative painting.
They are often interestingly shaped; they are small
and out of the way enough that people are often
more willing to do an adventurous finish; to me a
half-bath project feels like I've been asked to decorate
a jewel box.

**figuring out who you are and what you are good at is a
natural phase of life.** Now we have the complication
that the experiences traditionally had only by the
young are being had by beginners of any age. And
being a beginner gets more uncomfortable as you get
older: you feel you should be more confident by this
age, and even feel guilty for not being more settled, by
this time in your life, in a position that you wouldn't
have any doubts about.

**"Perhaps self-creation is ... a necessary creative act that
must precede other creative efforts."** John Gedo, *The
Artist and the Emotional World*, 1996, p. 4.

"temporarily deprived of positive feedback." Gedo, p. 4.
For lots more on this, see Howard Gardner, *Creating
Minds*, 2011.

"'Gorky' was not the novelist's family name either, but a nom de plume." Gedo, p. 4.

participation in the system For much more on this, see Harold Becker's excellent book *Art Worlds*. He makes the best argument I've seen for participating in the system: that it gives you a connection to "a tradition in which your work makes sense." (Becker, *Art Worlds*, 2008, p. 270.)

being an artist now "requires intense self-belief" From the BBC video on Sarah Thornton's website, sarah-thornton.com.

"private stage for the daily rehearsal of self-belief." Sarah Thornton, 33 *Artists in 3 Acts*, 2015, p. xiv.

Jeff Koons might be just as insecure Well... self-doubt is not psychologically possible for all of us. See also *narcissism*.

I could never write anything like this To clarify, faux painters do not generally write artist's statements: their work qualifies sufficiently as craft to escape having to do such poetic translation of it. Here I am referring to the later time when I had moved on to fine art, and talking about artists in general, not faux painters per se.

"an actor playing the role of the artist." Thornton, 33 *Artists*, p. 7.

dividing his time equally between "creation" and "platform." Thornton, *33 Artists*, p. 19.

"giving interviews is part of my practice." Thornton, *33 Artists*, p. 112.

"doesn't make great art as much as great use of the role of the artist." Roberta Smith, "The Message Over the Medium," *The New York Times*, October 11, 2012.

His rings are in the shape of the letter H. Thornton, *33 Artists*, p. 323.

"an aggressive belief in one's own importance." Judith Adler, *Artists in Offices*, 2003, p. 139.

"delighted to be the center of their own existence." Gedo, p. 373.

"It's genius, isn't it?" Smith, p. 268.

"Whatever-it-takes selfish." Claire Dederer, "What Do We Do With the Art of Monstrous Men?" *The Paris Review*, November 20, 2017.

shifted from a Culture of Character to a Culture of Personality Susan Cain, *Quiet*, 2013, p. 21.

"we measure ourselves against ever higher standards of fearless self-presentation." Cain, p. 31.

being an artist is now "dependent on a broad range of extracurricular intelligences." Thornton, *33 Artists*, p. xvi.

"Is it really as strong as that of other people who look the part of the devout believer?" Cain, p. 69.

"Figure out what you are meant to contribute to the world." Cain, p. 264.

we make value judgments about traits. Cain, p. 102.

"somewhere between a disappointment and a pathology." Cain, p. 4.

"discounted because of a trait that goes to the core of who they are." Cain, p. 4.

"finding a sphere of action in which he may work effectively." Maurice Beebe, *Ivory Towers and Sacred Founts*, 1964, p. 79.

"not allowed to remain [in the Ivory Tower]." Beebe, p. 80.

"a newfound sense of entitlement to be yourself." Cain, p. 15.

"The real prize comes to the artist when the work is made." Robert Genn, "Evaluating Art," painterskeys. com, Aug. 28, 2007.

Chapter 3

"the artist granted a favour to a rich prince...by accepting a commission from him." Gombrich, p. 288.

"a 'virtuoso' for whose favour princes and cardinals should compete." Gombrich, p. 363.

"men of unique and precious gifts." Gombrich, p. 288.

"shoes, or cupboards, or paintings, as the case might be" Gombrich, p. 287.

when art became expression, and the artist claimed rights to his imagination Woodfield, pp. 211-221.

Michelangelo's own family regarded his entry into the artistic profession as humiliating Arnold Hauser, *The Sociology of Art,* 1985, p. 144, citing Condivi, Michelangelo's biographer from the 1500s.

"felt aggrieved by their social status." Gombrich, p. 287.

a scientific, theoretical foundation. See Gombrich's fascinating piece on Leonardo and the significance of his innovations in drawing: "Leonardo's Method for Working out Compositions," Woodfield, pp. 211-221.

"the worst collection of snobs, flunkeys and self-seekers that the world has yet seen." Nikolaus Pevsner,

Academies of Art Past and Present, 1940, pp. vii-ix (Foreword, which is only in early hardcover editions).

"you know, not *de notre monde.*" Quoted in Beebe, p. 25.

"a certain elan in shapes and brushwork." Sara Genn, "Am I a Professional?" painterskeys.com, April 21, 2017.

"The ruling passion of my life was the detestation of the amateur." Henry James, *The Real Thing,* 1892.

"trivializes artistic accomplishment." A.O. Scott, "The Paradox of Art as Work," nytimes.com, May 9, 2014.

"plague of amateurism" Adler, p. 9.

the whole social structure around the definition of the artist. Adler, p. 135.

"difficult to determine whether or not artists were amateurs." http://www.agora-gallery.com/advice/blog/2017/01/03/art-history-art-competitions/

the battle of Art versus Craft. The Arts and Crafts movement was itself, at heart, an effort to improve the lives of artists, although indirectly, through the politics of work. John Ruskin and William Morris, who started it in the late 1800s, hoped to overthrow the evil factories of the Industrial Revolution and bring back handmade quality and joy in the lives of laborers.

has been debated forever. The Tate Museum stirred up the dust in 2011 when, on their blog, they asked people to respond to the question, "When is a craft an art?" For some excellent debate, see http://www.tate.org. uk/context-comment/blogs/tate-debate-when-craft-art

"A fully integrated application of one's capacities." Peter Korn, *Why We Make Things and Why It Matters,* 2015, p. 52.

"academic painterliness associated with oils." Philip Ball, *Bright Earth,* 2003, p. 321.

an utterly flat surface that doesn't show brush strokes The Golden paint company has just figured out this need, and created a new product called SoFlat.

nor did she officially try to teach me Years later, after she died, I moved my mother's sewing machine to my house. I hadn't expected to actually use it, but to my surprise, I discovered that I knew how to sew. I sat down and just found myself winding the thread through the fiddly twists and turns; it was in my muscle memory as if I had done it a thousand times. She had taught me without my knowing it. She was not gone entirely; some part of her turned out to be in me.

"slightly behind photography and slightly ahead of gold-fish." Robert Genn, "Women in Art," painterskeys. com, August 16, 2016.

Gombrich tells us Gombrich, p. 519.

"The Impressionists" Luckily public opinion proved these critics decisively wrong even in their lifetimes, and, clearly, by history.

hence our term vandalism Gombrich, p. 223.

Mannerism Mannerism had an interesting origin, namely that by the end of the Renaissance, it seemed that artists had achieved perfection in painting—anatomy, light, emotion, composition—and there was nothing left to be done. Young artists needed a new goal, and so took a new approach.

baroque, **meaning grotesque, absurd** For linguistics fans like me, the speculative etymology of this term is amusing. The French word means "irregular," from Portuguese *barroco,* "imperfect pearl," perhaps related to Spanish *berruca,* "a wart." From etymonline. com.

"deplorable lapse of taste." Gombrich, p. 387.

embalmed sharks Many of you will get the reference; if not, see the oeuvre of Damien Hirst.

purposefully childish, simplistic paintings Gombrich warns against people inauthentically working in this style: "One cannot become 'primitive' at will." (Gombrich, p. 589.)

"strange race after the naive and unsophisticated" Gombrich, p. 586.

New York Times cover article Nathaniel Rich, "A Training Ground for Untrained Artists," New York Times Magazine, December 16, 2015.

sympathetic enough to buy some Food for thought: is there a difference between including underprivileged, marginalized people in the name of political correctness, and the encouraging of untrained artists in adult education?

Chapter 4

"deliberate manipulation of natural materials" Ball, p. 54.

"metal-containing compounds pulled from the earth." Ball, p. 10.

"the aesthetic and intellectual." Ball, p. 11.

colormen The definitions of art and science have occasionally traded places. At that time "art" implied technical, manual skill, and thus, Ball says, a chemist was as much as an artist as a painter was (Ball, p. 8). In fact the field of chemistry went through very much the same tribulations of status as painting: it was seen as low status, practical, technical work, done by people such as apothecaries who lacked theoretical knowledge.

found in artifacts from 2500 BC Ball makes the excellent point that so many scientific innovators—the first person to extract an ore or to smelt bronze—lived before there were any means by which their names might be passed down through the ages. (Ball, p. 52.)

artists took to it. Ball, p. 324.

"delimited by the prevailing chemical technology." Ball, p. 7.

started using canvas The Venetians, again, led the way, using canvas earlier than others due to their growing shipbuilding industry. (Ball, p. 124.)

the coarse texture of canvas Exactly why I didn't like working on canvas.

undercolors showing where the paint skips Ball, p. 124.

"affordable paint by the gallon." Ball, p. 325.

the current state of paint technology Ball, p. 320.

"disembodied expectations gave me pause." Nell Painter, *Old in Art School*, 2018, pp. 86-87.

"disciplined application of vast artistic knowledge." From aristidesatelier.com.

"Ateliers are monasteries of art keeping skill and technique alive." Brandon Kralik, "Juliette Aristides On

TRAC With the Atelier Movement," *Huffington Post,*
February 25, 2014.

"a foot as seen from in front." Gombrich, p. 81.

"seemed to have made a hole in the wall." Gombrich, p.
229.

"outside the power of painting." Gombrich, "Leonardo's
Method for Working Out Compositions," in Wood-
field, p. 220.

who could record your face for posterity. Photography
was, however, a surprising benefactor of Impres-
sionism. It was invented around the same time that
Impressionism was being tested—the critics thought
it would never last—and it turned out to be just the
boost Impressionism needed to prove victorious. Just
as painters were painting en plein air, the portable
camera was invented; just as painters were capturing
the fleeting light or the movement of a moment, the
snapshot came in and accomplished the same thing.
It sounds like a competition that could have been
fatal to one side, but in this case there was no loser:
they both achieved the new style and helped the other
claim its success.

"something strong and powerful like human passion."
Gombrich, p. 551.

"a craft requiring years of practice." Adler, p. 83.

"a world which no longer exists." Adler, p. 136.

"I guess he is one since he exists in the art world." Adler, p. 135.

"pedagogical absence" Adler, p. 138.

"leave them feeling torn apart." Sarah Thornton, *Seven Days in the Art World*, p. 47.

"a really interesting conversation." Thornton, *Seven Days*, p. 72.

"rather than personal attack." Thornton, *Seven Days*, p. 5.

"socialize artists into suffering." Thornton, *Seven Days*, p. 71.

the easiest thing to work on in the format of a workshop. Chad Harbach, "MFA vs NYC," in *MFA vs NYC*, 2014, pp. 17-18.

"total openness to reconsider everything." Thornton, *Seven Days*, p. 67.

"a strong sense of nonentity." Adler, p. 143.

a Hirschfeldesque animal alphabet book You know how Al Hirschfeld hid his daughter Nina's name in his drawings? I started there and took it further: I found online simple vector outlines of unusual animals of every letter of the alphabet. I filled in the outline with

the name of the animal, over and over, in thin colorful marker, then erased the outline so the animal itself was made up of the word.

Chapter 5

"Where there is no choice there is no expression." Gombrich, p. 502.

"light a pipe or run after a bus." Gombrich, p. 503.

all the cleverness and knowledge that had been accumulated in Europe In other words, the careful development of technique of the previous several hundred years.

"intensity of feeling, and a direct way of expressing it." Gombrich, p. 550.

The Dada movement, founded in 1916 Dada has the distinction of being the only art movement to be formed on purpose, rather than just gathering strength.

"when art had lost every other purpose." Gombrich, p. 503.

"when it flowers as free play." Adler, p. xiii.

"aimlessness, immediacy, and spontaneity." Hauser, p. 26.

"it's always spontaneous." Thomas Hoving, *Andrew Wyeth: Autobiography*, 1995, p. 52.

"hidden dimensions of one's inner emotional landscape." "The Organization for the Arts & Whole Brain Learning," spontaneouspainting.com.

"deeply satisfying human psychological states" Robert H. Frank, "The Incalculable Value of Finding a Job You Love," nytimes.com, July 29, 2016.

a new concept in the Renaissance Hauser, pp. 163-4. As he says, the Italian Renaissance was a "cult of genius" that gave "brilliant position and unheard-of authority" to Michelangelo, Raphael, and Titian.

"a condition in which artistic freedom is taken for granted." Hauser, p. 167.

"a successor to God." Beebe, p.14.

"its most secret and its deepest poetry." Juliette Aristides, *Classical Painting Atelier*, 2008, p. 19.

laying the framework over many famous paintings To see these examples and analysis, see Aristides, pp. 24-43.

a circle within a square This is also the subject of Leonardo's *Vitruvian Man*. For lots more on this and everything Leonardo, see Walter Isaacson, *Leonardo da Vinci*, 2020.

"the challenge or dynamic feel it enjoys." Aristides, p. 36.

"composed as they painted." Ball, p. 125.

saw color as secondary Leon Battista Alberti—despite being Italian—criticized "those who waste their time using gold and rich colors while paying scant heed to their proper deployment." Ball, p. 106.

"furthering, without repeating, a great tradition." Aristides, p. 42.

"guided by traditions and patterns"; "to invent, not to execute"; "a process which is constantly going on in the artist's mind"; "stimulate the mind to further inventions." Gombrich, "Leonardo's Method for Working out Compositions," in Woodfield, p. 217.

"relationship between the Self and the world." Hans Richter, *Dada: Art and Anti-Art*, 1964, p. 219.

"often been made against modern artists." Gombrich, p. 371.

"liberated from manual labor." Which brings us full circle to the stigma against painters because they were manual laborers!

"through the assistants to the fabricator." Thornton, *33 Artists*, p. 80.

"the first major artist to paint by email." Peter Marks, "A Japanese Artist Goes Global," nytimes.com, July 25, 2001.

"simply too busy." Marks, "A Japanese Artist Goes Global," nytimes.com, July 25, 2001.

"come from a gregarious place" Cain, p. 75.

Chapter 6

"those who feel most uneasy about their own wealth." Tom Wolfe, *The Painted Word*, 1975, p. 19.

"Not to be in the scene is to be nowhere." Wolfe, p. 73.

"imagined they had found diamonds." Quoted in Gombrich, p. 519.

"recognize novel methods." Gombrich, p. 523.

"chroniclers of events" Gombrich, p. 523.

"this fall's avant-garde Breakthrough of the Century" Wolfe, p. 15.

"the most profound artistic upheaval the modern West has undergone." Hauser, p. 215.

"this zero point." Hauser, p. 182.

"Have they noticed me yet?" Wolfe, pp. 14-20.

"an artist in a pure state" Harold Rosenberg, *The De-definition of Art,* 1972, p. 12.

"that would come out as art." Quoted in Rosenberg, p. 12.

"sweet bourgeois idea of hanging up pictures" Wolfe, p. 87.

"placing this activity in an art context." Ursula Meyer, *Conceptual Art,* 1972, p. xi.

"what prevails *is inferior to* what is coming." Hauser, p. 681.

"a soldier who has to pick out a safe path for himself." Adler, p. 139.

"tradition personified." Rees and Borzello, eds, *The New Art History,* 1986, p. 9.

"its orthodoxy in research." Rees and Borzello, p. 2.

"the artist's genius." Rees and Borzello, pp. 4-5.

"burdened and hindered by every form of tradition." Hauser, p. 681.

"avoid anything which had existed previously." Hauser, p. 35.

"rebellion against convention itself." Michael Lind, "Originality versus the Arts," *The Smart Set,* Jan 12, 2017.

"in the long run this is hardly a task worth pursuing."
Gombrich, p. 596.

"the pursuit of originality at any price." Hauser, p. 35.

Chapter 7

"discrepancy between ambition and facility." Michael
Cunningham, *The Hours,* 1998, p. 104.

"full of vision, full of rage." Cunningham, p. 106.

"cutting the stems of flowers." Cunningham, p. 94.

"trivial, endlessly trivial." Cunningham, p. 94.

"even if you're an awful writer." Selfpublishingschool.com.
Surely it doesn't make me a snob to say that if you're
an awful writer, maybe you shouldn't write a book?
And, separately, why hold out the carrot of "easily
and effortlessly"? Ah, maybe it's a test: if you *are* a
writer, you know that it isn't either of those things;
hence, only the right people will apply. How efficient.

we also idealize and rarify creative genius. Gedo, p. 3.

"every gesture that each one of us makes is a work of
art." W.G. Collingwood, quoted in Roy Harris, *The
Necessity of Artspeak,* 2003, p. xvii.

"if you're alive, you're a creative person." Elizabeth Gilbert, *Big Magic,* 2016, p. 89.

you too could be a star. Scott, "The Paradox of Art as Work," nytimes.com, May 9, 2014.

"These things are Art like praying is medicinal." http://www.tate.org.uk/context-comment/blogs/ tate-debate-when-craft-art

"decorating the living room for a party." Mihaly Csikszentmihalyi, *Creativity,* 2009, pp. 7-8.

creativity is not part of many people's lives. It's one of those things that lead us to dangerous assumptions about other people. When you surround yourself with people like yourself, you are used to people doing these things and assume that everybody does. And when you find someone who doesn't, your first thought is, Well, you should.

"the difference-maker for you and your company." Josh Linkner, "5 Common Myths About Creativity," forbes. com, Oct 19, 2015.

a gold mine of a niche. Cameron has also quarried the other gold mine of self-help subjects: weight loss. She wrote a book called *The Writing Diet* in which she claims that creativity can block overeating. I can't help quoting the Amazon description: "This inspiring weight-loss program directs readers to count

words instead of calories, to substitute their writing's "food for thought" for actual food. *The Writing Diet* presents a brilliant plan for using one of the soul's deepest and most abiding appetites—the desire to be creative—to lose weight and keep it off forever."

"hearing that makes me feel worse." Gilbert, p. 197.

Chapter 8

from a book That book is Patti Brady's *Rethinking Acrylic,* 2008.

"a pejorative term [referring] to insular forms of language." "Drafting Artspeak," http://arcpost.ca/ articles/drafting-artspeak

what qualifies you for the job. David Levine, speaking in "Critical Language," a forum on International Art English, canopycanopycanopy, April 6, 2013.

on the wall itself at the entry to an exhibit. You'll notice this from the bottleneck in the foot traffic as people try to absorb what they are supposed to think about what they are going to see.

"discussions of like-minded people." Emily Mills, "Speaking 'Curator'," Sotheby's Institute of Art, sothebysinstitute.com, July 17, 2017.

Huffington Post quiz Jane Chafin, "Artspeak Quiz: Real or Randomly Generated?" huffingtonpost.com, June 7, 2011.

Which of these is "real"? For what it's worth, the real one is A.

"inapprehensible without words." Wolfe, p. 54.

if they can't read music. Hauser, p. 462.

Thomas Hoving, well-known director of the Metropolitan Museum Also author of the surprisingly useful *Art for Dummies,* and the subject of a fascinating biographical sketch by John McPhee.

you have to tell people what they're looking at. In "A Roomful of Hovings," profile by John McPhee in *A Roomful of Hovings and Other Profiles,* 1979, pp. 61-62.

"like a floundering person swimming to shore." Ksenya Gurshtein, "When Contemporary Art Feels Too Inaccessible," hyperallergic.com, May 2, 2018.

"they have lost all precision." Gombrich, p. 18.

"someone who speaks well and calls attention to yourself." Cain, p. 77.

you become increasingly powerful Cain, p. 51.

the martyr/monster dichotomy Marissa Korbel, "The Thread: Art Monsters," *The Rumpus,* July 16, 2019.

Does motherhood make you a less good artist? Paraphrased from Dederer, "What Do We Do with the Art of Monstrous Men?"

"something that must consume you entirely" Rufi Thorpe, "Mother, Writer, Monster, Maid," *Vela Magazine,* June 21, 2016.

analysis of the grammar and social uses of IAE Alix Rule and David Levine, "International Art English," *Triple Canopy,* July 30, 2012. http://canopycanopycanopy.com/issues/16/contents/international_art_english

thirteen years' worth of press releases This is another venue you find artspeak which we haven't mentioned yet. Press releases play an important role in the art market because of the now-global nature of the art world, and because "most of the art world's attention is online." They are "implicitly addressed to the art world's most important figures" and thus written in the best possible IAE. They also have, the authors say, the "purest articulation" of this unique language.

"past and present participles." Rule and Levine, "International Art English."

"like someone worth listening to." Rule and Levine, "International Art English."

"its allure as an exclusive private language is fading." Andy Beckett, "A User's Guide to Artspeak," theguardian.com, January 27, 2013.

"muddy the waters around the meaning of a work." Rule and Levine, "International Art English."

"heavily theoretical and text-influenced nature of much current art-making and education."

Beckett, "A User's Guide to Artspeak."

"a more widespread linguistic tic." ArtInfo, "How the Art World's Lingo of Exclusivity Took Root, Branched Out, and then Rotted from Within," blouinartinfo.com, August 7, 2012.

makes us confused and angry This is also why we are so frustrated by opaque conceptual art. The symbols of art, just like words, are supposed to be conventional enough to be understood by the viewer. So when contemporary art purposely uses language that viewers will not, cannot, understand—when our assumptions of the speaker's goodwill are shown to be misplaced (they weren't trying to communicate after all!)—we feel fooled, and thus bad, and thus angry.

Chapter 9

"you are only what you have written." Colum McCann in a speech at Grub Street's Muse and the Marketplace conference, May 2017.

producing something no one else had done Smith, p. 236.

"when you've just made something that wasn't there before." art-quotes.com

"Creativity is a gift to the creator, not just to the audience." Gilbert, p. 72.

"the catalyst for great art." Stephen Newton, "Why Women Can't Paint," newton-art.com. First of all, Freud has been proven ridiculous, but also: Newton is saying that women do not contain the catalyst for great art!

"except to get out of hell." art-quotes.com

Art as Therapy This is also the title of a great book by Alain de Botton and John Armstrong.

"to interact with people." Gedo, pp. 84-85.

"plumbed man's inner depths." Gedo, p. 89.

"may gradually be mastered." Gedo, p. 92.

"healing and psychic development." Stephen Newton, "Painting and Psychoanalysis," newton-art.com. He goes on to give a psychoanalytic explanation of why painting feels therapeutic: that painting is a type of exorcism. "Symbolic fragments of alienated, hidden and repressed aspects of the self ... are expelled and projected into the painting. ... The unconscious psychic structure is externalized and embodied in the 'flesh' of the paint."

"creative persons find joy in a job well done." Csikszentmihalyi, p. 5.

"the joy to be had through the sheer exercise of competence." Gedo, pp. 9-10.

"a centeredness that touches upon the very essence of fulfillment." Korn, p. 49-55.

"you've just done something as well as you can do it." Clare Crawford-Mason and Lloyd Dobyns, *Quality or Else,* 1991; quoted in art-quotes.com.

"art has its origin in the need for intercourse with other people." Hauser, p. 434.

"Rhetoric is one of its essential elements." Hauser, p. 219.

"cuts the creator off from all human ties." Gedo, p. 161.

"without wishing to make it visible to others" Hauser, p. 436.

"already concerned with communication." Hauser, p. 432.

"what are they doing it for?" Tom Rachman, *The Italian Teacher*, 2018, p. 118.

"partners in a dialogue." Hauser, p. 437.

"Nobody talks to himself in verse." Hauser, p. 432.

"he's only a nuisance." Quoted in Adler, p. 11.

"their final ascension to professional seriousness." Adler, p. 11.

"what the product does with and in experience." John Dewey, *Art as Experience*, 2005, p. 1.

Philip Ball has a gratifyingly tangible take on how a painting continues its life after it's finished: he reminds us how paintings physically fade and change over time. In this way, "a picture is never finished." Ball, pp. 250-1.

"neither its origin nor its completion to him alone." Hauser, p. 136.

"belonged to her, and never again to me." Gilbert, p. 125.

"reverie or unreciprocated monologue." Hauser, p. 430.

"a mere technical accomplishment" Humph!

"a dialectical, historico-sociological happening." Hauser, p. 438.

that she had taken over 150,000 photographs. This was two years before she died; I almost think that the shock of having her life's work exposed killed her.

art is not an end in itself Rees and Borzello, p. 13.

"work that engages one as an end in itself." Korn, p. 53.

"Maybe they are tougher." From "Women in Art," painterskeys.com, Aug. 16, 2016.

"the self-promotion obsessively imposed by the media." Elena Ferrante, *Frantumaglia*, 2016, p. 271.

"if we can do without Homer's or Shakespeare's" Ferrante, p. 200.

"It's not at all necessary for me to publish this book." Ferrante, p. 14.

"it's as important as breathing." art-quotes.com

"makes him its instrument." Quotes in Beebe, p. 10.

"it will cause you an outrageous amount of trouble." Gilbert, p. 171.

"I said that over and over." Smith, pp. 124-5.

Epilogue

"the burden of feeling that...I was shamefully alone."
Olivia Laing, *The Lonely City*, 2017, p. 7.

"childhood experiences of being unseen and unheard."
Nadia Colburn, "Poetry, Emptiness, and Mindfulness,"
nadiacolburn.com, Sept. 18, 2019.

"the medium that was patiently waiting for me all along."
helenmusselwhite.com

"the very things of which oneself is made." art-quotes.
com

Acknowledgments

This book is finally here thanks to all the people along the way who buoyed me up simply by saying that they thought that it was a great idea. It went through the hands of many talented people at Grub Street and at the Writer's Loft, and came out better for each of them. Much of it blossomed in invaluable discussions with my excellent husband; both the book and my life are infinitely richer for the existence of my beloved children.

A Note About this Book

This is an independently published book, and to be successful, it needs your help. If you liked it, please buy a copy for a friend. We all know someone who dreams of being an artist, and you definitely know more introverts than you think you do.

CPSIA information can be obtained
at www.ICGtesting.com
Printed in the USA
BVHW051342070821
613846BV00009B/1077